Wildlife Photographer of the Year

Portfolio 22

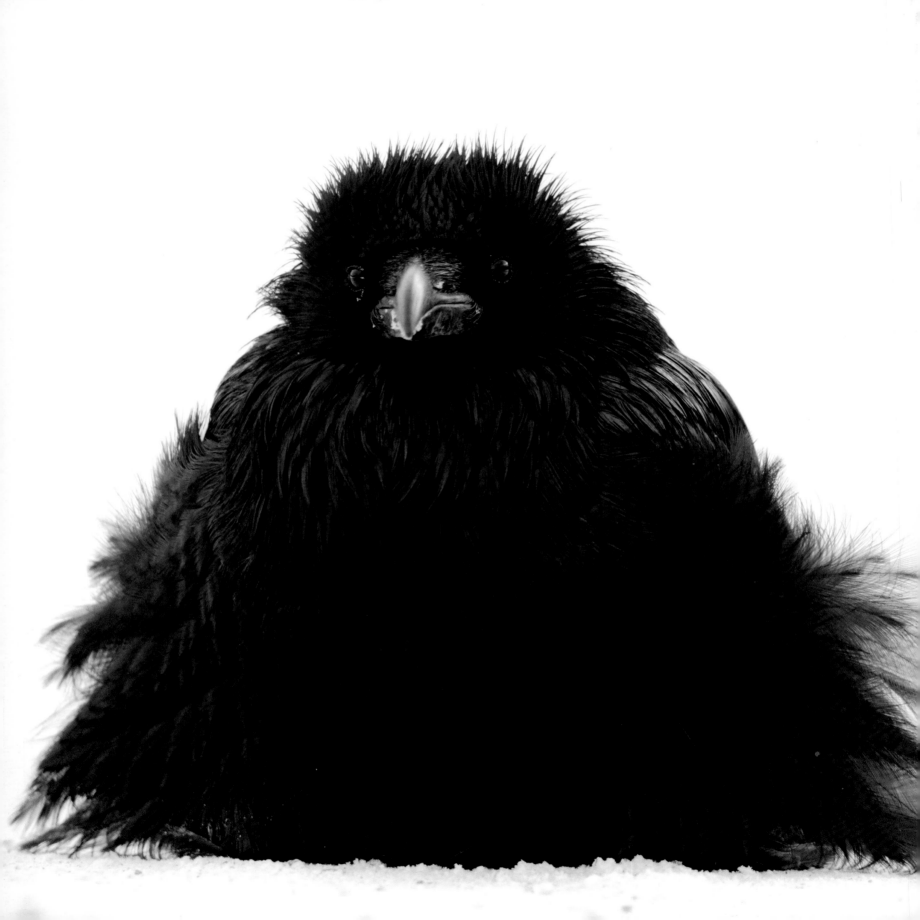

Wildlife Photographer of the Year
Portfolio 22

Published by the Natural History Museum, London

st published by the Natural History Museum,
omwell Road, London SW7 5BD

Natural History Museum, London, 2012

otography © the individual photographers 2012

N 978-0-565-09317

atalogue record for this book is available from the
ish Library.

tor: Rosamund Kidman Cox
signer: Bobby Birchall, Bobby&Co Design
otion writers: Rachel Ashton and Tamsin Constable
our reproduction: Metro Imaging Limited, UK
nting: Printer Trento Srl, Italy

Contents

Foreword

The responsibility of judging the world's largest competition of nature photography is not taken lightly. Picking the winning pictures can change a photographer's life. I have seen it happen.

The judging process is a bit like making a photograph. You must size up the visual components and make a decision. There are the inevitable second thoughts. But final decisions are needed. The ideal is having a consensus among a group of the most relevant and experienced professionals, who have spent a lifetime making decisions behind a camera or in an editing room. Knowing the anxiety and anticipation of entrants adds to the responsibility of getting the decisions right.

Over the years, the most talented nature photographers have entered the competition, and many of the finest natural history images have been submitted. But there are some blank spaces in the world, and work is being undertaken to recruit photographers from those quiet areas. I also know some professionals don't enter for many of their own personal reasons – one could even be a fear of winning. Nature photography often attracts quiet if not reclusive types of people.

While looking over the shoulders of our three stages of judging, as numbers were whittled down from 48,000 images, I felt there was harmony, and we generally agreed with each other's decisions. But there were losses, too. A lasting impression was the quality of the work of young photographers. One image stayed in my mind from first glance to the end. Sadly, that image had to be disqualified for not meeting one of the technical rules. The rules must guide us, especially those governing manipulation in the field or on a computer. That aside, my personal goal when reviewing an image on the screen in the judging room is to try to detach from the traditional means of evaluating a nature photograph, by looking at it as an artwork. I try to imagine how each image will stand outside of our little tribe of 'rocks and flowers photographers' – a term my journalist colleagues have used to describe us.

It seems a natural progression that some of this work should be shown in the finest art galleries of the world. A winning image hung in the Louvre, the American Museum of Modern Art or London's National Gallery would be an important cultural acknowledgement. Serious nature photography is worthy of this placement, but it may never happen in my lifetime.

My university studies were in art and art history, giving me a slightly different perspective as a judge. I learned that there is a political component to being accepted in that rarefied atmosphere of the capital-A Art world. How visual critics view this competition is varied but at the same time frustrating and exhilarating. The art world has never generally accepted nature photography as a valid art form. That discrimination happens everywhere. I've been a victim myself, in one of the most prestigious photographic competitions in American journalism. The final award was between a human-interest feature and my natural-history story. An observer of the final judging called me after the decision and told me there had been a strong protest from one of the judges who said, 'nature photography was not worthy of such an important award in journalism'. His protest stood, the judges were swayed.

During the three different years that I've been involved in the judging, there has been much discussion about raising the bar in the competition. The images printed here are the result of that effort. You can be the judge now.

JIM BRANDENBURG
Chair of the Judges, Wildlife Photographer of the Year 2012

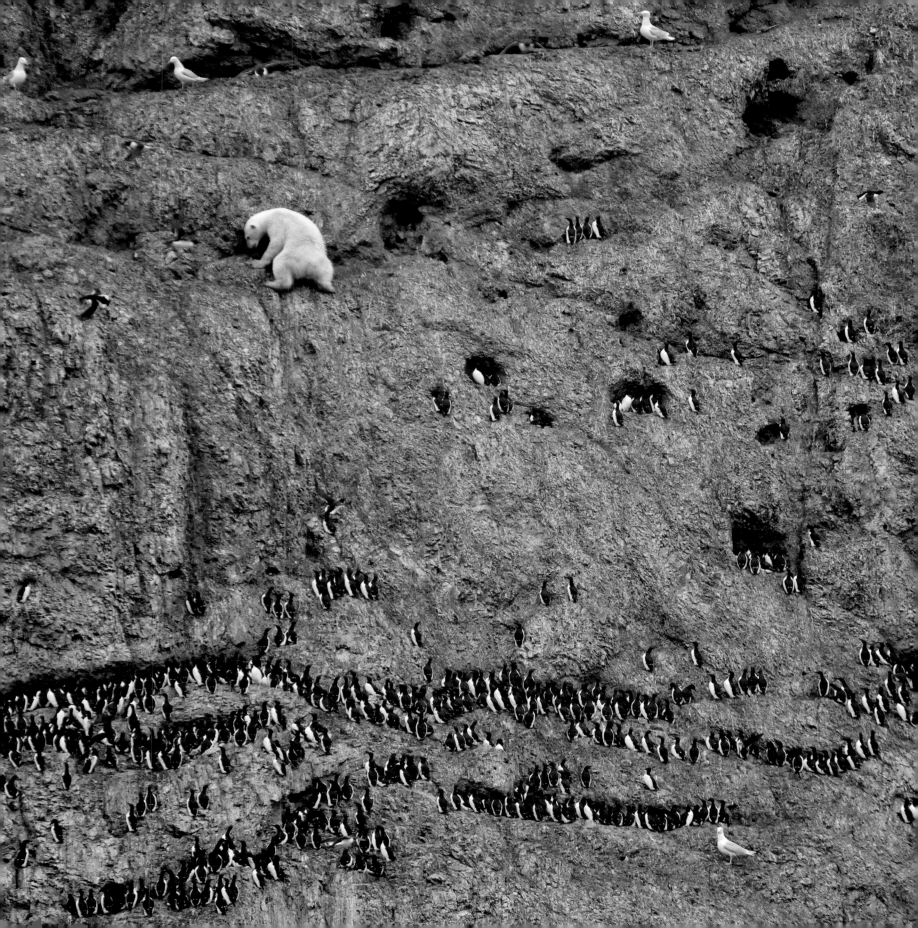

The Competition

One hundred unforgettable images of wildlife and the natural environment are displayed in this book. They are the very best of more than 48,000 entries in the 2012 competition, selected by an international jury, chaired by Jim Brandenburg, one of the world's most respected nature photographers and a past winner of the competition. These one hundred pictures will also be seen by an audience of millions in the form of a major exhibition that travels the world.

This is a collection of photographic art – images are chosen above all for their aesthetic qualities – but also of extraordinary, often technically amazing and sometimes shocking reflections of events in the natural world.

It aims to make its audience both wonder at the splendour, drama and variety of life on Earth and become more aware of human pressure on the environment, but great emphasis is also placed on ethics. Strict rules put the welfare of animals first and allow no image manipulation beyond digital processing, so that the pictures are truthful reflections.

The competition as it is today represents a collaboration between the Natural History Museum, London, and *BBC Wildlife* Magazine. Its foundations were laid in the early 1960s, with the birth of the conservation movement as we know it now and the launch of *Animals* magazine, the forerunner of *BBC Wildlife* Magazine. The results of the very first competition were published in 1965, and from then on it has sought to showcase annually the very best work of wildlife photographers worldwide, supported by the leading champions of wildlife, including David Attenborough and the late Gerald Durrell and Peter Scott.

Professionals, including some of the world's leading photojournalists, pick up many of the big prizes, but amateur photographers are also among the winners, highlighting the unique nature of the competition as being open to all photographers, whose work is judged anonymously. This year's entries came from 98 countries, 28 of which are represented in this book, reflecting its international scope and influence.

As it has grown, the competition has sought to show the winning pictures to the widest possible audience, displaying the range of styles, innovative techniques and cultural ways of seeing nature and, by doing so, inspiring photographers around the globe to produce new and innovative work.

Encouraging the next generation of photographic artists – through the Young Wildlife Photographer of the Year competition and the Eric Hosking Award – is also one of its aims. Indeed, many young photographers have risen through the competition to become inspirations themselves, including the 2012 judge Vincent Munier – three-time winner of the Eric Hosking Award. This year, for the first time, the gender split among the young photographers entering the competition was almost equal – an encouraging sign.

The Judges

Daniel Beltrá
conservation photographer (Spain)

David Doubilet
marine photojournalist (USA)

Edwin Giesbers
nature photographer (The Netherlands)

Joël Halioua
Director and Photo Editor,
Joël Halioua Editorial Agency (France)

Soichi Hayashi
Creative Director, K&L Inc (Japan)

Rosamund Kidman Cox
editor and writer (UK)

Neil Lucas
photographer and film director (UK)

Kathy Moran
Senior Editor for Natural History,
National Geographic Magazine (USA)

Vincent Munier
photographer (France)

Jari Peltomäki
wildlife photographer (Finland)

Tom Schandy
wildlife photographer and author (Norway)

Sophie Stafford
Editor, *BBC Wildlife* Magazine (UK)

Jan Töve
landscape photographer and writer (Sweden)

Chair of the judges

Jim Brandenburg
photographer (USA)

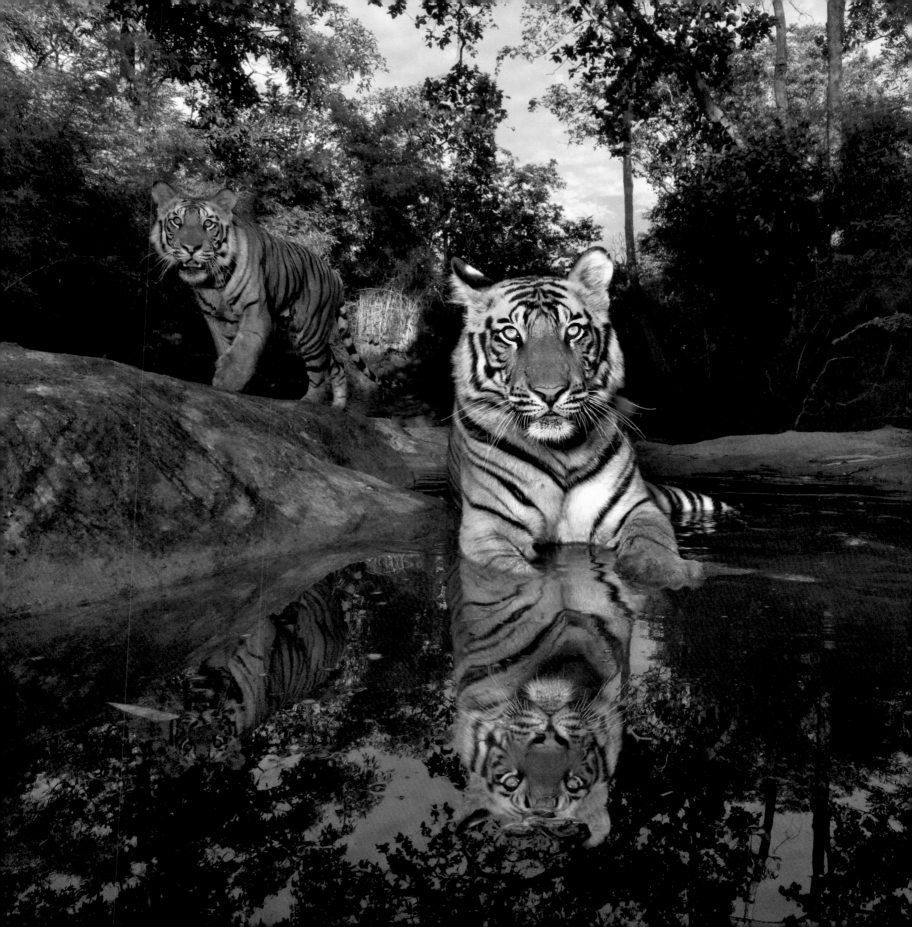

The Organizer, Sponsor and Magazine Partner

Wildlife Photographer of the Year is one of the Museum's most successful and long-running exhibitions. Together with *BBC Wildlife* Magazine, the Museum has made it the most prestigious, innovative photographic competition of its kind and an international leader in the artistic representation of the natural world.

The annual exhibition of award-winning images continues to raise the bar of wildlife photography and excite its loyal fans, as well as a growing new audience. People come to the Museum and tour venues across the UK and around the world to see the photographs and gain an insight into the diversity of the natural world – an issue at the heart of our work.

Open to visitors since 1881, the Natural History Museum looks after a world-class collection of 70 million specimens. It is also a leading scientific-research institution, with groundbreaking projects in more than 70 countries. About 300 scientists work at the Museum, researching the valuable collection to better understand life on Earth, its ecosystems and the threats it faces.

Last year, nearly five million visitors were welcomed through the Museum's doors to enjoy the many galleries and exhibitions that celebrate the beauty and meaning of the natural world, encouraging us to see the environment around us with new eyes.

Visit www.nhm.ac.uk for what's on at the Museum.
You can also email information@nhm.ac.uk
or write to us at:
Information Enquiries
Natural History Museum
Cromwell Road
London SW7 5BD

We are extremely proud to be title sponsor of the 2012 Veolia Environnement Wildlife Photographer of the Year competition and the UK touring exhibition.

Across the Veolia Environnement group, we work hard to protect the environment by providing efficient and sustainable services across water, energy and waste. We are also passionate about enhancing and promoting biodiversity so that wildlife can continue to thrive and delight people of all ages long into the future.

This competition and exhibition features the very best wildlife photography from across the world. Some of the images are truly stunning, some amusing and some disturbing, but what they all do is highlight the diversity and beauty of nature. We hope that you enjoy this book and that it inspires you to enjoy the natural world that can be found not only across the globe but also closer to home.

Visit www.veolia.co.uk for more information.

The origins of the world's most inspiring natural history photography competition can be traced back to the 1960s, when the forerunner of *BBC Wildlife* Magazine launched its first photography awards. In those early days, the competition attracted just hundreds of entries for three categories.

BBC Wildlife Magazine is proud to have worked with the Natural History Museum since 1984, to nurture and develop the competition into an international showcase for images of wildlife and the environment and the ultimate accolade for the finest talents in the business. But though the scale of the event has evolved, its aims and values remain the same: to celebrate the beauty of the natural world through the highest quality photographic art.

The winning photographs may be magnificent and powerful or intimate and intricate, but they are also moving and thought-provoking. The sense of wonder that they inspire is at the heart of *BBC Wildlife* Magazine: every issue highlights the breathtaking diversity of the natural world and the vital importance of understanding and conserving it.

Visit www.discoverwildlife for more stunning photography.
You can also email wildlifemagazine@immediate.co.uk

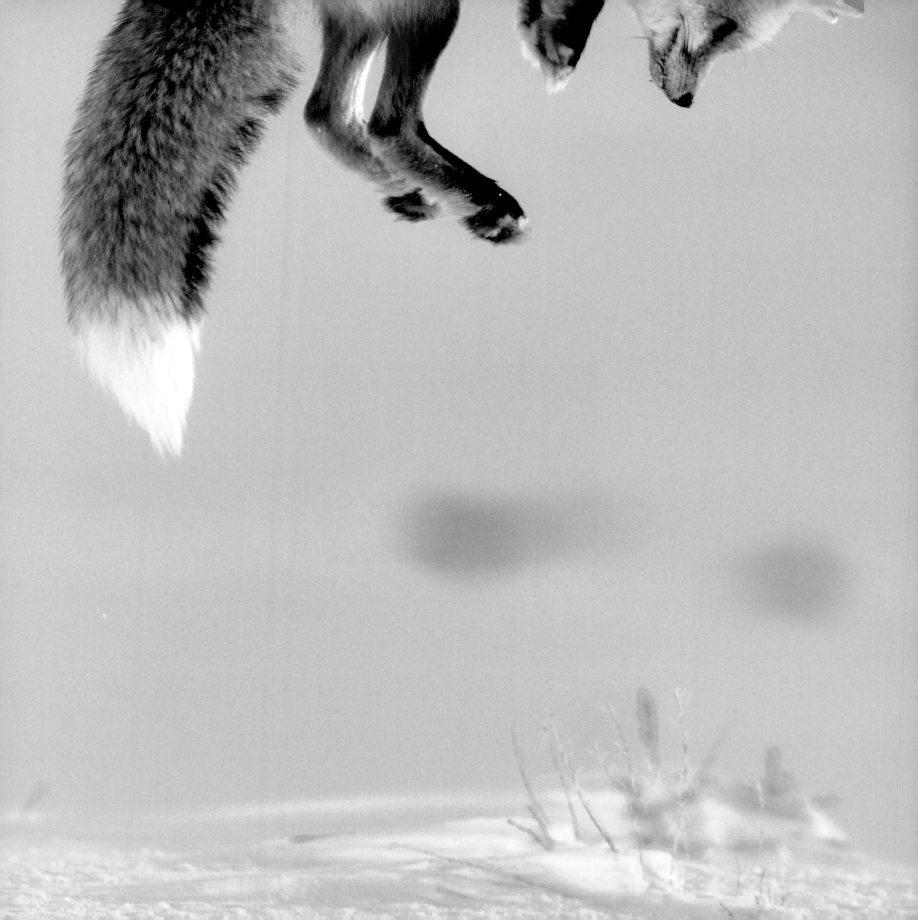

The Veolia Environnement
Wildlife Photographer of the Year Award

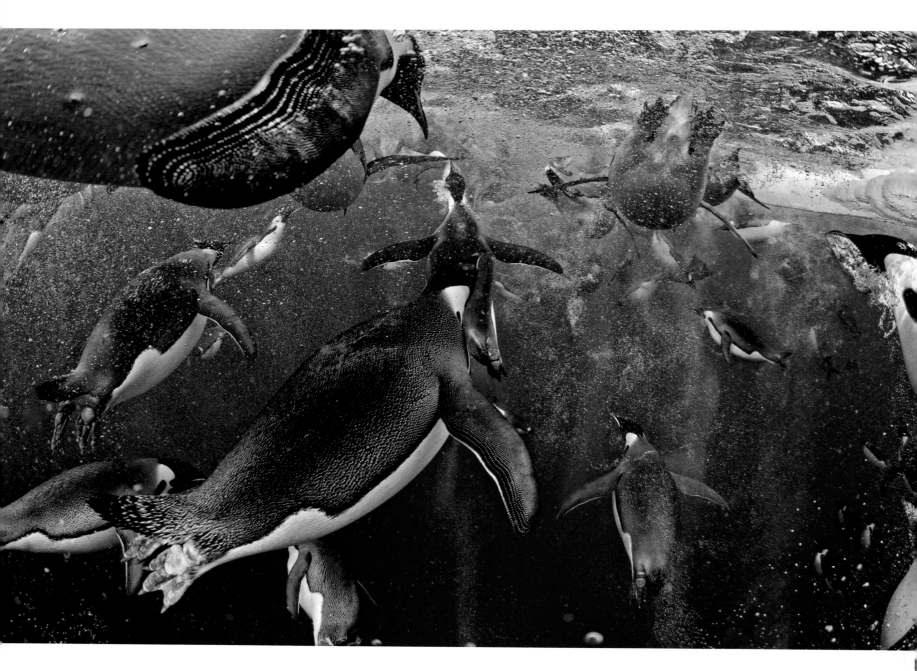

The Veolia Environnement
Wildlife Photographer of the Year

The title Veolia Environnement Wildlife Photographer of the Year 2012 goes to **Paul Nicklen**, whose picture has been chosen as the most striking and memorable of all the entries in the competition.

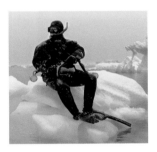

Paul Nicklen

A polar bear specialist and marine biologist, Paul Nicklen grew up on Baffin Island among the Inuit people. From them he learned a love of nature, an understanding of ice ecosystems and the survival skills that have turned him into an award-winning nature photographer. As an assignment photographer for *National Geographic*, Paul has produced stories from the slaughter of narwhals to salmon farming and the importance of polar ecosystems.

Bubble-jetting emperors

This was the image Paul had been so hoping to get: a sunlit mass of emperor penguins charging upwards, leaving in their wake a crisscross of bubble trails. The location was near the emperor colony at the edge of the frozen area of the Ross Sea, Antarctica. It was into the only likely exit hole that he lowered himself. He then had to wait for the return of the penguins, crops full of icefish for their chicks. Paul locked his legs under the lip of the ice so he could remain motionless, breathing through a snorkel so as not to spook the penguins when they arrived. Then it came: a blast of birds from the depths. They were so fast that, with frozen fingers, framing and focus had to be instinctive. 'It was a fantastic sight', says Paul, 'as hundreds launched themselves out of the water and onto the ice above me' – a moment that I felt incredibly fortunate to witness and one I'll never forget.

Canon EOS-1D Mark IV + 8-15mm f4 lens; 1/1000 sec at f7.1; ISO 500; Seacam housing.

Underwater Worlds

Underwater photography, whether marine or freshwater, requires specific skills, and to win, pictures must be memorable, either because of what they reveal or because of their aesthetic appeal – and, ideally, both.

Bubble-jetting emperors

WINNER

Paul Nicklen

CANADA (see previous page)

Blast-off

RUNNER-UP

Paul Nicklen

CANADA

When an emperor penguin returns to the colony after a fishing trip, exiting from the sea as swiftly as possible is a matter of urgency. To hang around could make it a target for any leopard seal lying in wait. 'I had been diving under the ice for a while,' says Paul, 'waiting for the penguins to arrive at the ice exit hole, when suddenly I realised they were emerging from the depths – and at incredible speed.' Recent research, based on analysing clips from a BBC film, has shown that as emperor penguins accelerate to their exit, they release millions of micro-bubbles from their feathers. This reduces the friction of their plumage against the water and helps them achieve maximum speed. This photograph captures the phenomenon perfectly. 'The penguin shot up, bubbles bursting from its bill and the feathers on its head, belly and back, looking like a rocket blasted from the depths,' says Paul, who is one of the few people to be able to appreciate first hand how penguins use air to 'lubricate' their ascent.

Canon EOS-1D Mark IV + 16-35mm f2.8 lens; 1/1250 sec at f5; ISO 400; Seacam housing.

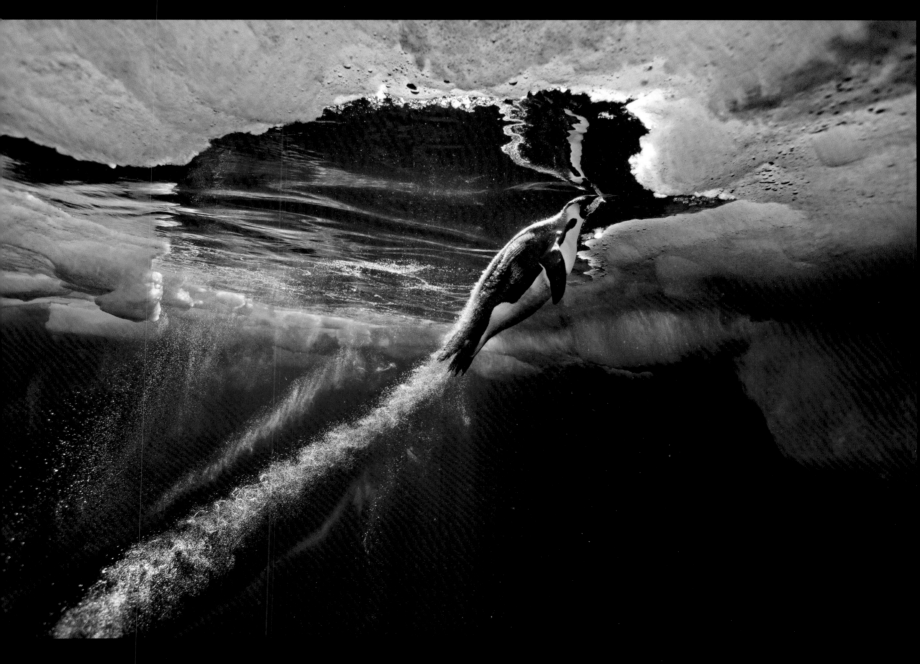

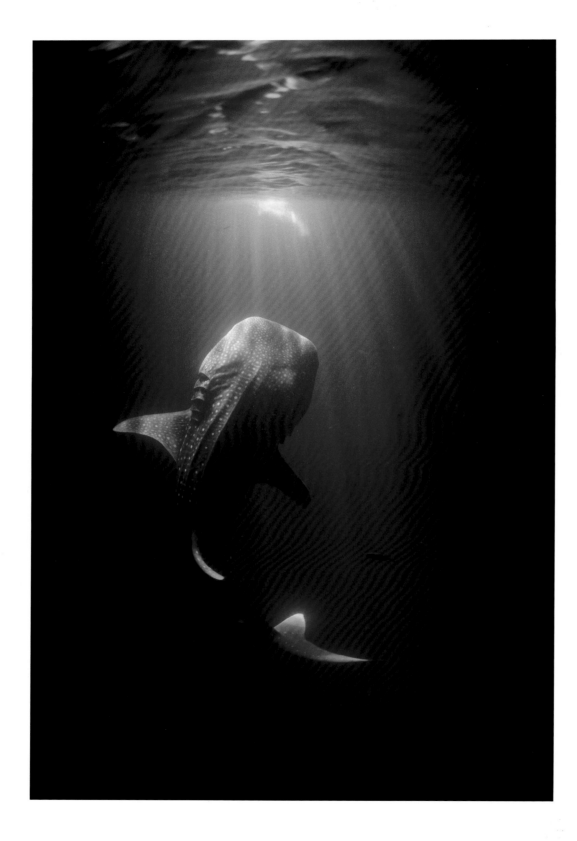

Midnight feast

COMMENDED

Thomas P Peschak

GERMANY/SOUTH AFRICA

In the dead of night, the young whale shark was feeding close to the surface. The challenge for Tom was to capture an image of it. The whale sharks in this area of the Gulf of Tadjoura, Djibouti, eastern Africa, feed at night on zooplankton attracted to the lights of small fishing boats. These lights were too dim to allow Tom to photograph without a flash, but a flash would have disturbed the shark. So from his boat, he hung an additional light just above the water. 'The cone of light was just large enough to illuminate the small whale shark emerging from the gloom,' he says. 'The shark was about two and a half metres long, but if it had been an adult, it would have been at least four times longer, and I would have only been able to get part of the animal illuminated in the frame.' This location is the only known one where juveniles gather and the only one where whale sharks are regularly documented feeding at night.

Nikon D3 + 16mm lens; 1/50 sec at f5; ISO 800; Subal housing; movie light above water.

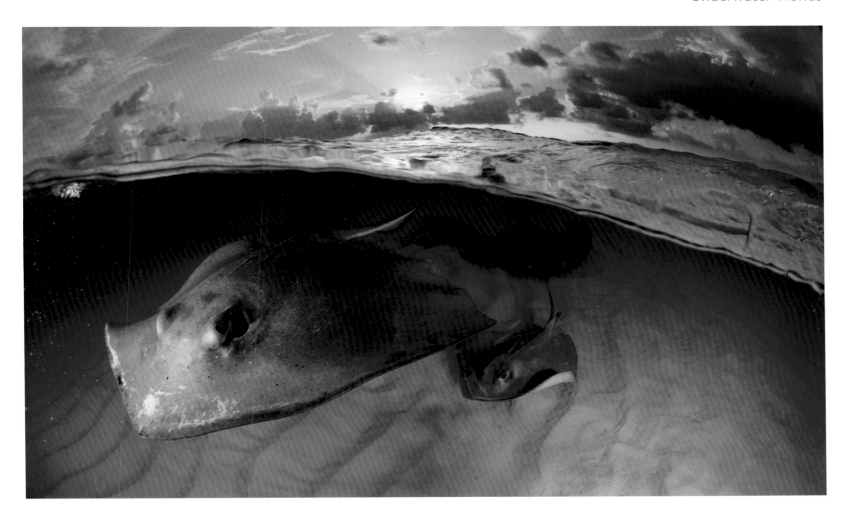

Evening rays

SPECIALLY COMMENDED

Claudio Gazzaroli

SWITZERLAND

North Sound, off the island of Grand Cayman, is a hotspot for 'friendly' southern stingrays – individuals accustomed to interacting with humans. Fishermen historically discarded their unwanted fish parts once they reached the calm waters of the sandbar at the Sound. The stingrays gathered for an easy meal and learnt to associate the boat-engine noise with food. Today, snorkellers gather in the waist-deep water to meet these charismatic fish. Inspired by David Doubilet's original split-level portrait of a Cayman stingray, Claudio set out to capture an image of the stingrays with a different perspective. 'There were about 75 of them undulating through the shallows,' he says. Balancing the light was a problem 'because of the extremes in contrast between the dramatic evening sky and sandy sea bottom', but keeping people out of the picture proved to be more of a challenge than executing the composition.

Canon EOS 5D Mark II + 15mm lens; 1/160 sec at f16; ISO 200; Nexus housing; two Subtronic Mega Color strobes.

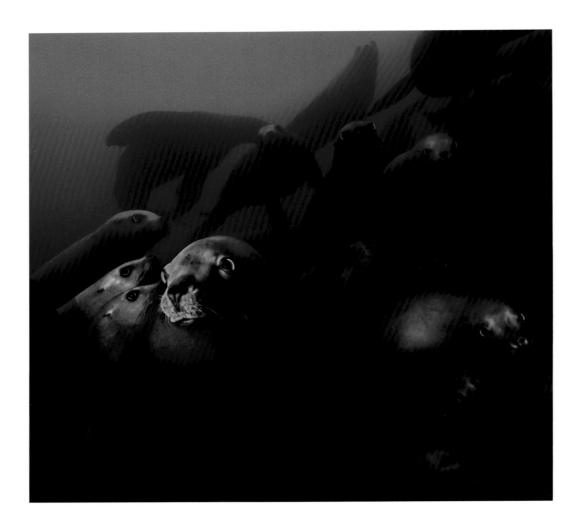

The lion pack

COMMENDED

David Hall

USA

David had tried many times to get close-ups of Steller sea lions – large and very active mammals that can grow up to an impressive four metres in length and weigh more than a ton. On this particular winter day he got more than he bargained for. Waiting patiently off Hornby Island, British Columbia, with appalling visibility, he suddenly realised he wasn't alone. There were at least 30 huge, inquisitive sea lions, swimming ever closer through the gloomy, green water. As their numbers increased, they grew bolder, and soon they were tugging on his arms and legs, and pushing him about. 'The situation was potentially dangerous,' says David, who was diving alone, 'and so I grabbed a few hasty shots, without checking camera settings or even looking through the viewfinder, and then made a sharp exit.' Loading the images onto his laptop later, he was amazed to see how well many of the shots had come out. 'That night in my bunk,' he adds, 'I couldn't sleep. All I could see were eyes staring at me in the dark.'

Canon EOS 5D Mark II + 17-40mm f4 lens; 1/100 sec at f9; ISO 800; Subal housing; two Ikelite DS125 strobes + diffusers.

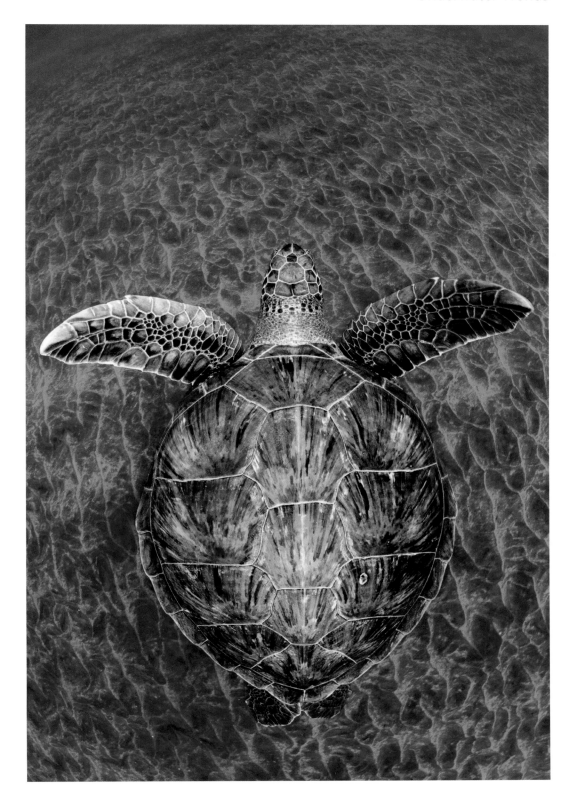

Turtle gem

COMMENDED

Jordi Chias

SPAIN

Armeñime, a small cove off the south coast of Tenerife, is a hotspot for green sea turtles. They forage there on the plentiful seagrass and are used to divers. Jordi cruised with this one in the shallow, gin-clear water over black volcanic sand. 'The dazzling colours, symmetry and textured patterns were mesmerising,' says Jordi, 'and I was able to compose a picture to show just how beautiful this marine treasure is.'
Like the other seven species of sea turtles, the green sea turtle is endangered, with populations declining worldwide. The many threats include habitat degradation, building development on their breeding beaches, ingestion of rubbish such as plastics and entanglement in fishing gear.

Canon EOS 7D + Tokina 10-17mm lens at 10mm; 1/80 sec at f11; ISO 160; custom-made housing; two Inon flashes.

Creative Visions

This category is for conceptual pictures – original and surprising views of nature, whether figurative or abstract – which are judged purely on their artistic merits.

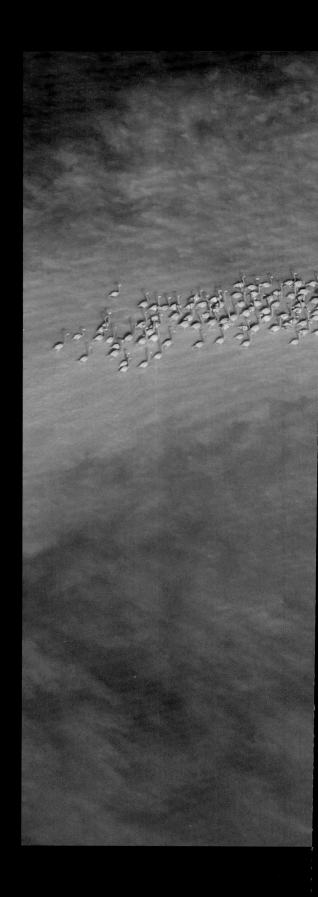

A swirl of flamingos

WINNER

Klaus Nigge

GERMANY

In winter, the 22-kilometre-long estuary of the Ría Celestún on Mexico's Yucatán peninsula attracts thousands of Caribbean flamingos, which congregate here to feed on the microscopic life in the shallow, briny water. These flamingos – the largest and pinkest of the five species – also use their time in the estuary to engage in synchronous courtship dancing as a prelude to breeding. To get the aerial shot that he wanted, showing the beauty of the mass aggregation of flamingos, with the birds appearing as if one organism, Klaus joined biologists on a flamingo count. 'Taking images out of the door of a plane flying in narrow circles is a challenge,' says Klaus. But lenses with image stabilisers helped overcome the vibration problem, and 'the photography in this situation was all about capturing the beauty of pattern, form and colour.'

Nikon D3 + 70-200mm f2.8 lens at 200mm; 1/1600 sec at f5.6; ISO 250.

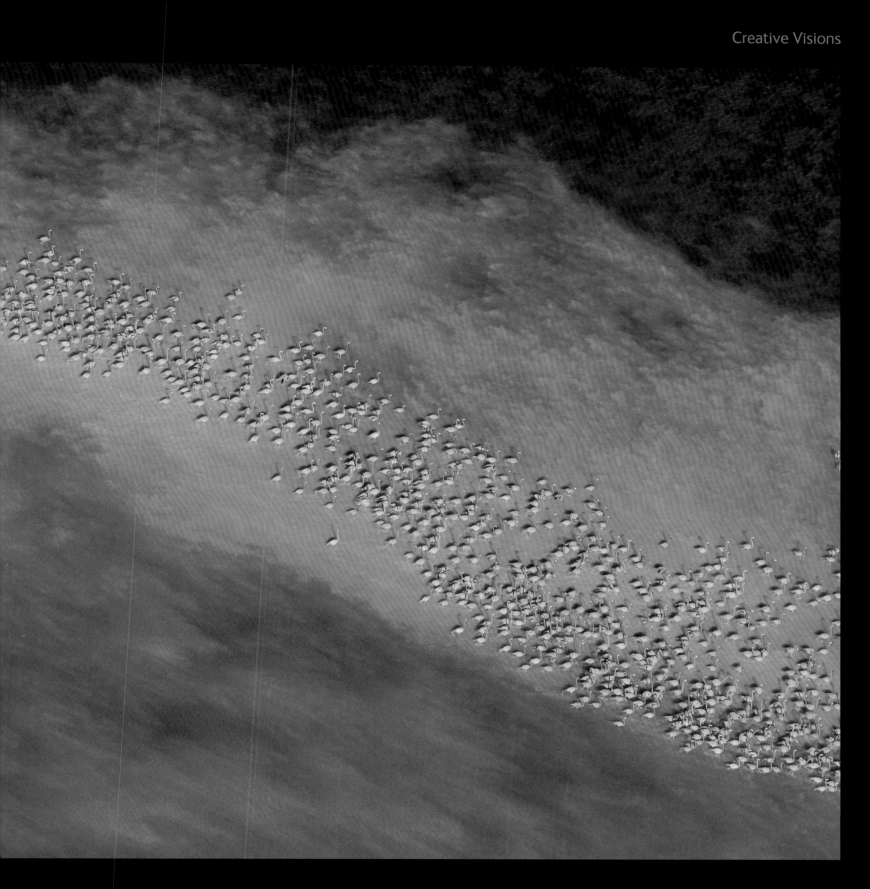

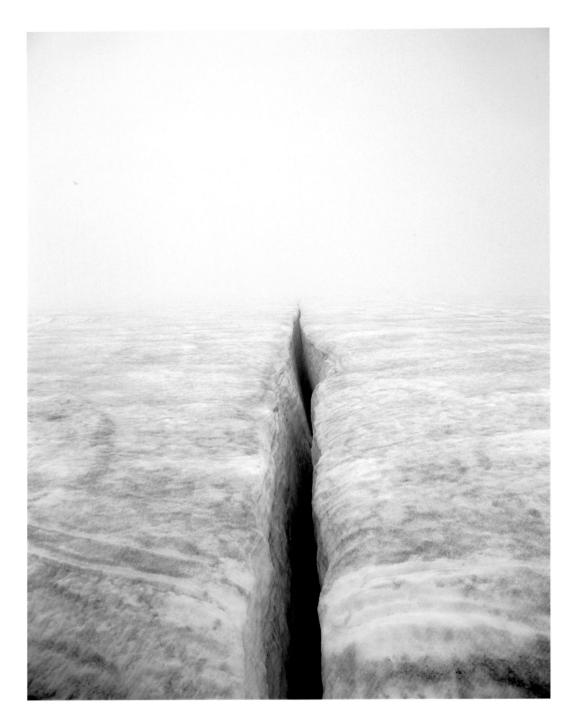

The crack

COMMENDED

Rudi Sebastian

GERMANY

As the fog descended, the chances of photographing the dramatic landscape of Iceland's Vatnajokull Glacier fell and the danger level rose. Then the jeep Rudi was travelling in suddenly stopped. The ice ahead had been torn apart by a crevasse. Though the crack was still narrow, the ice all around was extremely unstable. It was too dangerous to stand over the crevasse for more than a short time, and Rudi's guide was anxious to get off the glacier. So Rudi took just one shot. 'I wanted a 2D image, with the least possible depth and perspective,' he says, 'focusing on the crevasse disappearing into the horizon. At that moment, I was suddenly glad of the thick fog.'

Mamiya 645 + 80mm f4.5 Linhof Technorama lens; 1/30 sec at f11; Kodak Ektachrome 100VS film.

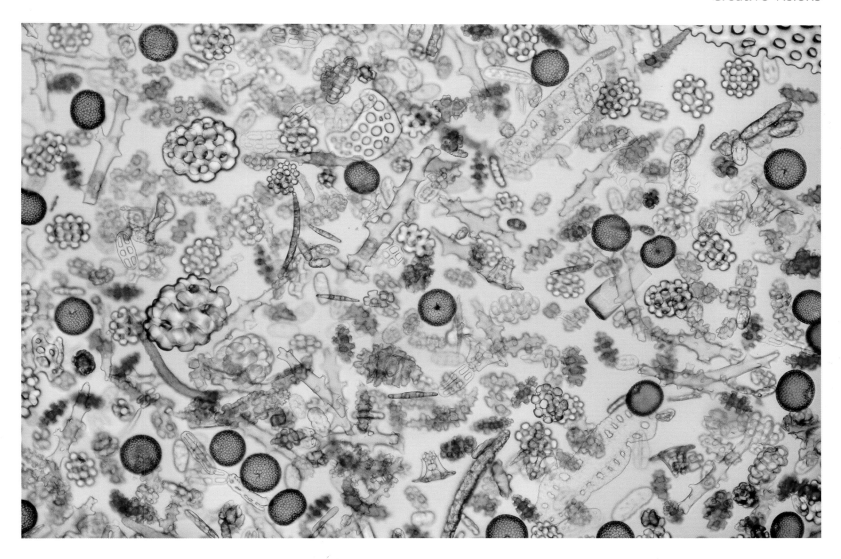

Sands of time

RUNNER-UP

David Maitland

UK

Watching one set of spicules after another come into focus under the microscope was, says David, 'like drifting through a magical galaxy'. Spicules are the calcareous skeletal remains of tiny, soft-bodied marine invertebrates such as sea fans and sea whips (corals) and sponges. These spicules, no bigger than grains of salt, accumulate on the seabed and wash up as sand, often turning beaches gleaming white. David attached his camera to a microscope to photograph an old sample on a Victorian slide. 'I wanted an image that would reveal the diversity and architectural beauty of the remains.'
The technical challenge was to get a perfect plane of focus. 'I spent ages making tiny adjustments, to get the right 3D effect,' he explains.

Canon EOS 5D Mark II; Olympus BX51 light microscope; 10x objective lens; 1/100 sec; ISO 50.

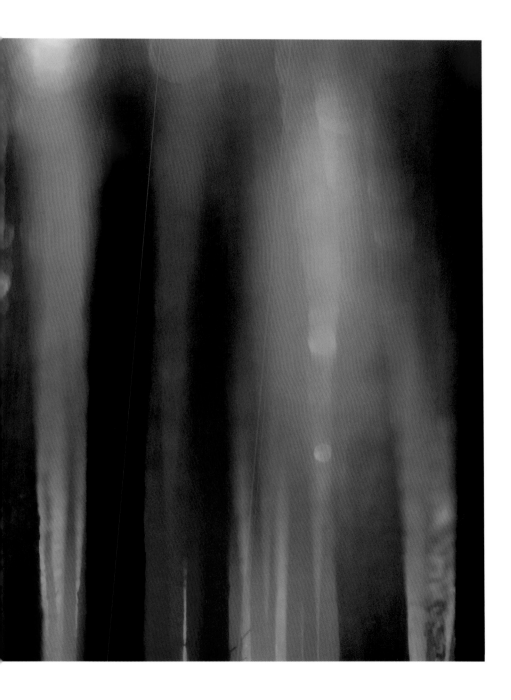

Light show

SPECIALLY COMMENDED

Sandra Bartocha

GERMANY

As the snow started to melt, a thick fog began to wrap itself around the forest near Sandra's home in Potsdam, Germany. Envisaging the photographic potential, she grabbed her camera and went straight to the forest. The scene was even more beautiful than she'd expected. 'The evening sun created a glow around the tall, wet trunks of the Scots pines,' she remembers. 'It was breathtaking.' She experimented with several different focal planes and lenses to try to capture the effect. Eventually, she settled on a mirrorless camera with a tilt lens, allowing her to change the layers of sharpness from parallel to horizontal, so the unsharp areas were not in front but behind and below the main focus. She played around with the focus 'to keep the warm, broken light at the top of the frame and the trunks below relatively sharp'.

Sony NEX-5 + Nikon 50mm f1.4 lens; 1/640 sec at f1.4; ISO 200; Lensbaby Tilt Transformer.

Positioning

COMMENDED

Hugo Wassermann

ITALY

Every morning Hugo listened to the local weather forecast. When rain was finally forecast for South Tyrol in northern Italy, he headed to the countryside on the outskirts of the nearby town of Feldhurns. There he put his hide up near a dead sweet chestnut tree and settled down to wait. In the tree was a brood of hoopoe chicks, and Hugo knew the habits of their parents. 'The hoopoes would fly in with food and perch on this beautiful fork before going to the nest hole,' he says. But the background view was distracting, and what Hugo had been waiting for was fog to sail up the valley and obliterate the background. 'The hoopoes kept perching on the lower bough,' he says. 'Just once in the whole seven hours I was there did one of them sit on the top branch. I love its posture as it concentrates on trying to position a pupa in its beak before flying to the nest hole.'

Canon EOS 5D Mark II + 300mm f4 lens; 1/250 sec at f6.3; ISO 320; Gitzo tripod.

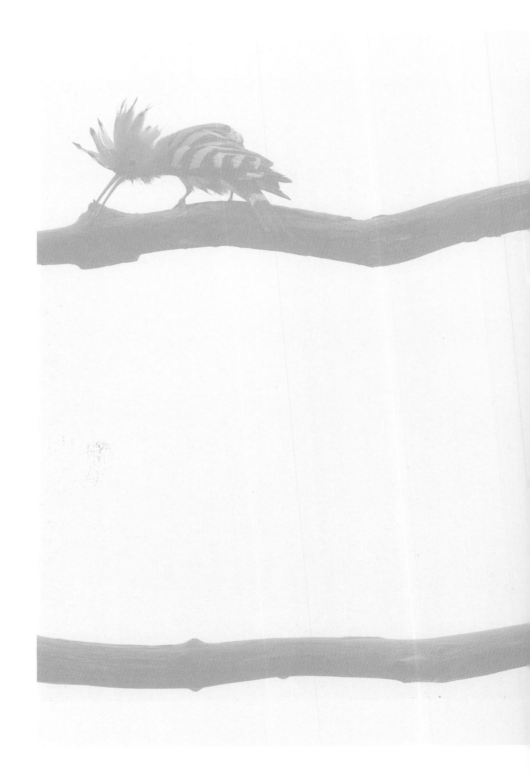

Animals in Their Environment

Here a sense of place and atmosphere is all-important, conveying an impression
of an animal integrally linked to its environment.

Living on thin ice

WINNER

Ole Jørgen Liodden

NORWAY

Ole had photographed polar bears more than
a hundred times before around the islands of
Svalbard, northern Norway, but on this particular
summer evening, everything came together to
sum up the bear and its ice environment.
'The landscape, the shape of the ice floe, the shape
of the bear and the footprints were just perfect,'
says Ole. Drifting ice is normal for midsummer
in the region. But, says Ole, two weeks later, all
the ice around Svalbard had melted, much earlier
than in previous years. 'I hope the picture also
makes people think about an environment that
is disappearing faster than most of us realise and
appreciate the scary future most polar bears are
facing, with ever-thinner ice or no ice at all.'

Nikon D3S + 14-24mm f2.8 lens; 1/400 sec at f11; ISO 1000.

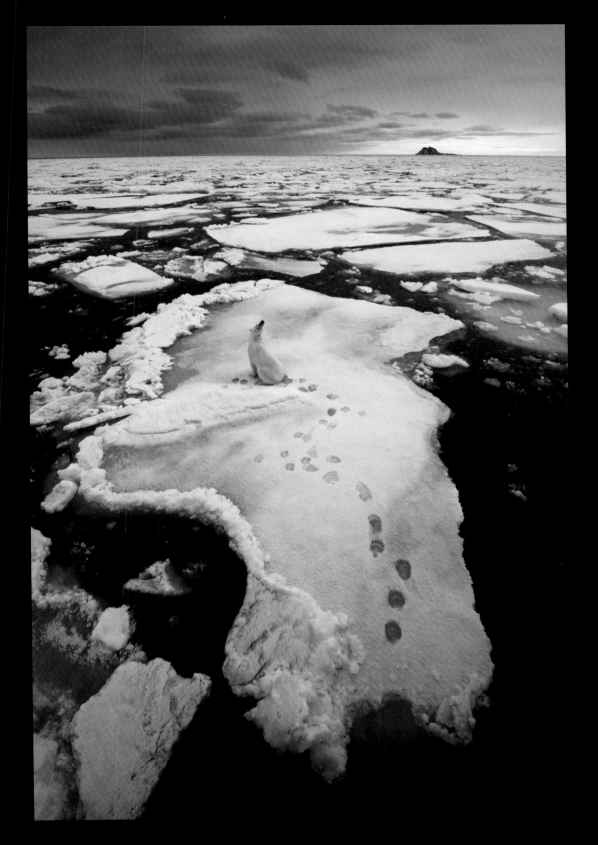

Lion by lightning

RUNNER-UP

Hannes Lochner

SOUTH AFRICA

This young male seemed blissfully unconcerned by the lightning and thunder rolling in across the Kalahari. Hannes, who was taking night shots in the South African part of the Kgalagadi Transfrontier Park, came across him stretched out beside the track. 'He raised his head to stare at me a couple of times,' says Hannes, 'but he wasn't really interested in either me or the dramatic goings-on behind him.' Hannes worked fast, framing the lion against the illuminated night sky at the moment a bolt of lightning flashed to the ground. 'Just after I took this picture,' he adds, 'there were a few more lightning bolts and then everything went still and dark again.'

Nikon D3 + 17-55mm f2.8 lens; 5 sec at f2.8; ISO 400; SB 900 flash; Badger Gear door bracket + Benro head.

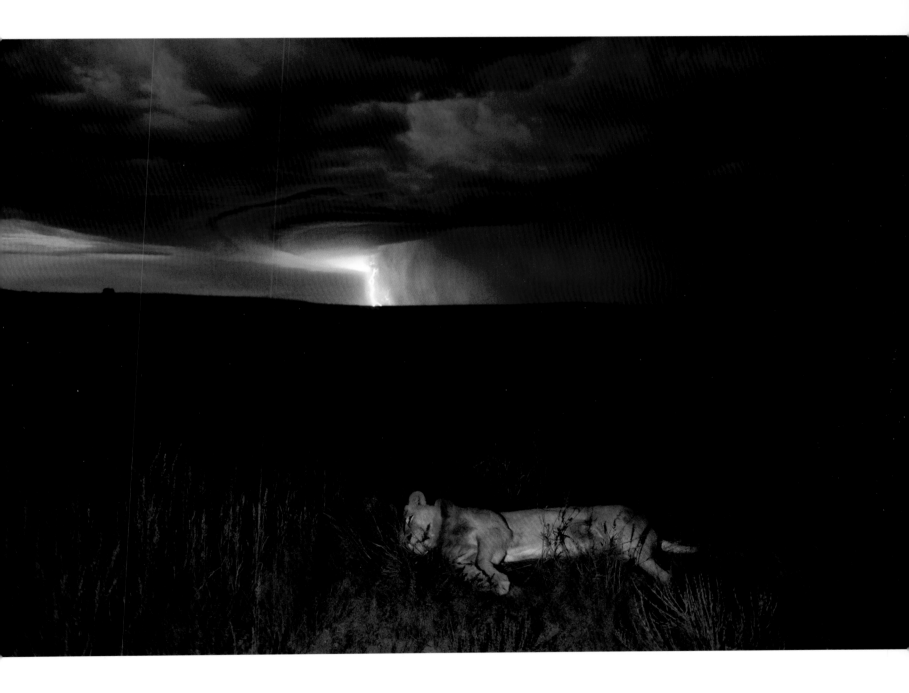

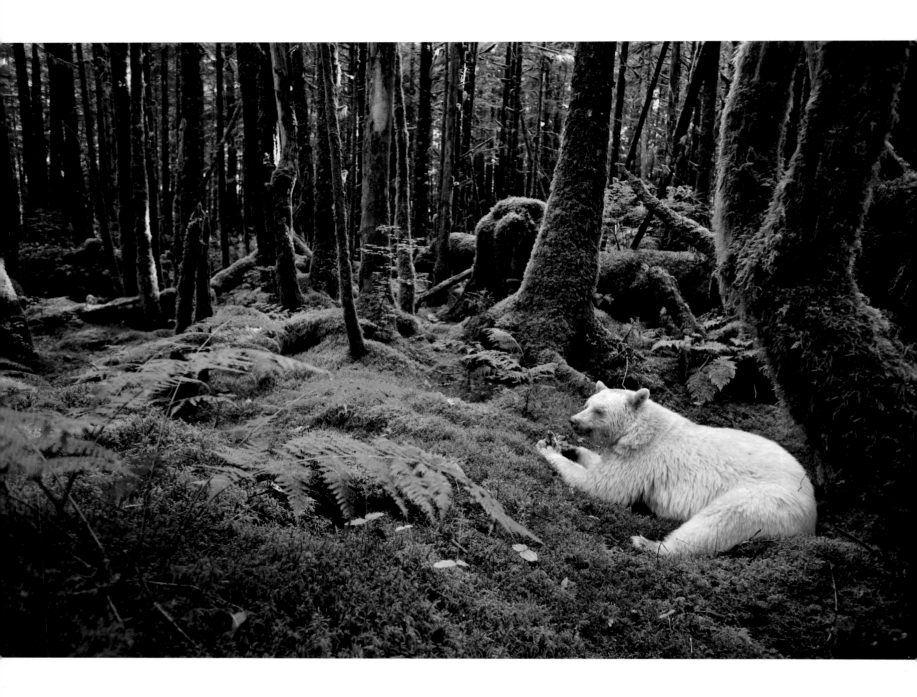

Spirit of the forest

SPECIALLY COMMENDED

Paul Nicklen

CANADA

The First Nations people of British Columbia (BC), Canada, have for centuries revered the spirit bear, or Kermode bear, to be found in the Great Bear Rainforest – a vast, old-growth temperate rainforest that runs up from southern BC to Alaska. The spirit bear is a rarity – a black bear with recessive genes that give it a creamy white coat. Its other name, 'ghost bear', reflects its elusiveness. Paul encountered this individual in September, at the height of the salmon run, when the bears are feasting on the fish bonanza and fattening up in preparation for hibernation. Spirit bears seem to prefer to escape the busy bear-fishing areas and wander into the forest to savour their meals in peace. 'I followed this bear until it settled down to eat. I was crouched less than a metre away,' says Paul, 'but he acted as though I wasn't there. It was really a dream come true, a dream I'd had since a kid, to walk through the forest with a bear.' The Great Bear Rainforest is one of the largest unspoilt temperate rainforests left, and it's the only place where spirit bears can be found. First Nations people are using the spirit bear as an ambassador animal in their campaign against a pipeline that will carry oil from Canada's tar sands in Alberta down to the BC coast. The pipeline and associated infrastructure will destroy forest, but the greatest concern is the risk of an oil spill from a tanker entering the hazardous coastal channel to collect the oil – one spill could wipe out an entire coastal ecosystem.

Canon EOS-1Ds Mark III + 16-35mm f2.8 lens; 1/50 sec at f2.8; ISO 800.

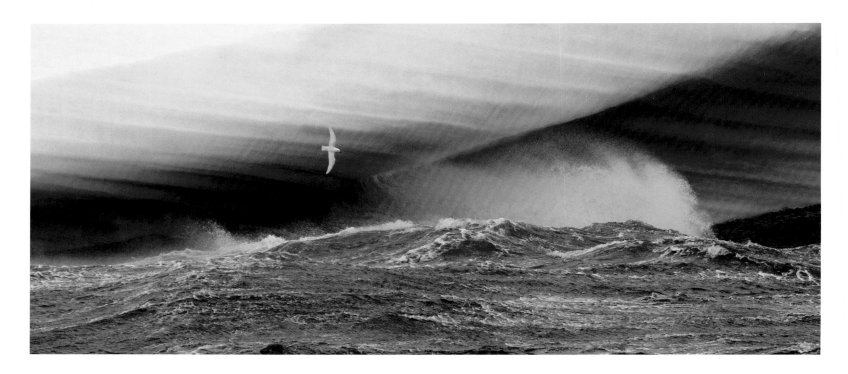

Where petrels dare

COMMENDED

Mark Tatchell

UK

It was blowing a good Southern Ocean gale that December day as Mark's ship headed south from South Georgia. Huge tabular icebergs, drifting north from the Weddell Sea, gave an extra edge to the windswept journey. Daring snow petrels swooped between them. Mark wanted to capture a shot that would 'combine the beauty of the ice, the power of the boiling sea and the elegance of the birds in flight'. He caught the moment when a single bird swept close to the wave-cut base of an enormous berg, 'a wonderful contrast to the harshness of the scene of that unforgettable place'.

Canon EOS 30D + 100-400mm f4.5-5.6 lens at 400mm; 1/1250 sec at f10; ISO 400.

Rocky stranding

COMMENDED

Alessandra Meniconzi
SWITZERLAND

It was late summer in northern Norway, and Alessandra was out in a dingy. But driving snow, terrible wind, poor light and seasickness meant that conditions weren't ideal for photography. The situation for the polar bear was, however, much worse. The ice around Svalbard had melted, stranding the bear ashore on one of the islands. Its only sustenance was the skeleton of a beached whale, and the bear would have been unable to hunt seals again until the sea froze over several months later.

Canon EOS-1Ds Mark III + 300mm f2.8 lens; 1/640 sec at f6.3; ISO 800.

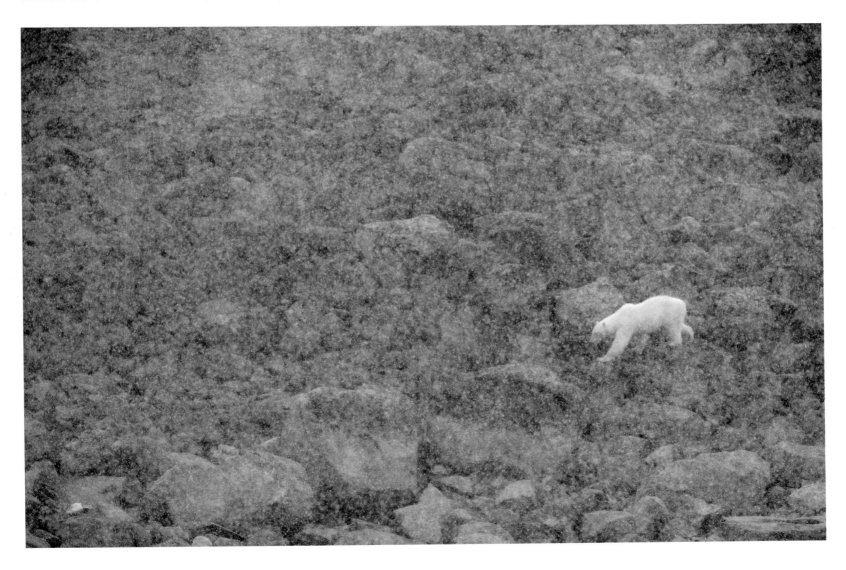

Ice birds

COMMENDED

Jeanine Lovett

USA

This giant iceberg, drifting just off the South Orkney Islands in the Southern Ocean, was as tall as a 14-storey building. At some point in its being, it had rolled over, to expose a dazzling underbelly of water-textured layers. It was the perfect backdrop. Jeanine had been watching a flock of Cape petrels soaring, swooping and dipping down over the sea, their long wings catching the updraughts and carrying them at speed. As the boat started to move around the iceberg, she realised that the birds would fly straight past the ice, and she raced across the deck to grab the moment. 'The beauty of the scene took my breath away,' she says. 'The photograph gives the impression that the berg was right beside our ship, but the petrels with their 60-centimetre wingspans show the true scale.'

Nikon D200 + 80-400mm f4.5-5.6 lens at 370mm; 1/1000 sec at f6.3; ISO 250.

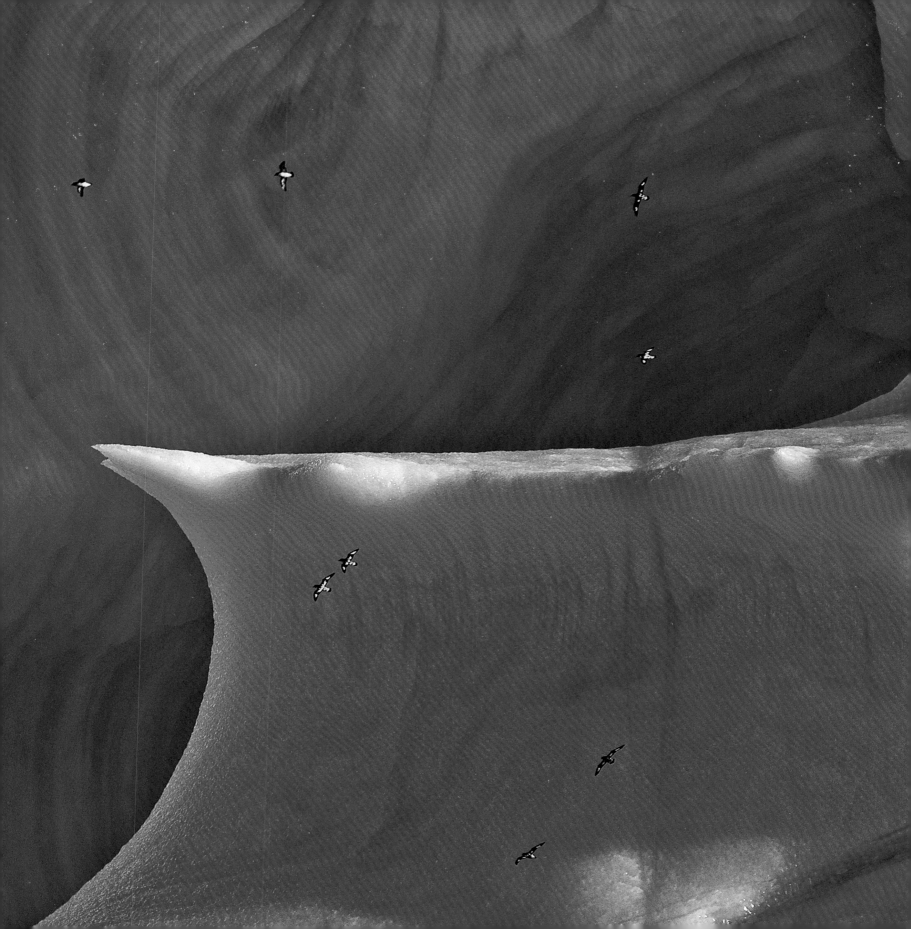

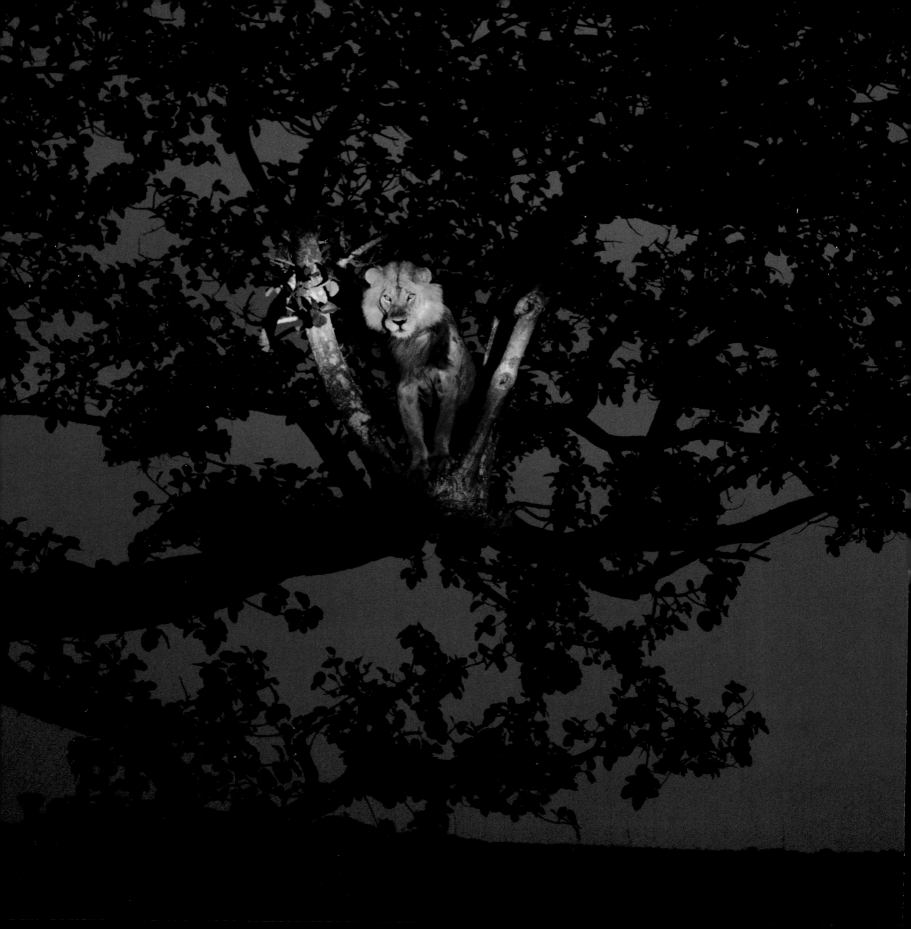

Lion in the spotlight

COMMENDED

Joel Sartore

USA

Tree-climbing is not a normal lion habit, but lions in Queen Elizabeth National Park, Uganda, often take to the trees in the day, probably to cool off and escape the flies. This tree held two dozing brothers. 'It was dusk by the time the first young male woke from his nap,' says Joel. 'I worried about camera shake, because the light levels were next to nothing. I also worried that he wouldn't look up so that I could see his face. He did, though, for all of five seconds, listening to a female calling in the distance.' Joel was with Dr Ludwig Siefert, the chief biologist studying the lions in the park, who spotlit the male so it could be identified and photographed. 'The lions are used to him and his truck and paid zero attention to us,' says Joel. 'But they are in trouble. Cattle herders desperate for grazing are taking their livestock into the park. When lions kill a cow, the herders often lace the carcass with poison, and the lions are poisoned when they return to finish feeding.' Only about 60 lions remain, and Dr Siefert estimates that if nothing is done to prevent the grazing of cattle in the park, the lions will be gone within 10 years.

Nikon D3 + 24-70mm f2.8 lens; 1/125 sec at f2.8 (-1.3 e/v); ISO 4000.

Aurora over ice

WINNER

Thilo Bubek

GERMANY

Thilo packed a flask of hot tea and a sleeping bag
and reindeer skin for his friend to sit on and set
off for Kvaløya Island, some 30 kilometres from
the city of Tromsø in northern Norway, to watch
for auroras. It was February, and the temperature
was -17°C. The moon shone high in the sky and
illuminated the landscape all around as Thilo
walked out onto the frozen lake at Kattfordeide,
and set up his tripod. At first, he saw only tiny
auroras in the distance. But as the evening
wore on, the dancing lights moved closer, until
eventually they flashed in vast, dramatic luminous
arcs across the sky. 'Auroras move fast, and so
I chose a fairly high ISO to capture six images
quickly and create a panorama,' says Thilo.
The aurora borealis (or northern lights)
phenomenon occurs when highly charged
electrons from the solar wind interact with oxygen
and nitrogen in the atmosphere, miles above the
surface of the Earth. The colour varies depending
on the nature of the atom (green is oxygen)
and the altitude at which the reaction happens.

**Nikon D3 + 14-24mm f2.8 lens at 17mm; 3 sec at f2.8;
ISO 1600; Berlebach UNI 15 tripod + FLM 58 ball head;
Nikon Capture NX2, stitched with PTGui Pro 8.**

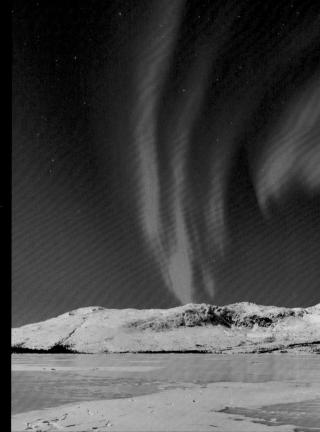

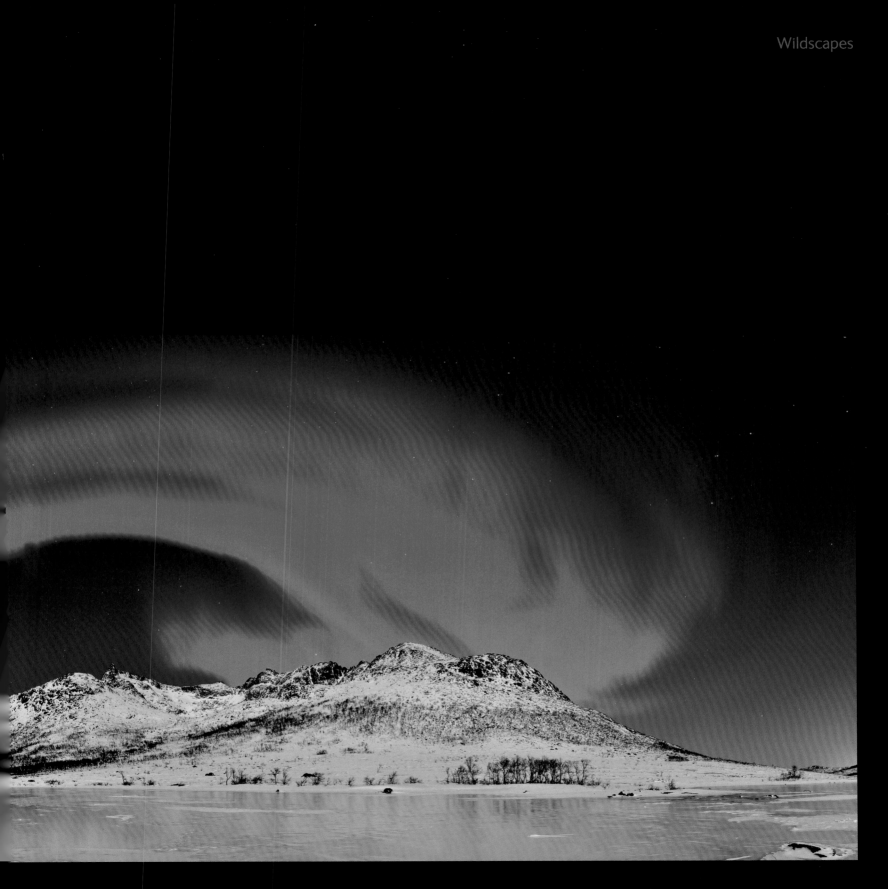

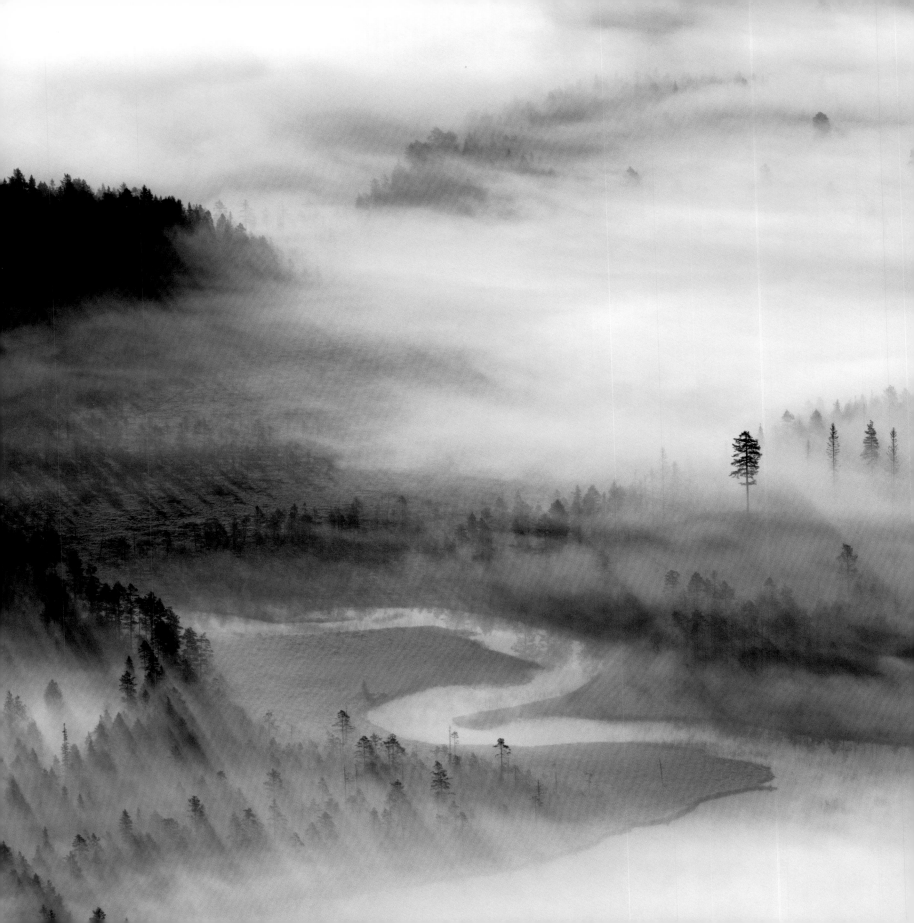

Heavenly view

RUNNER-UP

Magnus Carlsson

SWEDEN

To take his photography to the next level, Magnus gained a pilot's licence. His challenge then was to perfect the art of flying a floatplane while leaning out of the door to take photographs. In particular, he longed to photograph the forest near his home in Swedish Lapland. So when the forecast predicted mild winds and falling night temperatures, Magnus knew there would be a good chance of early morning fog. 'It was still dark as I cleared the frost from the plane's wings. Then I took the plane's doors off, because aerial photography is so much better if there's no Plexiglas in the way.' As dawn broke, Magnus taxied across the water, took off and soared towards the forest. 'As soon as I was airborne, I knew that it was going to be a magical morning,' he says. 'The sun threw shadows on the dense mist, which rose like steam, framing the creek. My fingers were soon numb with the cold. But I didn't mind – the view was so breathtaking. It's a portrait of where I live, where I work – my home, which I love.'

Canon EOS-1D Mark IV + 135mm f2 lens; 1/2000 sec at f13; ISO 640.

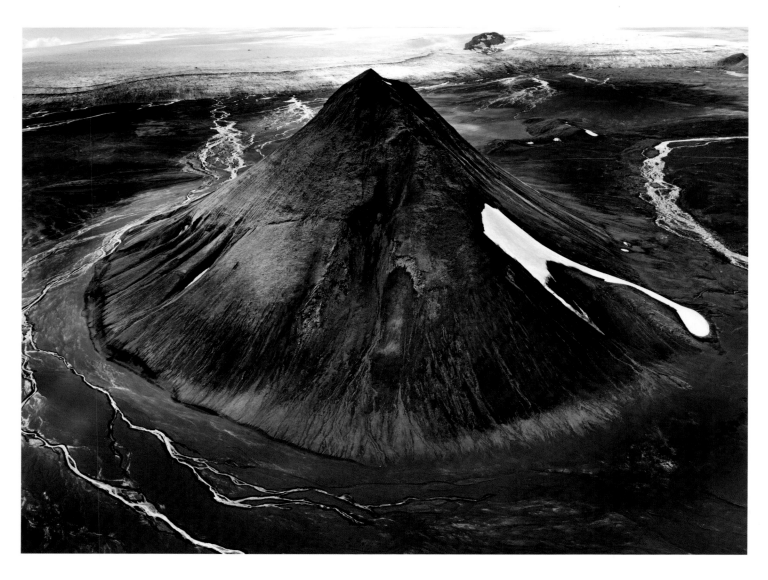

The great Maelifell

COMMENDED

Hans Strand

SWEDEN

Hans had photographed the extinct Maelifell volcano, icon of the Icelandic highlands, many times. On this occasion, though, he wanted to show it towering over the massive Mýrdalsjökull Glacier, through which it emerged some 10,000 years ago. Today the cone is cloaked not in ice but in a type of cushion moss, which is a coloniser of lava and is vibrant green when wet. Hans also wanted to set the glowing green cone against the sea of volcanic soil surrounding it, encircled by the ice-water streams flowing down from the glacier. To do this, the pilot had to fly much lower and closer than usual. In fact, the plane went so fast, says Hans, 'that I managed only one single frame. It was like trying to shoot clay pigeons.'

Hasselblad H3DII-50 + 35-90mm f5.6 lens at 35mm; 1/500 sec at f5.6; ISO 200.

Celebration of a grey day

SPECIALLY COMMENDED

Fortunato Gatto

ITALY

If the Isle of Eigg is a gallery of landscapes, then Laig Bay is its masterpiece. Fewer than 100 people live on this tiny geological jewel off the northwest coast of Scotland. It's part of the Small Isles (an archipelago in the Inner Hebrides), the result of volcanic eruptions millions of years ago. 'On a stormy day, you get the feeling of having been catapulted into a black-and-white world, with more shades of grey than you could ever name,' says Fortunato. Bracing himself against the powerful winds blowing in from the Atlantic Ocean, he photographed the textured patterns in the volcanic sands of the long, silvery beach, etched by the ebbing tide. 'To me, it represents the essence of this place.'

Canon EOS 5D Mark II + Zeiss Distagon T* 21mm f2.8 lens; 121 sec at f16; ISO 50; Giotto tripod + remote; Lee Neutral Density 0.6 hard & soft filters + neutral density 0.9 filter.

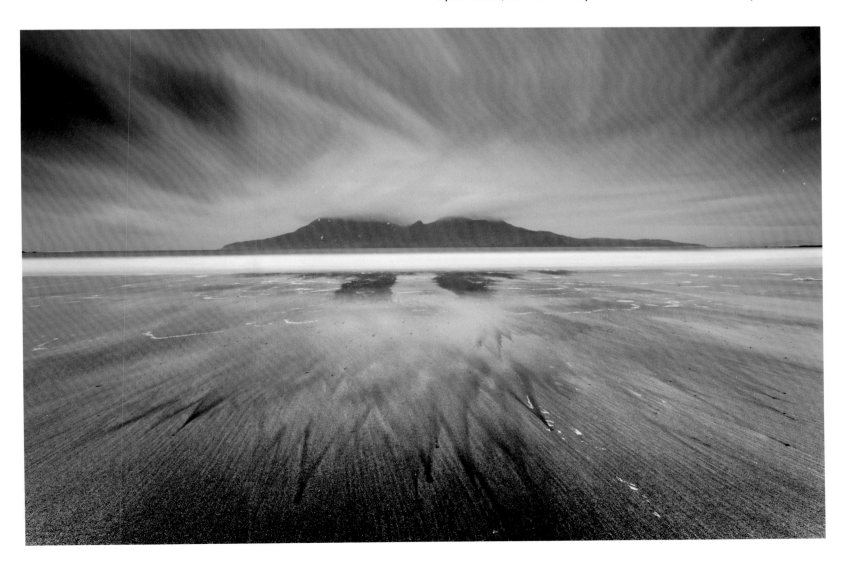

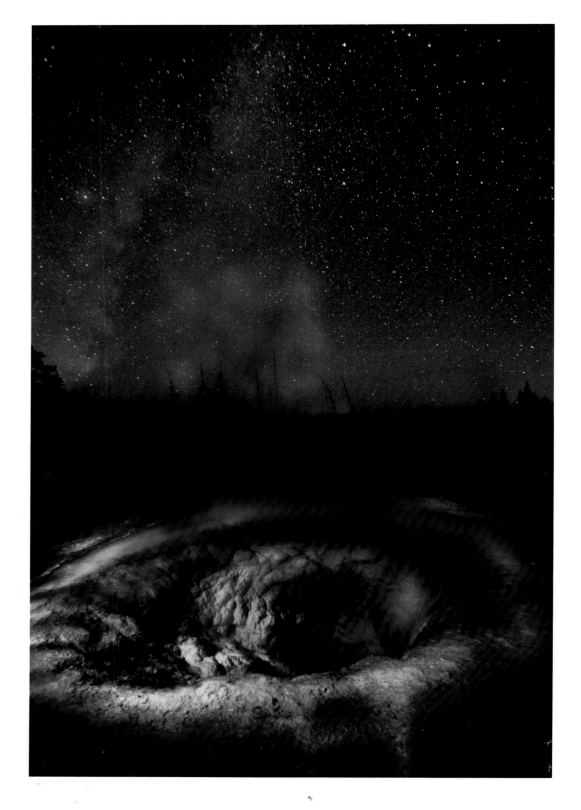

Morning Glory by night

COMMENDED

Robert Sinclair

USA

There must be thousands of images of the thermal
Morning Glory Pool, taken in daylight by visitors
to Yellowstone National Park in the USA. Some
seven metres in diameter, the pool is home to
thermophilic bacteria that thrive in the heat and
give the pool its extraordinary colours. To capture
the scene in a new and dramatic way, Robert
waited for a warm autumn night and then carefully
positioned two flashlights to illuminate the details
of the inner walls beneath the star-filled sky.
'To minimise interference from steam rising off
the surface, I had to wait for the breeze to blow it
away from the camera,' he says. After three hours,
he got the shot he wanted, of a giant eye staring
up at the Milky Way, looking for all the world as
though it might, at any moment, blink.

**Canon EOS 5D Mark II + 16-35mm f2.8 lens at 16mm;
45 sec at f2.8; ISO 100; Gitzo tripod + Canon remote
shutter release.**

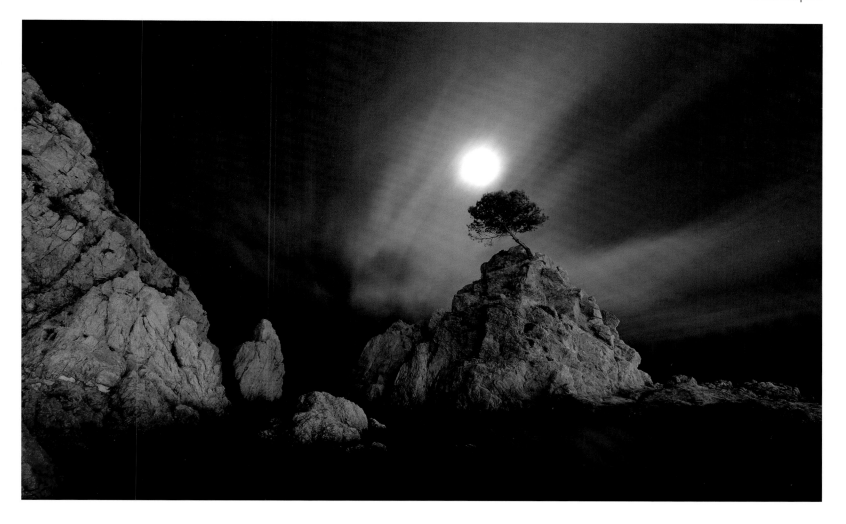

The cove by moonlight

COMMENDED

Miquel Angel Artús Illana

SPAIN

Shallow, sheltered and warm, this corner of the Sa Banyera de Ses Dones cove at Tossa de Mar, northeast Spain, is more bath than bay, shielded by the rocks from the wind. The older inhabitants of the village talk of how the local women used to gather at this tranquil spot to bathe. Today, tourists swim here. It's also much photographed. But Miquel, who lives in the village, set out to create a picture that would capture the spirit of the bay and commemorate its place in the heart of the local culture. For nearly a year he tried to create his ideal image, using just the light of the moon, without night divers and fishermen visible and without light pollution from the nearby promenade casting strong shadows. Finally, one night offered the perfect combination of a full moon, cloud and strong winds. 'I was so lucky,' he says. 'No ship passed through the horizon, no diver left the water, and the tripod did not move during the long exposure.'

Nikon D7000 + Sigma 10-20mm f3.5 lens at 10mm; 300.8 sec at f11; ISO 100; Giotto tripod.

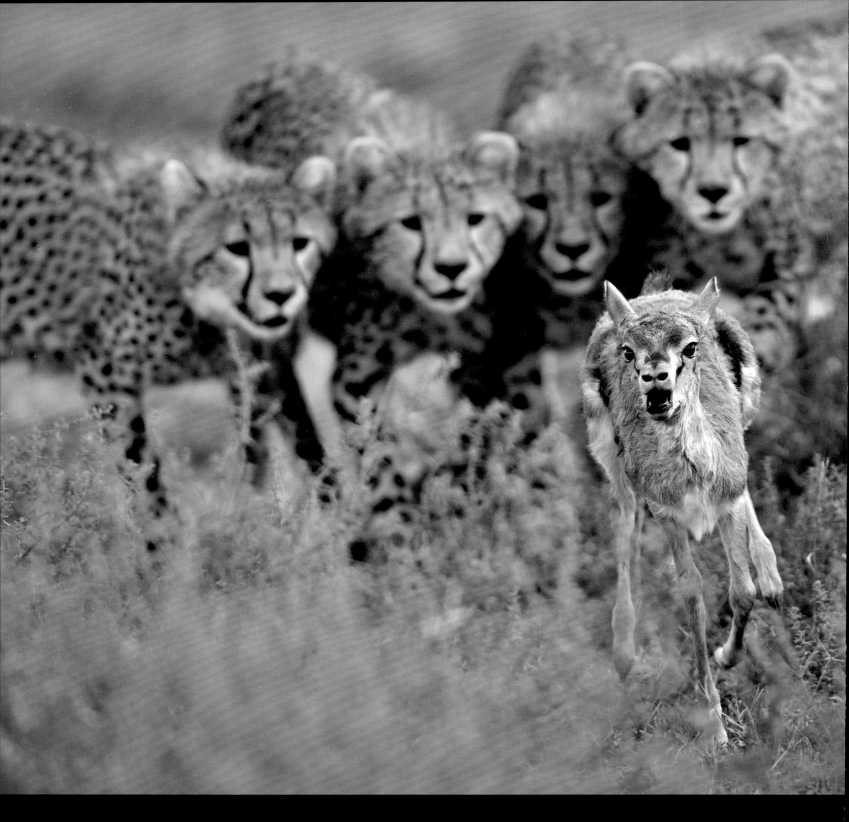

Behaviour: Mammals

Memorable, unusual or dramatic behaviour is needed for this category. Combining that with aesthetic appeal is a challenge that requires fieldcraft as well as skill.

Practice run
WINNER
Grégoire Bouguereau
FRANCE

When a female cheetah caught but didn't kill a Thomson's gazelle calf and waited for her cubs to join her, Grégoire guessed what was about to happen. He'd spent nearly a decade studying and photographing cheetahs in the Serengeti National Park, Tanzania, and he knew that the female's behaviour meant one thing: a hunting lesson was due to begin. The female moved away, leaving the calf lying on the ground near her cubs. At first, the cubs took no notice of it. But when it struggled jerkily to its feet 'the cubs' natural predatory instincts were triggered,' says Grégoire. 'Each cub's gaze locked on to the calf as it made a break for freedom.' The lesson repeated itself several times, with the cubs ignoring the calf when it was on the ground and catching it whenever it tried to escape – 'an exercise that affords the cubs the chance to practise chases in preparation for the time they'll have to do so for real.'

Nikon D3 + 300mm f2.8 lens; 1/1250 sec at f2.8 (-0.7 e/v); ISO 400.

Ghost bears

RUNNER-UP

Kimmo P Pöri

FINLAND

Two adult male brown bears turned up at the reindeer carcass within moments of each other. Both were hungry from their long winter sleep. Both wanted priority access to the remains of a reindeer. Conflict was inevitable. The carcass was positioned as bait in front of the hide in which Kimmo was stationed in a remote forest region of eastern Finland, near the Russian border. 'At first, they just roared,' says Kimmo. 'But when neither backed down, they began to fight, hitting out and slamming into each other.' The mist had settled, and it was almost too dark to take photographs. 'But then I saw the magic of the scene,' says Kimmo. 'It reminded me of the Finnish epic poem *Kalevala*, which includes many mystical passages about bears and battles, reflecting the old Finnish religion, in which the bear is a god – born within the Big Bear constellation and set down on Earth to live alongside humans.' The battle between the two real bears was brief, ending when the darker one gave way. Kimmo took just a few shots, but this one, he felt, encapsulated the spirit of the bears in the *Kalevala* epic.

Canon EOS 50D + 300mm f2.8 lens + 1.4x extender (420mm); 1/10 sec at f4; ISO 800.

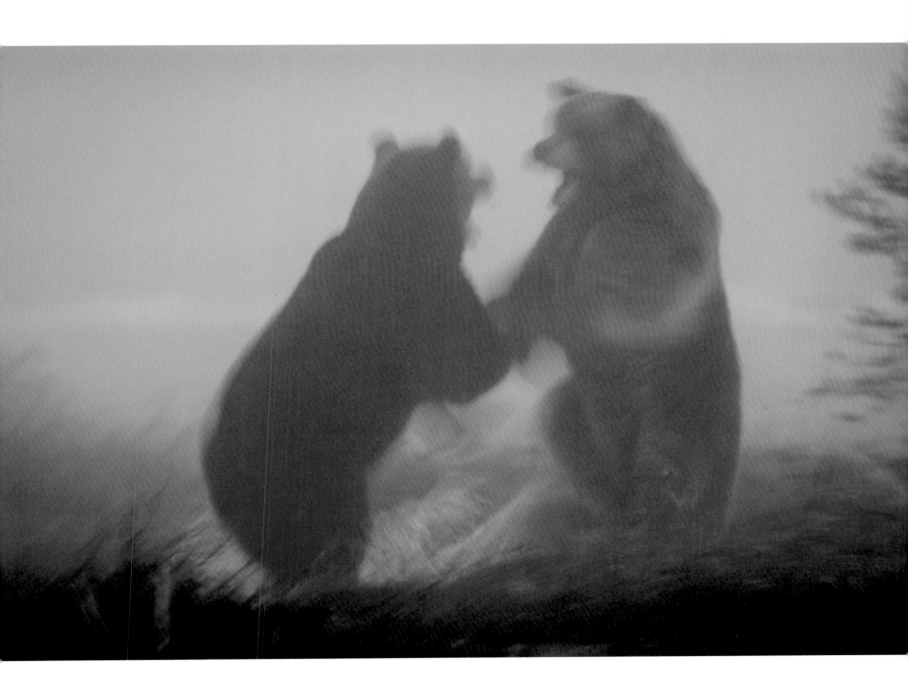

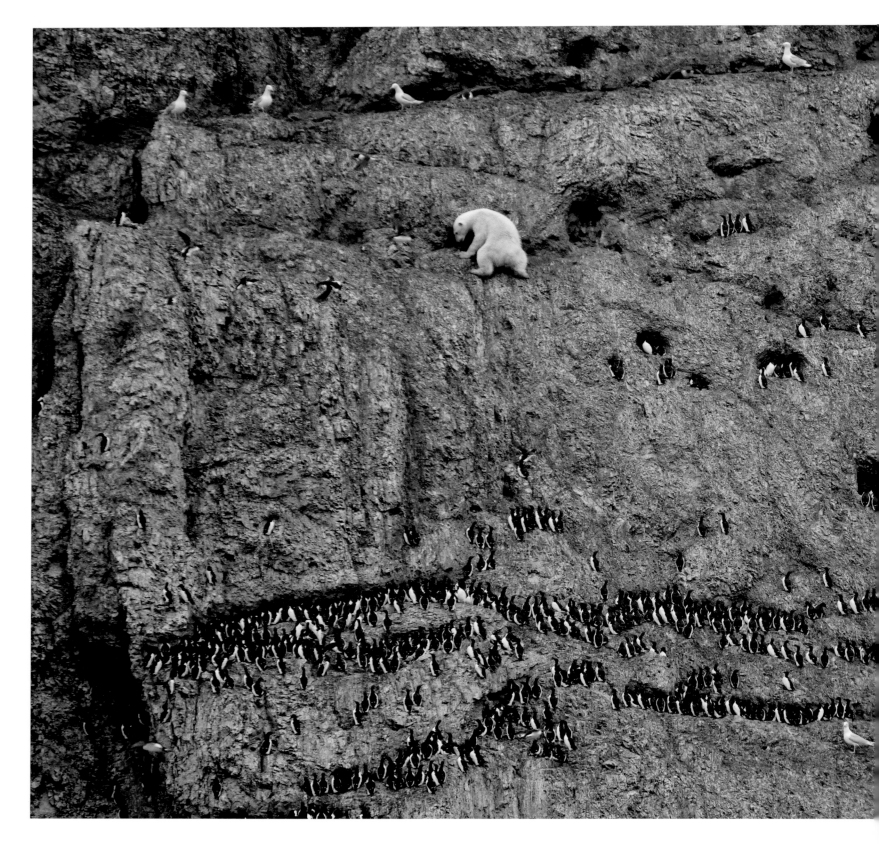

Perilous pickings

SPECIALLY COMMENDED

Jenny E Ross

USA

At first, the white speck looked like a patch of snow on the cliff. But as the Zodiac inflatable boat got closer, Jenny realised it was a polar bear. 'I knew instantly what he was doing and why,' she says. Polar bears require sea ice for every essential aspect of their lives. They normally feed on blubber-rich marine mammals, and they rely on a sea-ice platform to catch their prey. But in an increasing number of regions, the sea ice now melts completely in summer, forcing the bears ashore. There they must starve until the sea ice forms again in winter. This hungry young male was desperately attempting to climb down the rock face to scavenge eggs from nesting Brünnich's guillemots, 'risking his life and probably expending more energy climbing than he would have gained from any meagre meal of eggs.' Jenny photographed the spectacle in the Ostrova Oranskie region of the Novaya Zemlya archipelago on a trip to the newly opened Russian Arctic National Park. Historically, the sea ice to the far north and east of the islands has remained frozen in summer, but in recent years it has receded further, melted earlier and taken longer to freeze up again. On every summer Arctic trip she has done during the past several years, Jenny has watched bears swimming far out to sea in an attempt to find ice or land. With the continuing loss of ice cover and other temperature-related changes, she regards the Arctic as 'the ecological equivalent of a war zone'.

Canon EOS-1Ds Mark III + 100-400mm lens at 275mm; 1/800 sec at f5.6; ISO 800.

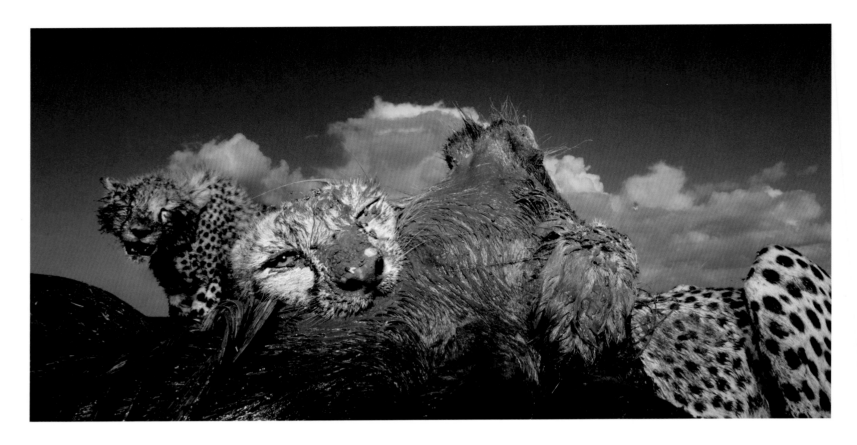

Seized opportunity

COMMENDED

Grégoire Bouguereau

FRANCE

A single cheetah would never normally dream of taking on prey the size of an adult wildebeest. But there was obviously something wrong with this wildebeest, which was lying on the ground, covered in mud. It kept trying, laboriously, to get to its feet. Each time it did manage to stand, it would collapse again. Its behaviour caught the attention of a female cheetah with two cubs, which Grégoire had been watching for several days in Tanzania's Serengeti National Park. 'She had just caught a newborn Thomson's gazelle, but that wasn't enough food for her family. So, after observing the struggling wildebeest for a while, she decided to make the most of the opportunity.' While the female was assessing the situation, Grégoire positioned his camera and set it on remote control so that he, too, could seize the opportunity.

Nikon D3X + 16-35mm f4 lens; 1/200 sec at f22 (-1 e/v); ISO 100; Nikon SB-900 flash; Oppilas Wireless Shutter Remote Control.

Snow pounce

COMMENDED

Richard Peters

UK

Richard sat in his car and from a distance watched the fox hunting, just enjoying the performance. He was in Yellowstone National Park, in Wyoming, USA, and there was snow on the ground. The fox was listening for rodents under the snow, then leaping high to pounce down on the unsuspecting prey. It was too far away to photograph, and so when it disappeared and suddenly reappeared, on a snow bank level with the car window, Richard was taken by surprise. 'It was already in pounce position, and I barely had time to lift the camera before it leapt up into the air almost clean out of my field of view. I managed to get a sequence of the leap, but I love this quirky image best, which gives a real sense of just how high these wonderful animals can jump.'

Nikon D7000 + 600mm lens; 1/500 sec at f8; ISO 400.

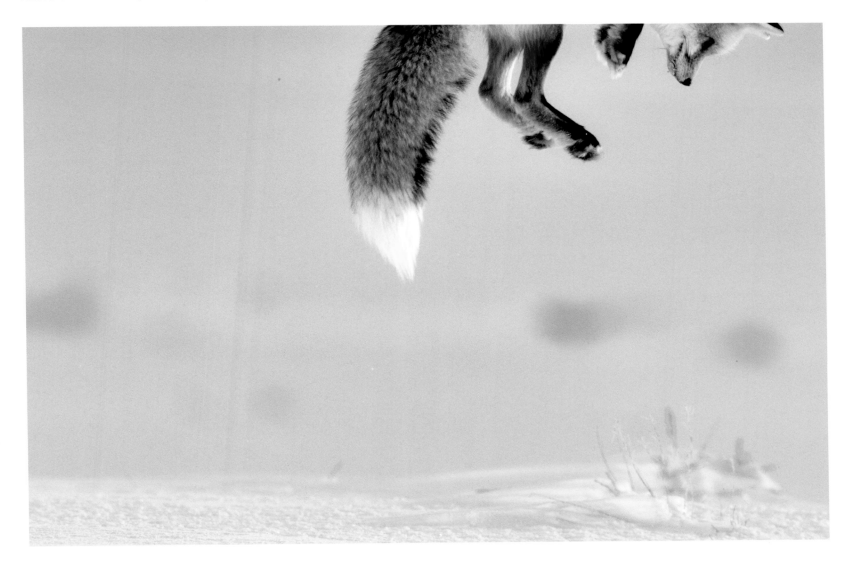

Behaviour: Cold-blooded Animals

This is the category which encompasses all animals that are not mammals or birds – in other words, the majority, including all the tiny creatures on Earth.

Into the mouth of the caiman

WINNER

Luciano Candisani

BRAZIL

Motionless but alert, a yacare caiman waits, 'like a small tyrannosaurus' for fish to come within snapping reach, says Luciano. Caimans are usually seen floating passively on the surface. Under the water, it's another story. It's this secret life that has fascinated Luciano ever since he first came face to face with a caiman while snorkelling. Once he'd recovered from the shock, he realised that the reptile was neither aggressive nor fearful – and that he could approach it. Luciano now regularly documents the underwater life of caimans in the shallow, murky waters of Brazil's Pantanal (the biggest wetland in the world), which contains the largest single crocodilian population on Earth. Caimans can grow to be three metres in length. Most aren't aggressive, but some individuals can be. 'The safest way to get close is when they are concentrating on a shoal of fish,' says Luciano. 'While I was concentrating on this caiman emerging from the gloom, I had a field biologist with me all the time.' The result was 'the picture that's been in my imagination since my father first showed me a caiman 25 years ago'.

Canon EOS 5D Mark II + Sigma 15mm lens + Kenko 1.4x extender; 1/100 sec at f4; ISO 400; Aquatica housing + dome port + extension ring; two Sea&Sea YS-110 strobes.

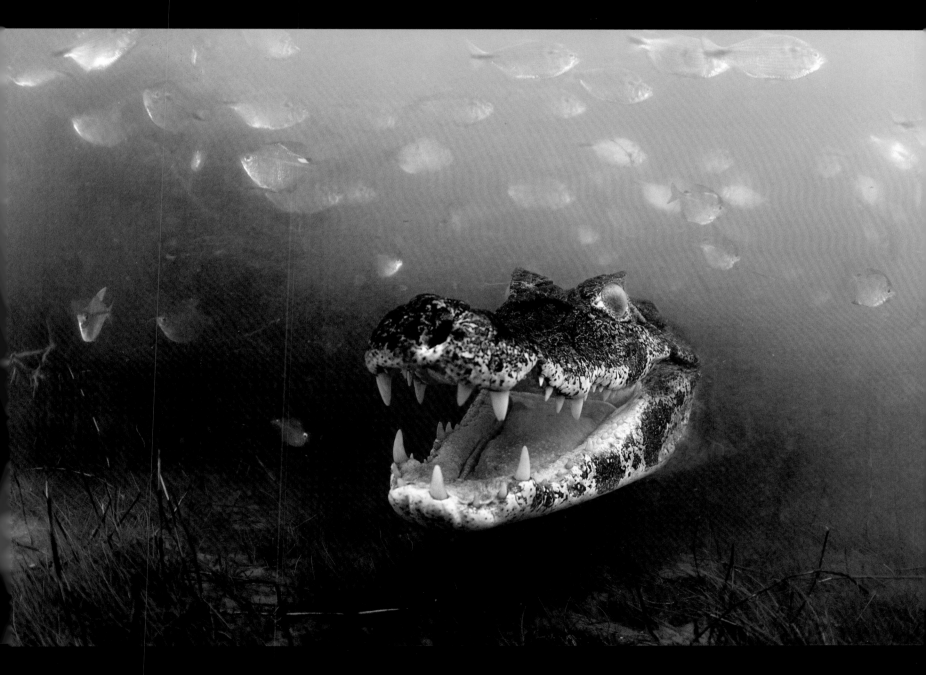

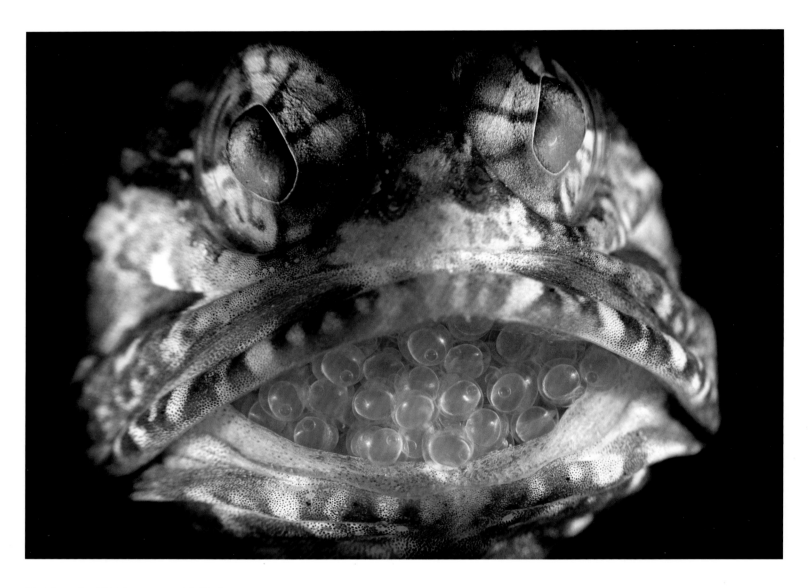

Father's little mouthful

COMMENDED

Steven Kovacs

CANADA

A dusky jawfish father is a diligent parent, protecting fertilised eggs in his mouth until they hatch. This male, in the opening of his burrow off the coast of Florida, was aerating his eggs. Says Steven: 'He seemed unconcerned by my presence and didn't retreat into his burrow when I started taking pictures.' Steven used home-made snoots (tubes that control the direction and radius of light) to focus the light on both sides of the jawfish's face. 'He couldn't have been more cooperative,' says Steve. 'For the next hour he barely moved,' more interested in making sure the eggs were rotated and in a good flow of water.

Nikon D200 + 105mm lens; 1/250 sec at f22; ISO 100; SubSee +10 diopter; Ikelite underwater housing; three Ikelite DS160 strobes; home-made snoots.

Sizing up

COMMENDED

Klaus Tamm

GERMANY

A scattering of gecko droppings on the sunny veranda of Klaus's holiday apartment near Etang-Sale-les-Hauts, on the French island of Réunion, had attracted some unusual-looking insects. They were neriid long-legged flies. Klaus settled down with his camera to watch as they interacted. 'Every so often, a couple of males would take a break from feeding and engage in a kind of combat dance that involved spinning around each other,' he says. 'They would finish by stretching up to their full one and a half centimetres, then pushing with their mouthparts, shoulders and forelegs until one gained height, before flying away or mating with nearby females. I was so impressed by the harmony in the combat dance that I ended up photographing them for several hours.'

Canon 5D Mark II + 100mm lens; 1/250 sec at f3.2 (+ 0.75 e/v); ISO 800.

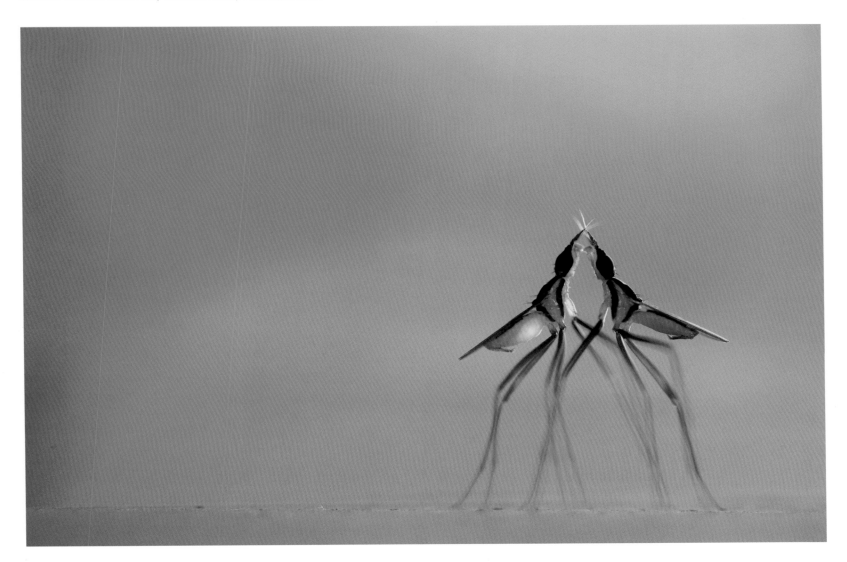

Behaviour: Birds

A picture of bird behaviour that is both artistic and interesting is not easy to achieve, but a love of birds among photographers results in a large number of contenders for the top places.

Frozen moment

WINNER

Paul Nicklen

CANADA

Paul was not the only mammal lying patiently in wait on the edge of the Ross Sea, Antarctica, to greet the explosion of emperor penguins. Leopard seals – measuring up to three and a half metres long – were almost certainly lurking at the edge of the ice ready to grab a meal. The penguins were therefore exiting as fast as possible, sky-rocketing out of the water to land well clear of the edge. 'I also kept an eye out for leopard seals myself,' says Paul. 'I'd previously had one hit me square in the face when I was five metres from the ice edge, knocking me down and stunning me. Luckily it realised that I wasn't a penguin and slipped back into the icy water.' The penguins' survival is vital to that of their two-month-old chicks, hungrily waiting some 10 kilometres away at the Cape Washington colony. With full bellies, the penguins toboggan to the colony, where they regurgitate the food to their respective single chicks. They then head back to the Ross Sea for another three-week stint at sea.

Canon EOS-1D Mark IV + 24-105mm f4 lens; 1/2000 sec at f11; ISO 400.

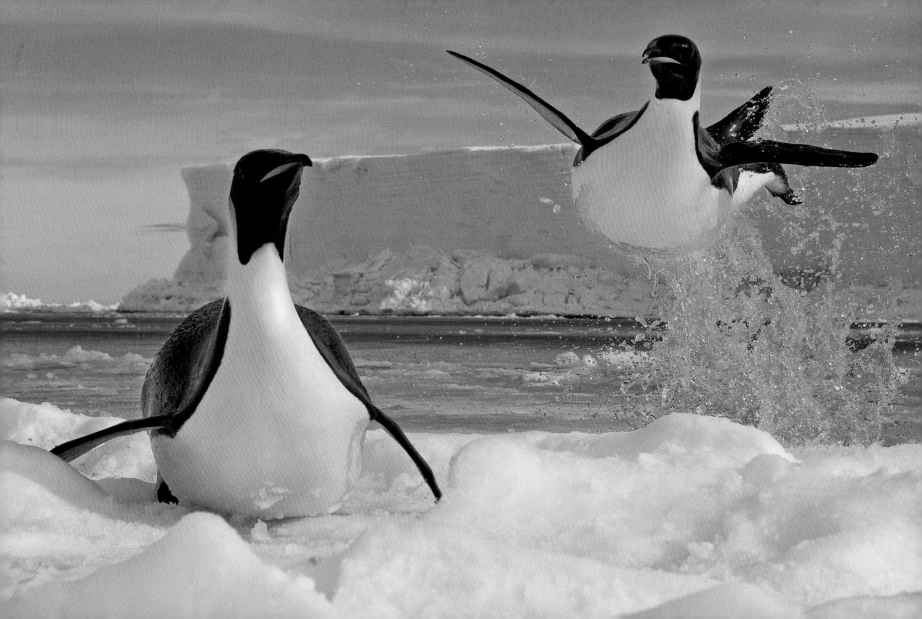

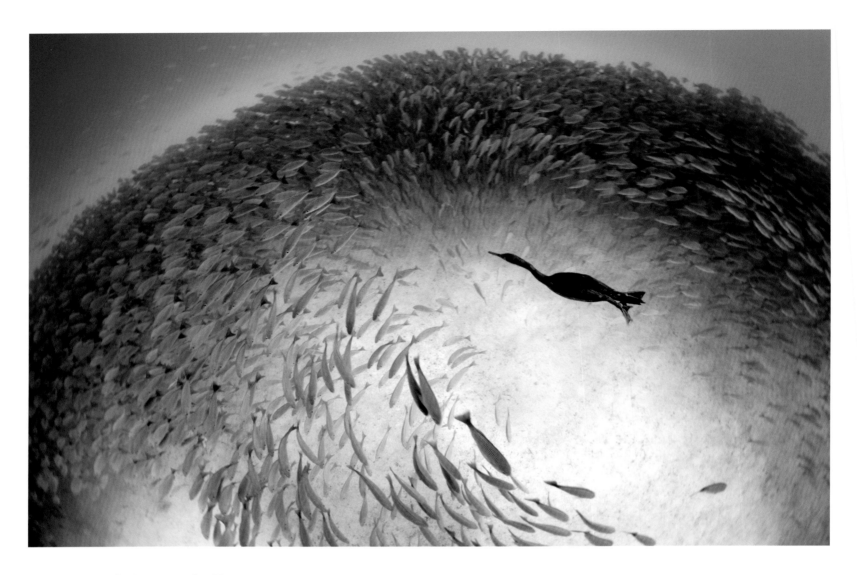

The eye of the baitball

RUNNER-UP

Cristóbal Serrano

SPAIN

Cristóbal found this great circling shoal of grunt fish in the Sea of Cortez, Mexico, and watched it over two days. He would dive down and then sit on the sandy bottom some 20 metres below the surface to watch. 'With the sky behind the fish ball,' he says, 'it looked like a shimmering body of energy. I just needed a focal point to get the picture I was after.' A pelagic cormorant was also watching the fish, and now and then it would shoot a hole through the ever-tightening baitball (tightening in response to the predator), making it easier for it to pick off individual fish. Cristóbal tried to predict the angle that the cormorant would use. After many attempts, using a fisheye lens and strobes to illuminate the fish and the sandy bottom, he got the shot.

Canon EOS 5D Mark II + 8-15mm f4 lens; 1/125 sec at f4.5; ISO 100; Seacam housing; strobes.

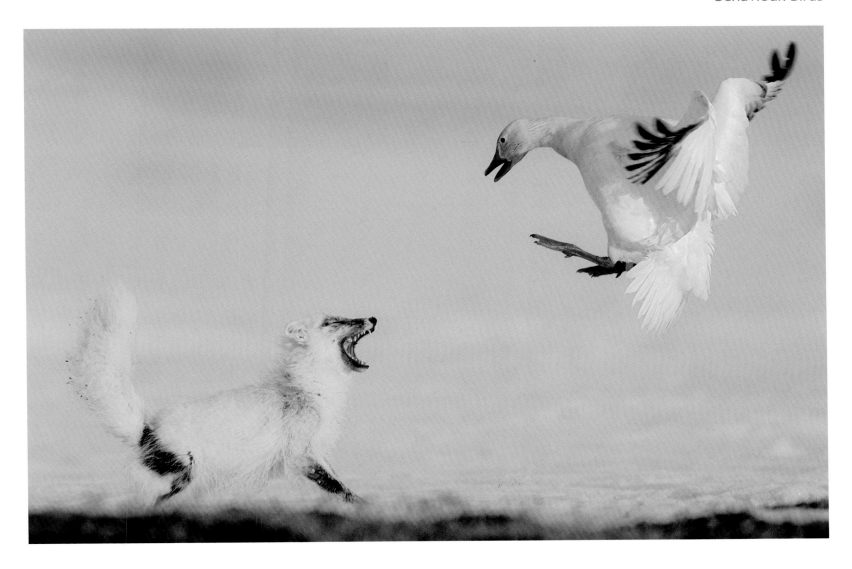

The duel

COMMENDED

Sergey Gorshkov

RUSSIA

In late May, about a quarter of a million snow geese arrive from North America to nest on Wrangel Island, in northeastern Russia. They form the world's largest breeding colony of snow geese. Sergey spent two months on the remote island photographing the unfolding dramas. Arctic foxes take advantage of the abundance of eggs, caching surplus eggs for leaner times. But a goose (here the gander) is easily a match for a fox, which must rely on speed and guile to steal eggs. 'The battles were fairly equal,' notes Sergey, 'and I only saw a fox succeed in grabbing an egg on a couple of occasions, despite many attempts.' Surprisingly, 'the geese lacked any sense of community spirit', he adds, 'and never reacted when a fox harassed a neighbouring pair nesting close by.'

Nikon D300S + 600mm f4 lens; 1/2000 sec at f5; ISO 640; Gitzo tripod.

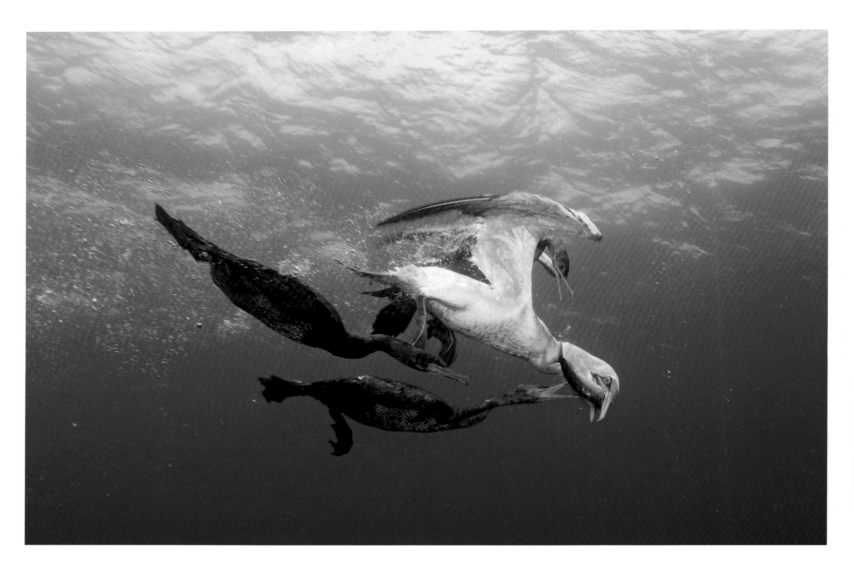

Dive robbers

COMMENDED

Jean Tresfon

SOUTH AFRICA

For five days, Jean had been trying to photograph the feeding frenzy that develops when sardines and herrings migrate off South Africa's Wild Coast. His luck finally changed in clear water a few miles off Port St Johns. 'Activity was intense, with dolphins herding the fish into a ball from below, while Cape gannets rained down from above. I couldn't wait to get in the water.' Gannets were plunging down several metres at great speed, catching and swallowing several fish in a dive. In contrast, Cape cormorants diving from the surface were much less successful. But what they lacked in fishing skill they made up for with thievery. 'In this picture,' says Jean, 'the gannet is desperately trying to swallow a herring as a gang of cormorants gives chase.'

Nikon D300 + 12-24mm lens; 1/250 sec at f7.1; ISO 400; Subal housing; two Sea&Sea strobes.

Snatch and grab

COMMENDED

Stefan Huwiler

SWITZERLAND

Stefan hiked for five kilometres in thick snow in the Sinite Kamani National Park in Bulgaria to reach a hide known to be a golden eagle hotspot. It was one of the coldest winters in recent years, and using a vehicle was out of the question. On the second day, he spent a long while watching a golden eagle eating a carcass. 'I was able to get some great portrait shots,' says Stefan, 'but what happened next took me by surprise.' A red fox sidled up and tried to snatch the meal, but the eagle was having none of it. 'After a short, fierce spat, the fox fled with the eagle literally hard on its heels.' A golden eagle can kill prey even bigger than a fox, but with a carcass to defend, the eagle was almost certainly just trying to scare the fox away rather than grab it.

Nikon D3 + 600mm f4 lens; 1/1000 sec at f5.6; ISO 400; Gitzo tripod; hide.

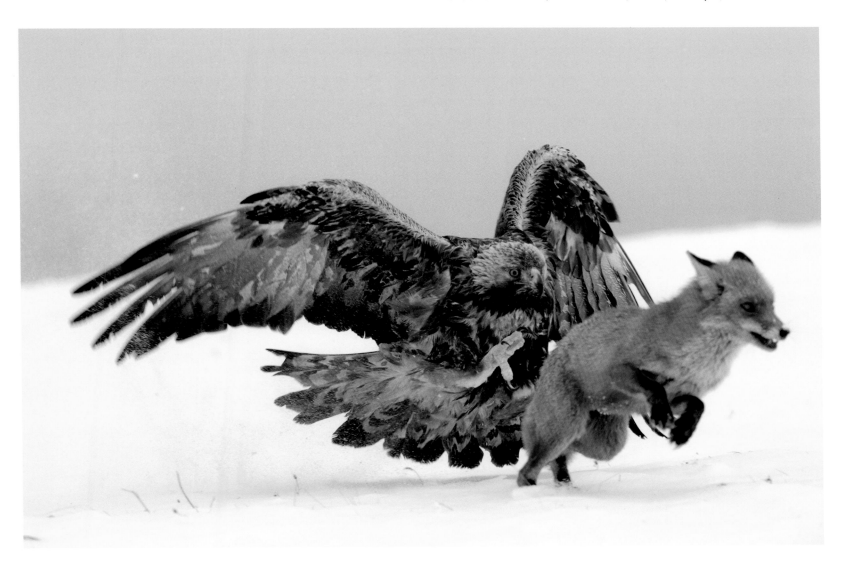

In this category, a portrait should focus in on the subject and capture the personality or spirit of an animal in an imaginative and intimate way.

Warning night light

WINNER

Larry Lynch

USA

One evening, while walking along the riverbed of the Myakka River State Park in Sarasota, Florida, USA, Larry came across a group of alligators. It was the dry season, and they had been gorging on fish trapped in the pools left behind as the water receded from the river. One big alligator had clearly eaten its fill. 'It wasn't going anywhere in a hurry,' says Larry. 'So I set my tripod and camera up about seven metres in front of him and focused on his eyes.' Just after sunset, Larry set his flash on the lowest setting to give just a tiny bit of light, enough to catch the eyeshine in the alligator's eyes. Like cats, an alligator has a tapetum lucidum at the back of each eye – a structure that reflects light back into the photoreceptor cells to make the most of low light. The colour of eyeshine differs from species to species. In alligators, it glows red – one good way to locate alligators on a dark night. The greater the distance between its eyes, the longer the reptile, in this case, very long.

Nikon D2X + 80-400mm f4.5-5.6 lens; 8 sec at f8; ISO 200; SB-800 flash; Gitzo 3125 tripod; Manfrotto

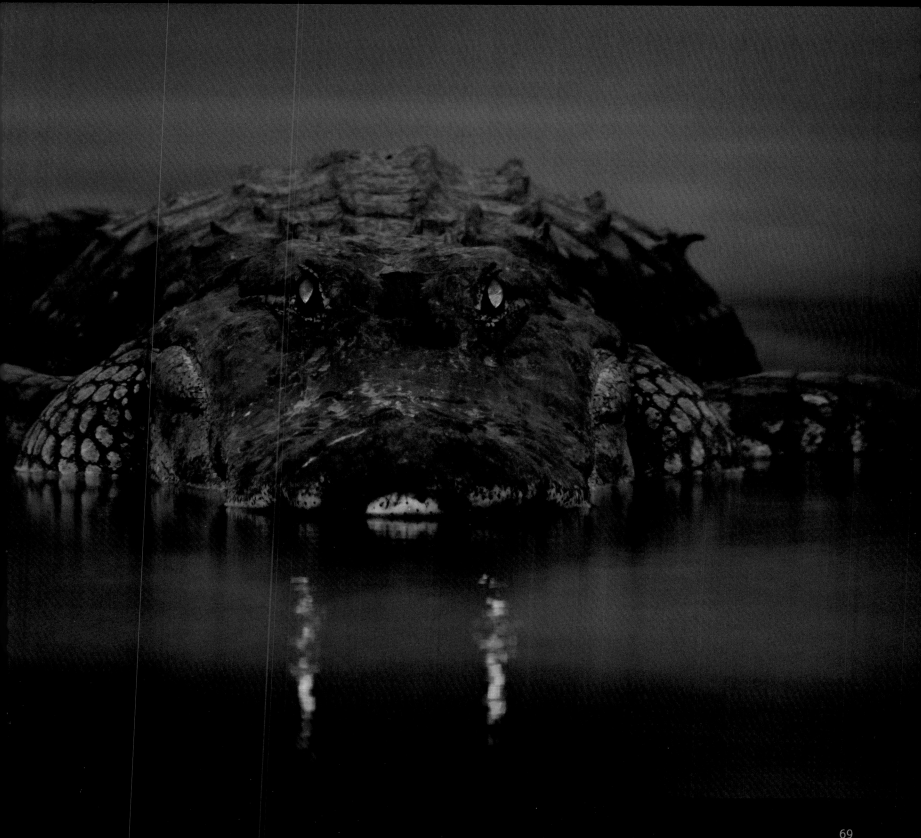

Fluff-up

RUNNER-UP

John E Marriott

CANADA

A shapeless lump of puffed-up black: that's what
the figure looked like, squatting in the middle
of a snow-covered road in Jasper National Park,
Alberta, in the heart of the Canadian Rockies.
As John drove slowly towards the feathers, he
realised it was a raven. 'I fully expected it to
fly off at any moment, but it just sat there,
looking as though it had just got out of bed.'
John cruised slowly by and stopped some
30 metres away to photograph the bird. 'Looking
through the images afterwards, I laughed out
loud.' Fluffing up may look like a bad-hair day to
a human, but if a male does it to a female raven it
signals an invitation to take note or even to party,
though a good fluff does also keep out the cold.

**Canon EOS-1D Mark IV + 500mm lens; 1/1250 sec at f7.1;
ISO 1600.**

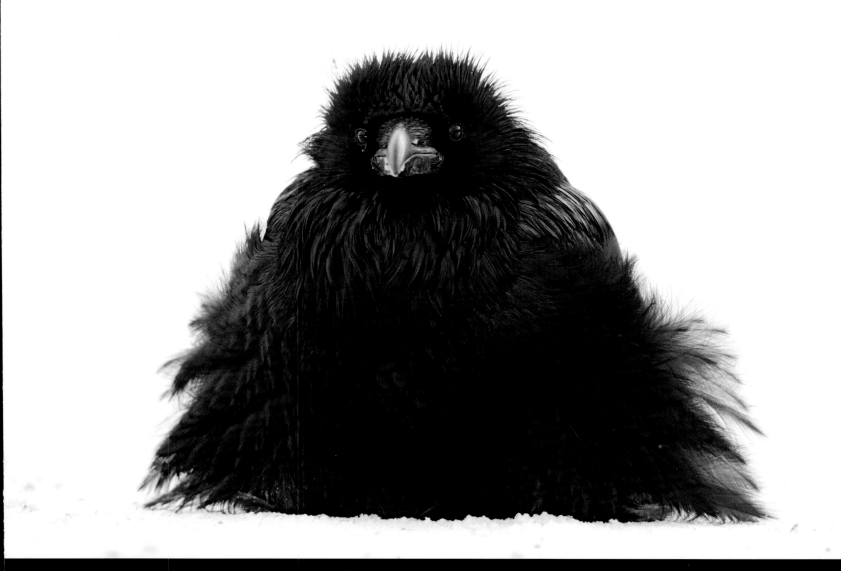

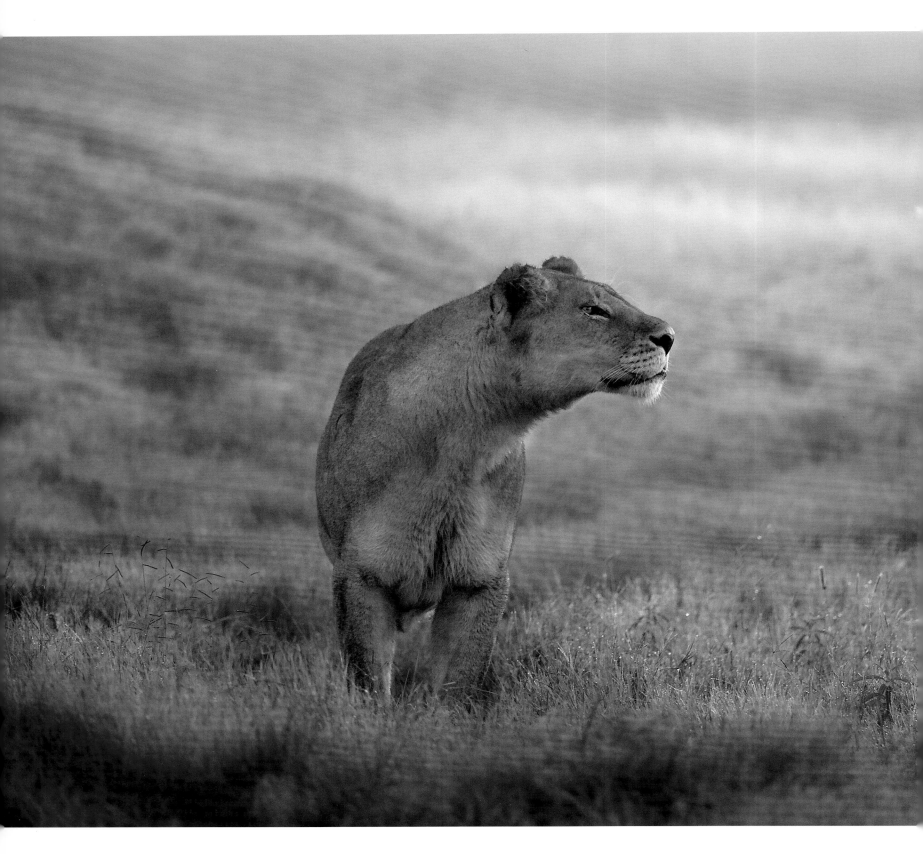

In the light of dawn

COMMENDED

Frits Hoogendijk

SOUTH AFRICA

The pride hadn't eaten for several days. They were hungry, and a hunt was very likely. A blanket of fog lay thickly over the Okavango Delta's Duba Plains, Botswana, and the dawn light was very low. It was hard to make out anything, but fortunately the lions were still lying where Frits had left them the evening before. A short while later, the females set off to hunt. 'I wanted to photograph one out in the open, in the wet and misty weather. So we positioned the vehicle where they might walk towards us. When this lioness stopped by a tuft of grass and peered into the distance, it was perfect. I love the intense green, the drops of dew on the grass and the soft light and detail on her body. Her focused gaze captures the energy and intensity of a hunt that hasn't yet happened.'

Nikon D3S + 200-400mm f4 lens at 200mm; 1/400 sec at f4; ISO 1000.

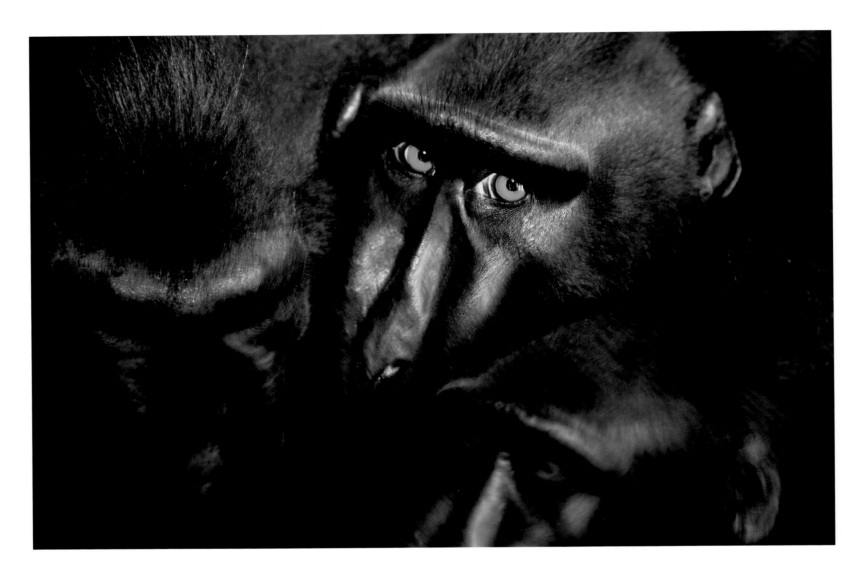

The glance

COMMENDED

Jami Tarris

USA

Two of the young Sulawesi black-crested macaques entered into a boisterous game with an older, stronger male, involving much ear-piercing shrieking and chasing. Though they were in high spirits, Jami had spent weeks with them and could tell that their play was becoming increasingly heated. When the playmates huddled briefly together, she snatched a close-up shot. But as she did, the older male threw her an intense and challenging look. 'I didn't take this lightly,' Jami says, and she quickly withdrew to a safe distance. Moments later, the older macaque turned rough, and the younger ones scattered, screeching. The real drama is that these characterful primates are at high risk of extinction, both from poaching and forest loss on their Indonesian island home.

Canon EOS-1Ds Mark III + 24-105mm f4 lens; 1/30 sec at f4; ISO 400; Speedlite 580EX flash.

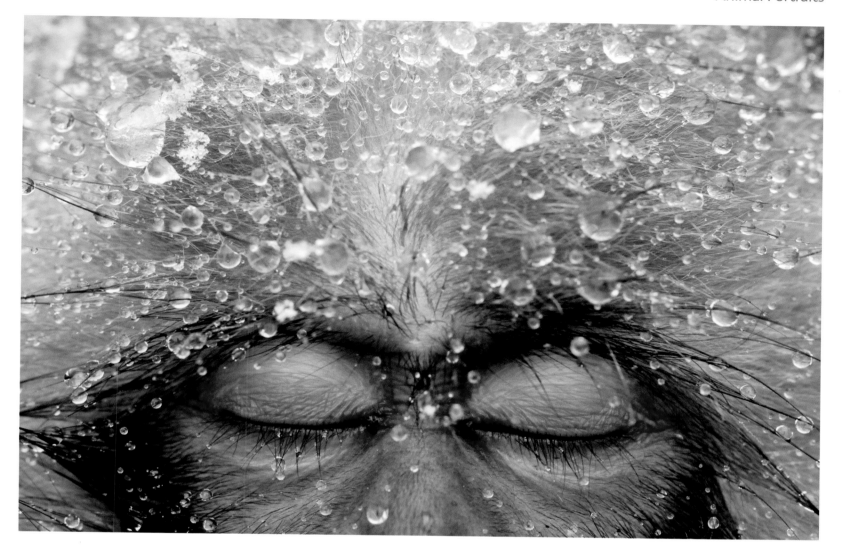

Relaxation

COMMENDED

Jasper Doest

THE NETHERLANDS

In winter, Japanese macaques in the Jigokudani Valley of central Japan congregate in the hot-spring pools, to stay warm and to socialise. The colder it gets in the mountains, the more of them head for the pools, as do humans. Jasper found about 30 macaques enjoying a steamy soak, their heads covered in fresh snow. 'The warm water has a very relaxing effect on the monkeys, and most of them were asleep.' He watched with delight as this youngster became increasingly drowsy and eventually closed its eyes. 'It's such an honour when an animal trusts you enough to fall asleep in front of you,' says Jasper. 'I used a close-up shot to capture the moment of tranquillity and to emphasise the human likeness in both face and pleasure.'

Nikon D3 + 105mm f2.8 lens; 1/200 sec at f16; ISO 2000.

Nature in Black and White

What is required here is skilful use of the black and white medium to create a beautiful or unforgettable composition, whatever the subject.

Hare in a landscape

WINNER

Robert Zoehrer

AUSTRIA

This steep, ploughed field, in Burgenland, Austria, with a ribbon of dazzling yellow oilseed rape on the horizon and a swathe of green to the side, was just what Robert was looking for. 'But it lacked a focus point', he says. As if on cue, a brown hare entered stage right from the grass and sat motionless on the furrowed soil. 'But once I saw the image in black and white,' says Robert, 'not only was the stark geometry highlighted but also the small hare became the centre of the composition rather than being lost among the colour.'

Canon EOS-1D Mark III + 500mm f4 lens; 1/640 sec at f11; ISO 250.

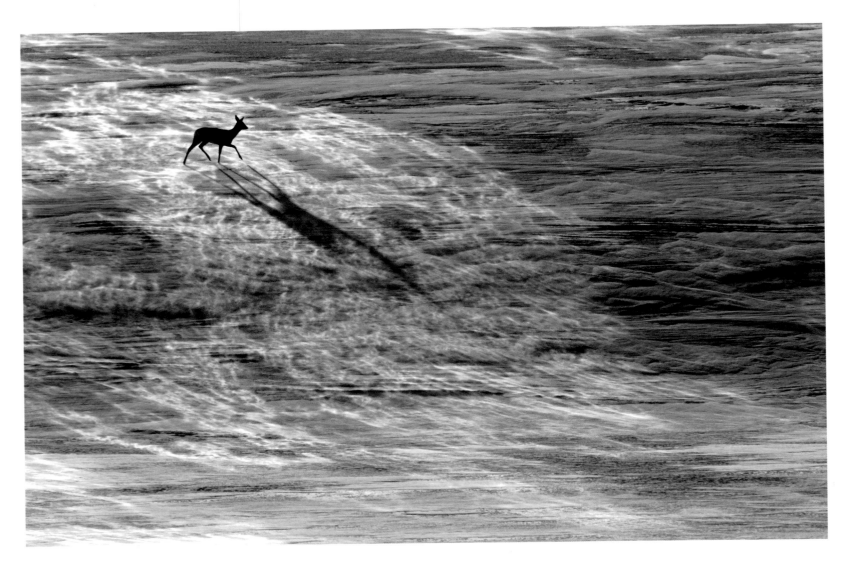

Winter counterpoint

RUNNER-UP

Remo Savisaar

ESTONIA

Despite it being a bitterly cold winter day, Remo had faith that the light would hold out as he headed towards Vooremaa Landscape Reserve, in Estonia, and a particular area that is a hotspot for roe deer. The deer are hunted and so are very nervous, and the wind was lashing snow across the frozen ground. Then late afternoon sunlight began to stream through the clouds and give the whole scene a beautiful glow. All Remo needed was for 'a deer to walk through the frame'. Forty minutes later, the scene was 'everything I had hoped for and more', as this individual picked its way across the stark landscape, its long shadow providing the magic touch. The beauty of the picture belies the tough time this roe deer would have been having. Only the strongest survive winter in Estonia.

Canon EOS-1D Mark III + 300mm f2.8 lens + 2x extender; 1/800 sec at f9; ISO 400.

Lookout for lions

SPECIALLY COMMENDED

Charlie Hamilton James

UK

Charlie was filming lions around the Gol Kopjes area of the Serengeti National Park in Tanzania when he came across these cheetahs. They, too, were watching lions. 'Once the danger had gone,' Charlie says, 'they relaxed into a gloriously symmetrical pose, in the middle of a curved rock, under a symmetry of clouds, crowned by a perfectly positioned small cloud at the top.' He adds that 'normally when taking wildlife pictures, everything conspires against the photographer, but with this picture it was the reverse. Everything worked in harmony.' The cheetahs stayed posed for only a few minutes and afterwards, as though on cue, went straight to sleep. Charlie chose to photograph them with a converted infrared camera, which in bright sunlight makes an azure sky dark and dramatic.

Canon EOS 5D Mark II infrared converted + 24-105mm lens; 1/250 sec at f10; ISO 100.

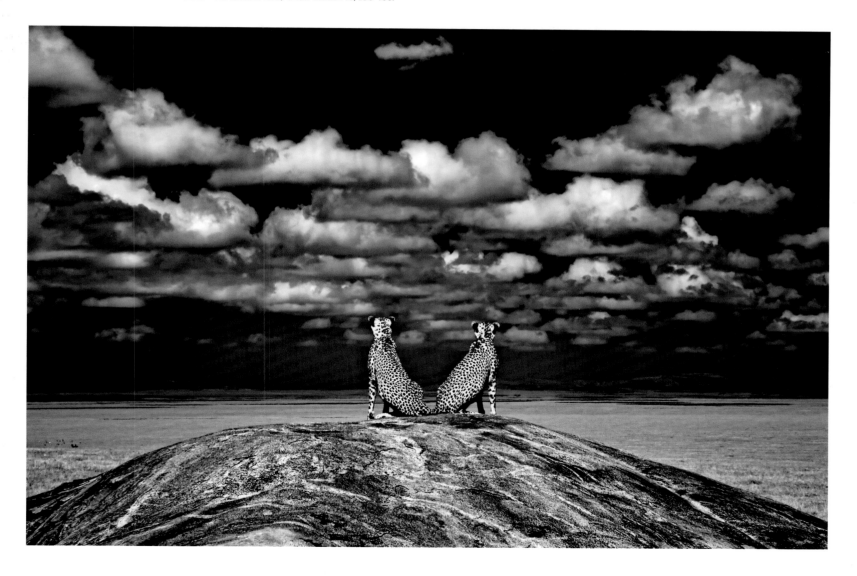

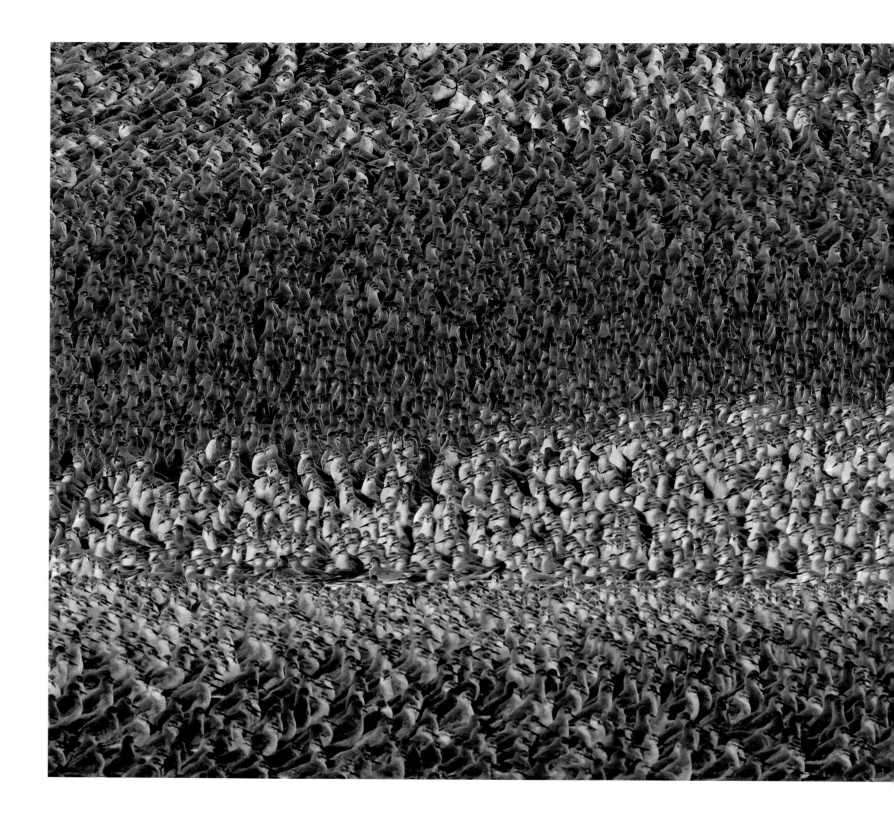

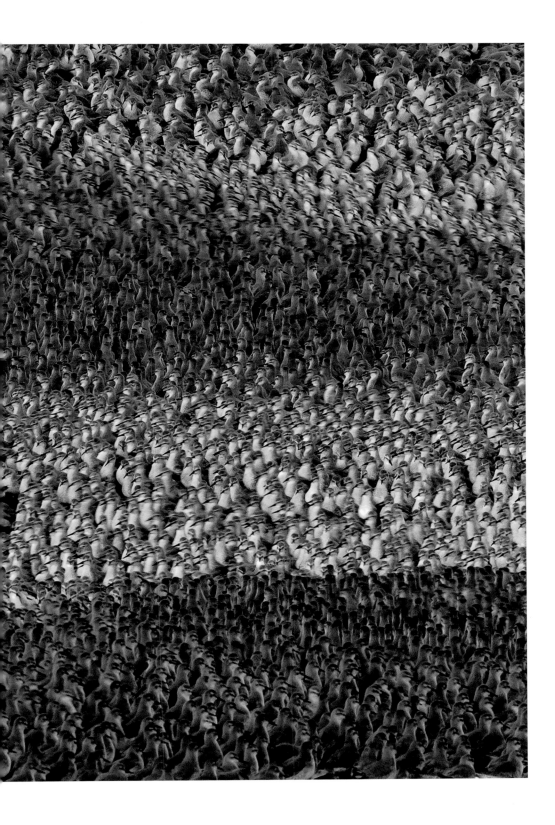

A wave of knots

COMMENDED

Thomas Hanahoe

UK

The mudflats of the Wash in East Anglia provide feeding grounds for tens of thousands of knots each year. As the tide floods in, they move ashore to the banks of freshwater lagoons alongside the beach. To catch the birds at high tide, Thom got to the hide at Norfolk's Snettisham Beach before dawn. 'As first light spilt across the mudflats,' he says, 'I was greeted by the incredible sight of thousands upon thousands of knots roosting together on the sloping bank of a lagoon.' The shoving of birds competing for space created giant snake-like waves of movement through the flock. 'To capture the dynamic scene required a substantial depth of field,' adds Thom, 'and in the pre-dawn light, even accompanied by a high ISO, this resulted in a very slow shutter speed.' The image was almost monochrome, and so it was a perfect candidate to develop in black and white.

Canon EOS-1D Mark IV + 500mm f4 lens; 1/30 sec at f16; ISO 1600; hide.

Botanical Realms

This is the category for images of any botanical subjects, in the traditional sense, including fungi and algae as well as land plants. The pictures should convey a feel for the beauty, mystery, fragility or strength of the subjects.

Painting with snow

WINNER

Glenn Upton-Fletcher

UK

The sky above Brock Valley in Lancashire, England, suddenly darkened, and the snow began to fall heavily. Glenn was thrilled. He'd grown up in Africa, and snowfall this thick was a complete novelty. As the soft, heavy flakes whispered through the oak trees, he was so distracted that he had trouble concentrating on the technicalities of photography. 'I was captivated by the feeling of solitude, with my visibility so limited and the silence so surreal,' he says. The steep sides of the ravine seemed to channel the snow into a concentrated sheet, and Glenn put aside all thought of photographing the roe deer he was tracking and set about depicting both the sense of the density of the snow and the beauty of the effect. 'I needed a good depth of field to keep much of the tree in focus but also to choose my focal point carefully, so some of the snow was blurred to give motion and some static to appear as flakes.' With that in mind, Glenn set about painting the magical scene'.

Canon EOS-1D Mark II N + 500mm f4 lens; 1/80 sec at f11; ISO 400; Gitzo tripod + Wimberley Sidekick + Really Right Stuff BH-55 Ball Head; remote shutter release.

Spirit of the volcano

COMMENDED

Francisco Mingorance
SPAIN

In the end, Francisco had just five minutes to photograph the flowering bugloss with the Milky Way in the position he wanted it. But he was prepared. He had spent several days walking among the spiky larva environment of Tenerife's volcanic Teide National Park (the largest and oldest of the Canary Islands' four national parks) searching for the perfect red bugloss flower spikes. He needed them growing in a position that would allow him to photograph them relative to the movement of the Milky Way. For Francisco, the red bugloss represents the soul of the island. Like many Canary Island plants and animals, which have been isolated from southern Europe and North Africa for millions of years, it is adapted to specific soil and climatic conditions, in this case to the volcanic slopes of Tenerife. Francisco used a long exposure for the stars, a flash to bring out the colour of the flowers and a ground-level viewpoint to emphasise the height of the plants (nearly three metres) against the dramatic night sky.

Nikon D3S + 14-24mm f2.8 lens; 65.4 sec at f5; ISO 1600; two Speedlight SB-900 flashes.

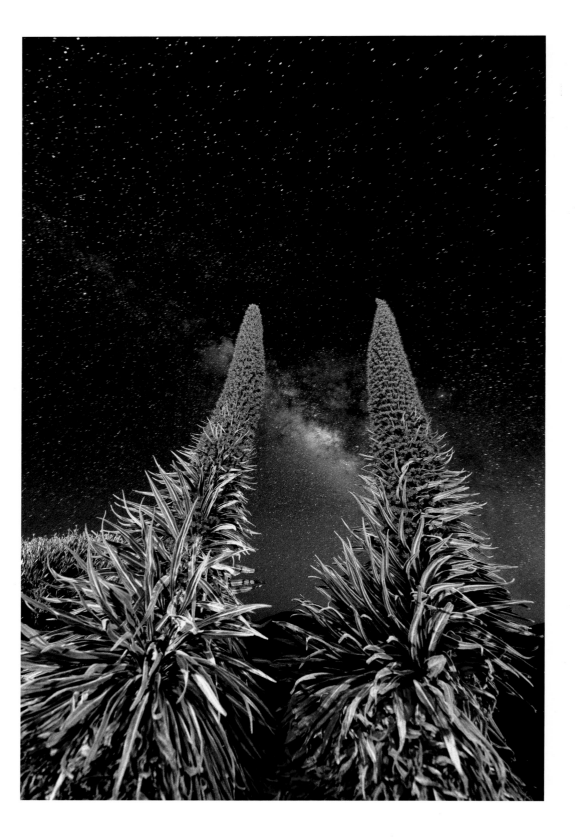

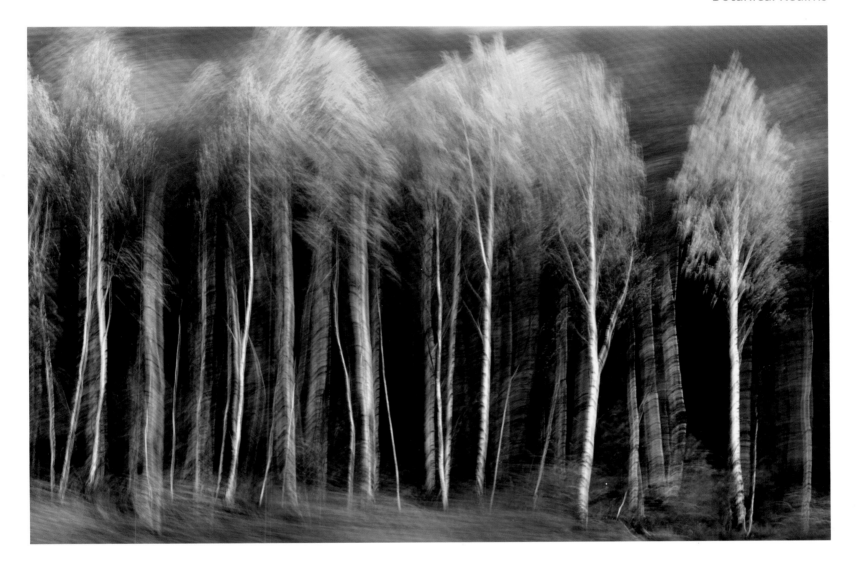

A movement of trees

COMMENDED

Cezariusz Andrejczuk

POLAND

Cezariusz is fascinated by creating what he calls 'movances' – images of stationary subjects made by moving the camera in various ways, a style derived from his work as a film cameraman. He frequently travels in his home area, Podlasie in eastern Poland, with the sole purpose of taking movances, especially of trees. For this picture, 'I first searched for the most beautiful silver birches in the region,' he says. Then, from the train, he used a long exposure to achieve a series of images, moving the camera in the direction of travel. For Cezariusz, such pictures 'reveal the underlying and mysterious vibrations of nature'.

Canon EOS 5D Mark II + EF 85mm f1.8 lens; 0.25 sec at f9.5; ISO 200.

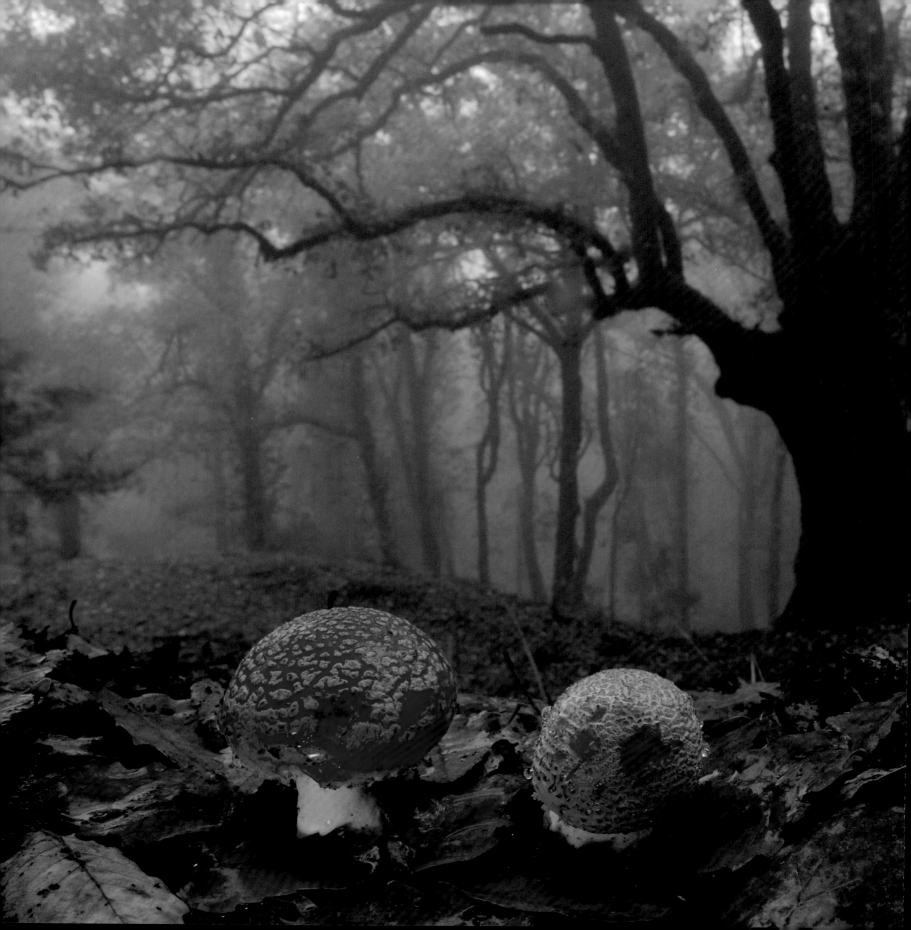

Woodland magic

COMMENDED

Andrés Miguel

SPAIN

It was a cold, foggy, drizzly day – perfect conditions for searching for and photographing the many types of fungi pushing up through the fallen leaves on the forest floor of Los Alcornocales Natural Park in Andalucía, southern Spain. 'It had been a very wet year, and the atmosphere in the woodland was wonderful,' says Andrés. 'I love photographing fly agaric fungi, but I'd never tried using a wide-angle lens to capture the perspective in this way before.' To do so required spending some time lying in the leaf-litter in the rain, not just to get on eye-level with the fruiting bodies but also to show the overarching, ancient, pollarded Andalucían oak in the background. The fungal fruiting bodies are produced by a vast web of mycelium threads – the main body of the fungus – spread through the soil and leaf-litter and living in association with trees, in this case, birch.

Canon EOS-1D Mark III + 17-40mm f4 lens at 20mm; 1 sec at f16 (-0.75 e/v); ISO 200; 580EX flash; Giotto tripod.

Cypress swamp in a golden dawn

COMMENDED

Ralph Arwood

USA

Ralph works as a volunteer photographer in the huge Big Cypress National Preserve, part of Florida's Western Everglades. Bald-cypress is a typical tree of this vast wetland, often growing within the swamp areas, draped in moss, and providing food, nesting places and shelter for many of the animals found here. Twice a year, Ralph joins biologists as they fly transects over the cypress swamp to monitor the numbers of white-tailed deer. The deer feed in the open prairies in early morning, and so the flights begin at sunrise. 'As so often on an early morning flight, the ground fog rising from the water crystallised the light,' he says. 'A huge, glistening spider's web hanging from one of the bald-cypress trees added the perfect accent to a mystical view of the swamp.'

Nikon D3 + 80-400mm lens at 400mm; 1/2000 sec at f8 (-1 e/v); ISO 1600.

Fairy Lake fir

COMMENDED

Adam Gibbs

CANADA/UK

Much of the area around Port Renfrew (the start of the West Coast Trail), on the west coast of Canada's Vancouver Island, has been heavily logged. So for Adam, this miniature Douglas fir growing out of a stump in the middle of Fairy Lake was symbolic. 'It always amazes me how resilient nature is and what a tenacious existence some plants live.' It's not uncommon for saplings to take up residence on another tree or log, but Adam was fascinated by the way this one had used a submerged Douglas fir stump as a nurse log. 'To me, the little tree looked as though it had been nurtured by a bonsai master.' Adam focused in on it to exclude the vegetation around the lake and, waiting for a mirror-still moment, used the reflection of its surroundings as the backdrop.

Canon EOS 5D Mark II + 100-400mm f4.5-5.6mm lens at 350mm; 20 sec at f22; ISO 50.

Urban Wildlife

These pictures reveal nature surviving in a human environment in a surprising or memorable way.

Secret lives

WINNER

Kai Fagerström

FINLAND

Once, some 40 or so years ago, a family of 13 people lived in this cottage in Suomusjärvi, Salo, Finland. They have long gone, but though the building has fallen into disrepair, it is still a winter home to many woodland creatures, including this red squirrel, which lives in the attic. Kai has spent the past 15 years documenting the secret life of such places. 'Deserted buildings are so full of contradictions,' he says. 'I am fascinated by the way nature reclaims spaces that were, essentially, only ever on loan to humans.' He usually starts off with a particular image in mind. Sometimes, he achieves that relatively quickly. But it often takes a considerable time for all the elements to come together in just the right way, subject included. 'This is fine with me,' he says. 'The journey is more important than the destination.'

Nikon D3S + 70-200mm f2.8 lens; 1/30 sec at f4; ISO 1800; hide.

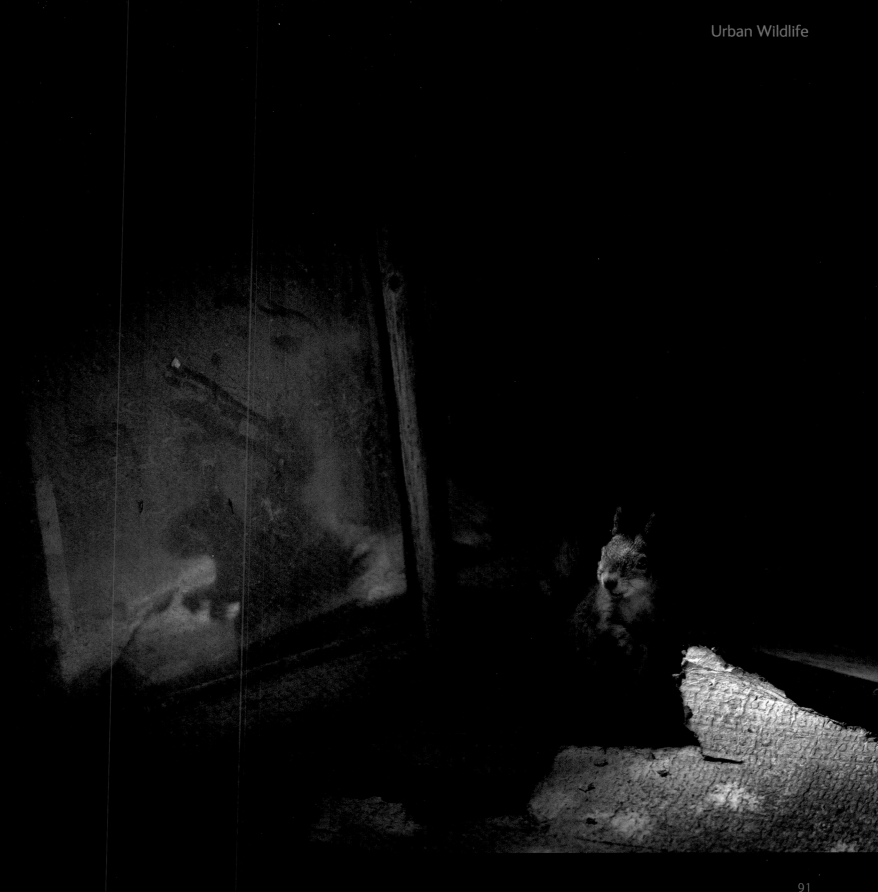

Bumper life

RUNNER-UP

Pål Hermansen

NORWAY

When Pål discovered an abandoned scrapyard
in southern Sweden, near to his home, he began
to visit it regularly. Abandoned for more than
60 years, the cars have succumbed to nature.
Algae and moss cover the paintwork, plants grow
up through the floorboards and tiny creatures nest
in the seats. 'One particular squirrel would cross
the yard at almost the same time every morning,'
says Pål. 'It would jump from car to car, and I got
to know the sound of its little metallic footsteps
so well that I could tell which car it was on.
I'm fascinated by how wildlife slowly occupies
what were once powerful human symbols of
status. Plants and animals pay no attention to our
icons. It is nature that rules, not wealth.' Pål set up
a hide and used nuts to tempt the squirrel to
pause, resulting in a surprising, story-book picture.

**Hasselblad H3D-39 + 210mm lens + 1.7x converter; 0.3 sec
at f7.1; ISO 100.**

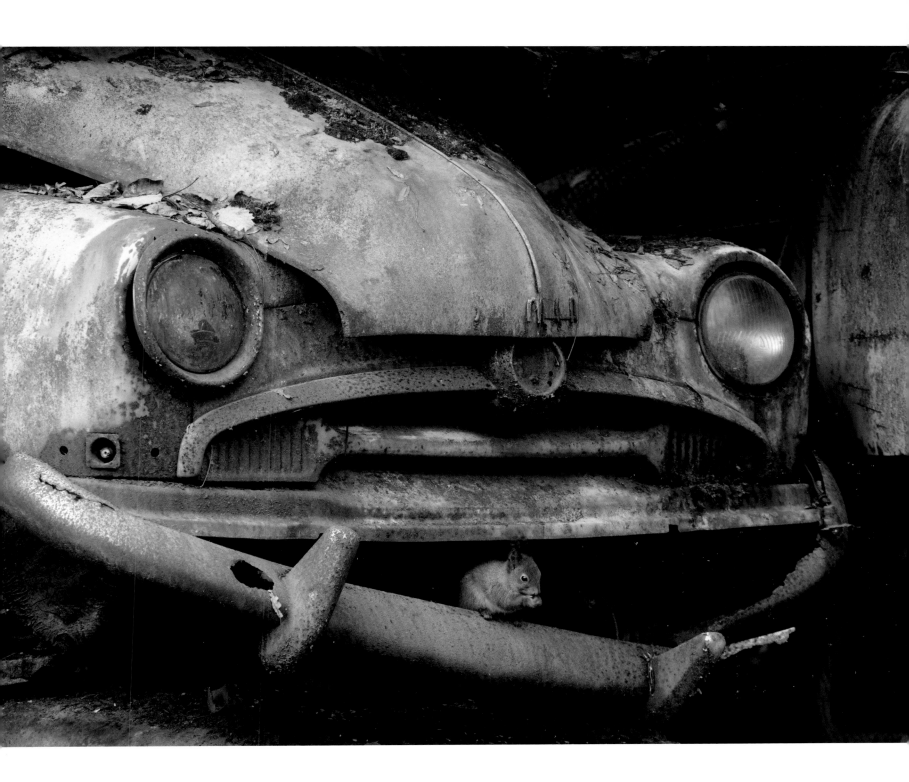

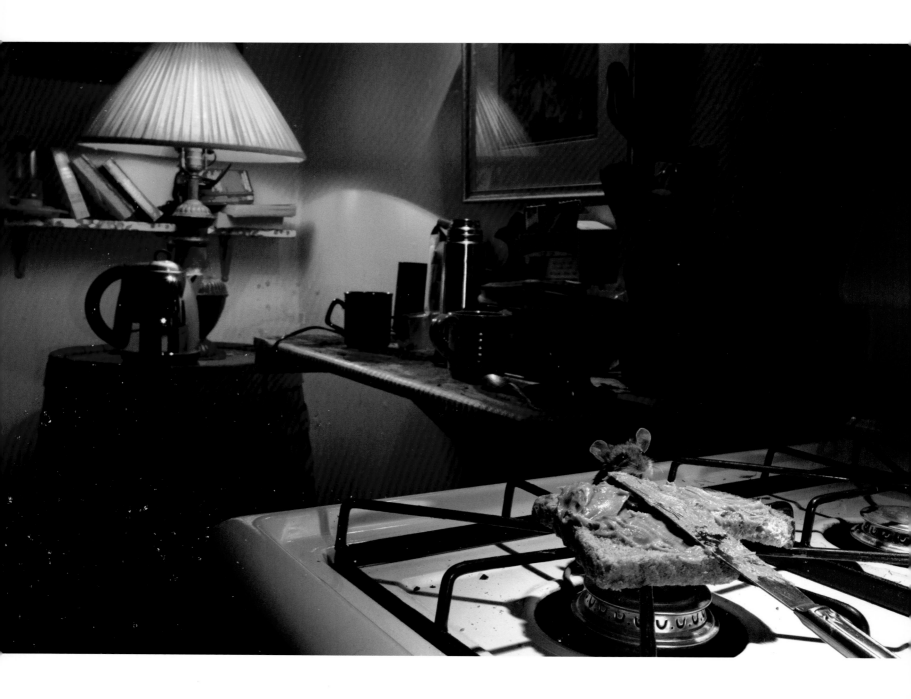

94

Midnight snack

SPECIALLY COMMENDED

Alexander Badyaev

RUSSIA/USA

Alexander's research cabin in the Blackfoot Valley, Montana, USA, is permanently occupied. But not by him. He just goes there every so often to work. Instead a range of forest creatures makes full use of the shelter and food remains. He doesn't see much of them, but there are always signs, particularly in the kitchen. 'I had long suspected that a family of mice was living under my cooker and tasting my food,' he says. 'Then, late one evening, I returned to retrieve a peanut-buttered slice of bread I'd left briefly in the kitchen and discovered a deer mouse sampling it. When it disappeared into the hob, I grabbed my camera, quickly put a flash on the shelf behind the cooker, and when the mouse popped up again, shot a single frame. It took much longer to convince myself to finish my snack.'

Canon EOS-1D Mark IV + 16-35mm lens at 25mm; 1/200 sec at f18; ISO 250; two Speedlite 430EXII flashes.

The World in
Our Hands Award

Here the challenge is to show in a thought-provoking and memorable way, whether graphic or symbolic, our interaction with the natural world and to create awareness of how our actions can affect it.

Ice matters

WINNER

Anna Henly

UK

Anna was on a boat in Svalbard – an archipelago midway between mainland Norway and the North Pole – when she saw this polar bear at around four in the morning. It was October, and the bear was walking on broken-up ice floes, seemingly tentatively, not quite sure where to trust its weight. She used her fisheye lens to make the enormous animal appear diminutive and create an impression of 'the top predator on top of the planet, with its ice world breaking up'. The symbolism, of course, is that polar bears rely almost entirely on the marine sea ice environment for their survival, and year by year, increasing temperatures are reducing the amount of ice cover and the amount of time available for the bears to hunt marine mammals. Scientists maintain that the melting of the ice will soon become a major problem for humans as well as polar bears, not just because of rising sea levels but also because increasing sea temperatures are affecting the weather, sea currents and fish stocks.

Canon EOS 5D + 15mm f2.8 lens; 1/100 sec at f3.5; ISO 400.

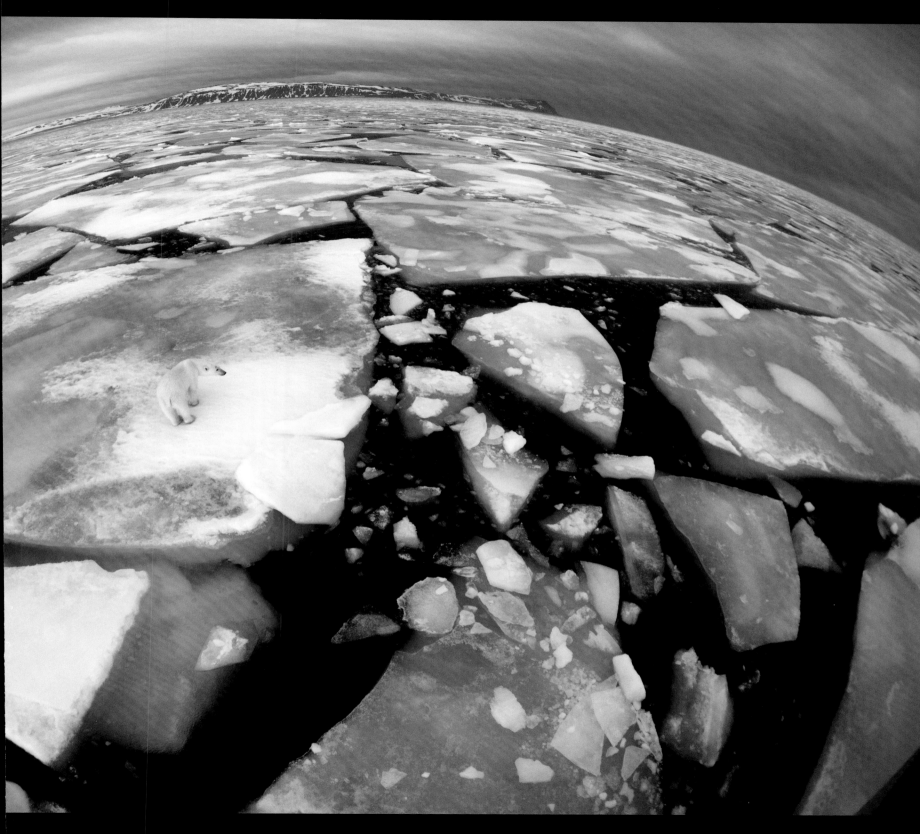

Trophy room

RUNNER-UP

David Chancellor

UK

The sheer diversity of stuffed animals in the one room is extraordinary, but the focal point is not the leopard or the rhino but the man with the cigar, relaxed in the corner. He is a lawyer from Dallas, Texas, and has shot all of the animals. In fact, his collection amounts to more than 230 stuffed and mounted trophies, which he has killed during a lifetime of hunting. He is a recipient of the Dallas Safari Club Africa Big Game Award for his collection of African elephant, buffalo, lion and leopard, and the Outstanding Hunting Achievement Award for his 30-year quest and collection of all 30 North American 'big game' animals, of which 15 are 'records class' (big). The picture is one of a series of thought-provoking images that David has taken to 'illustrate the complex relationship between man and animal, hunter and hunted'.

Mamiya 7 II + 80mm f4 lens; 2 sec at f11; Kodak Portra 160 film; Manfrotto tripod; cable release.

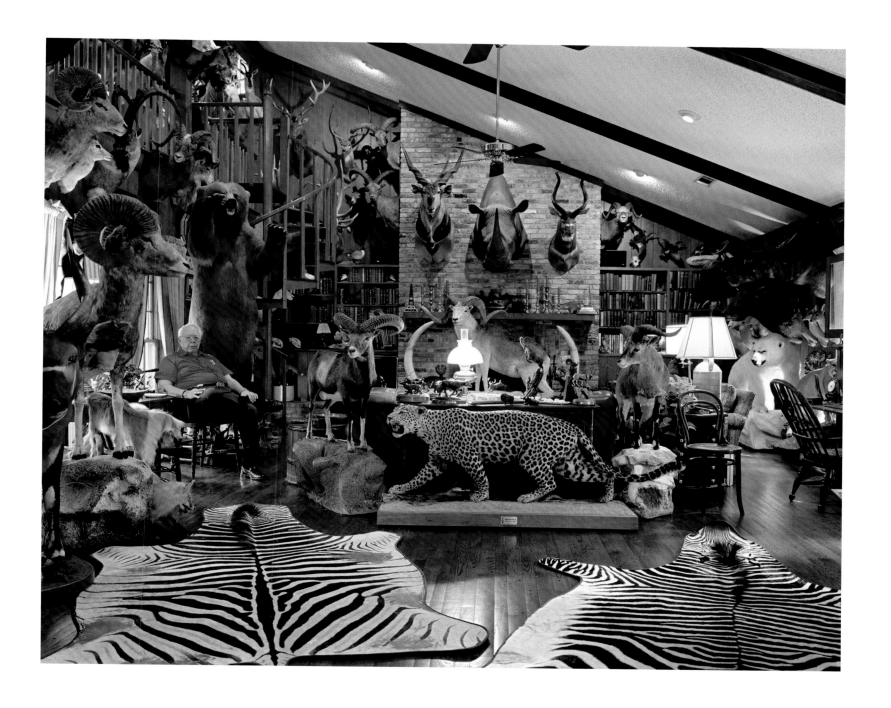

The dolphin show

COMMENDED

Huang-Ju Chen

TAIWAN

Wandering behind the scenes at a Japanese aquarium, where captive dolphins perform for the paying public, Huang-Ju came across this scene. 'I saw the workers scrubbing the tank,' he says, 'but then I suddenly realised there were dolphins lying in the drained pool.' It was a stark reminder of how different life in a sterile aquarium is to a dolphin's natural ocean habitat. 'I was shocked,' says Huang-Ju, 'at how the staff ignored the dolphins and didn't seem to be in any hurry to refill the pool.' Such captivity seemed a high price for the animal to pay just for human entertainment.

Fujifilm FinePix S5 Pro + Nikon DX 17-55mm f2.8G lens; 1/285 sec at f5.6 (+1.3 e/v); ISO 125.

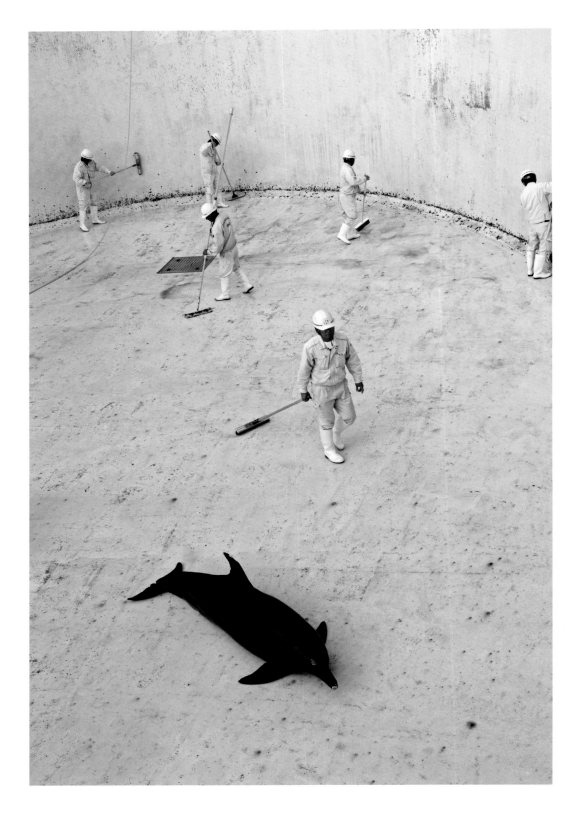

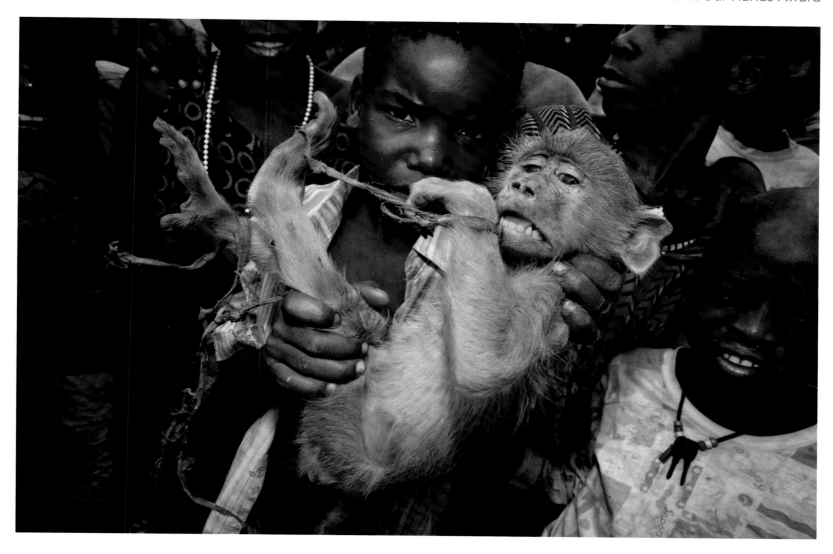

Primal fear

SPECIALLY COMMENDED

Jabruson

UK

Jabruson was on his way to northern Mozambique to cover the poaching of elephants when, passing through a village, he saw a group of children with a tethered yellow baboon. It had been caught when its troop raided local crops, probably forced to by loss of habitat. 'Few animals show such human expressions,' says Jabruson, 'and this youngster's face spoke volumes.' Then things got tricky when men appeared demanding that he bought it. The best he could do was take a picture 'to highlight yet another human-wildlife conflict issue so common in Central Africa'. He never knew the youngster's fate. Without access to the appropriate wildlife authorities, he had no alternative but to leave it – another sad example of humans and wild animals clashing over dwindling resources.

Sony DSLR-A900 + 24mm f2 lens; 1/200 sec at f11; ISO 200.

Garbage picking

COMMENDED

Jasper Doest

THE NETHERLANDS

'This was the filthiest shoot I have ever done,' says Jasper. 'Clambering about this ghastly landfill site in southern Spain made me aware of just how much trash we generate on a daily basis.' In the Andalucía region of Spain and elsewhere, the dumps are affecting the storks' natural behaviour. Instead of feeding on frogs, insects, young birds, rodents and worms, they are attracted to this ready source of rotting food, ingesting potentially lethal elements, in particular, rubber bands and plastics, even feeding them to their chicks. But population counts have revealed that, in recent years, rubbish dumps have become increasingly important to white storks, providing a constant food source during both the breeding season and winter and helping to increase their numbers. The concern, though, is that some populations are now so dependent on rubbish that the replacement of dumps with incinerators, combined with increasing loss of their natural habitat, may cause a future decline in numbers.

Nikon D3 + 70-200mm f2.8 lens; 1/1000 sec at f11; ISO 400.

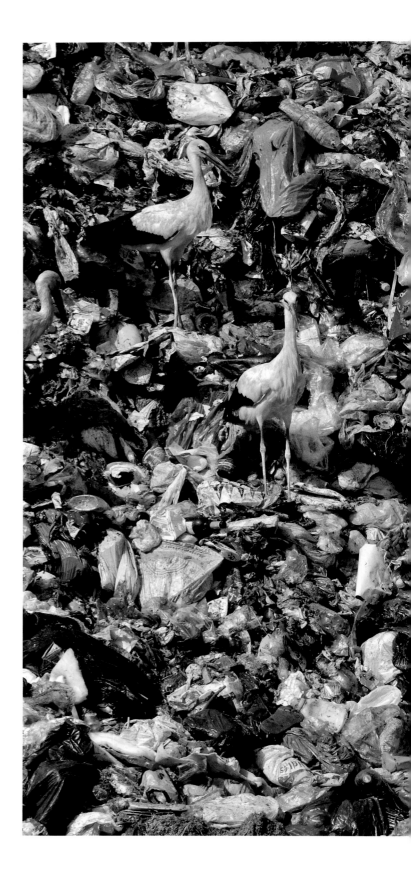

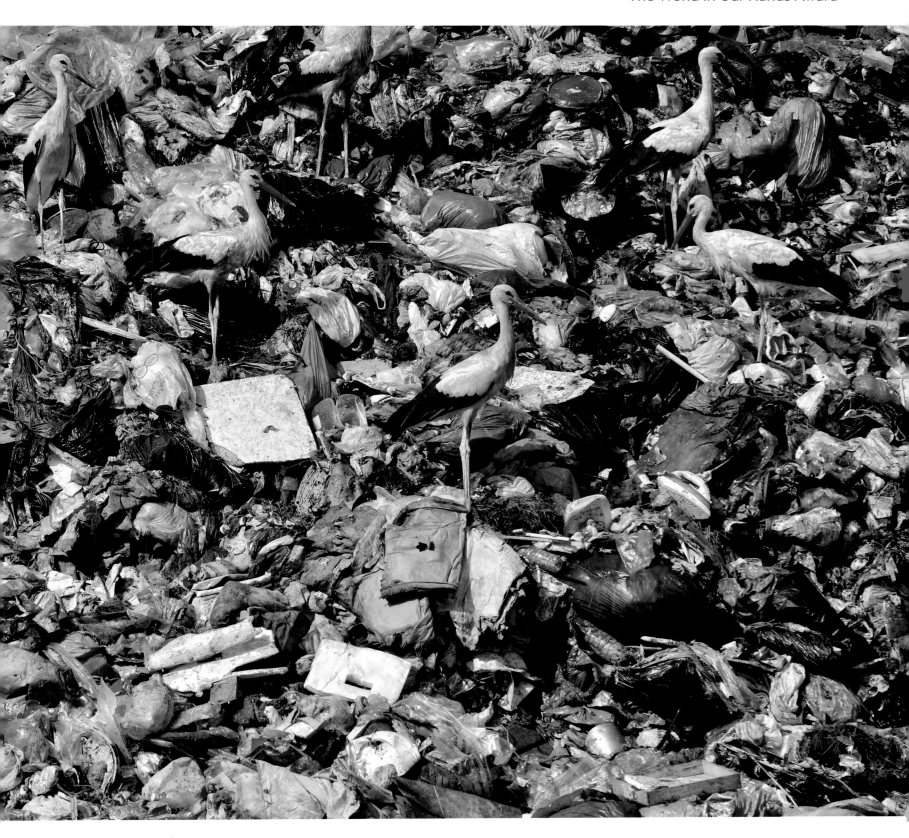

The end of sharks

COMMENDED

Paul Hilton

UK/AUSTRALIA

Workers at Dong Gang Fish Market in Kaohsiung, Taiwan, routinely process thousands of frozen shark fins a day to service the growing international demand for shark-fin soup. Once a delicacy, the dish is increasingly popular with China's growing middle class. The statistics are grim: up to 100 million sharks are killed each year, 73 million for their fins to service this demand, taking one in three shark species to the brink of extinction. Since 1972, in the northwest Atlantic, the blacktip shark population has fallen by up to 93 per cent, the tiger shark by 97 per cent and the bull shark, dusky shark and smooth hammerhead populations by 99 per cent or more. Many millions of sharks are taken solely for their fins and get thrown back into the ocean, where it takes hours for them to die. Says Paul, 'It was sobering to think how many sharks had been killed to produce this pile of fins for a soup that isn't even healthy' (the fins contain high levels of methylmercury). Another sombre thought: in the time that it has taken to read this caption, around 50 sharks will have been slaughtered worldwide.

Canon EOS 5D Mark II + 16-35mm f2.8 lens; 125 sec at f4.5; ISO 1600.

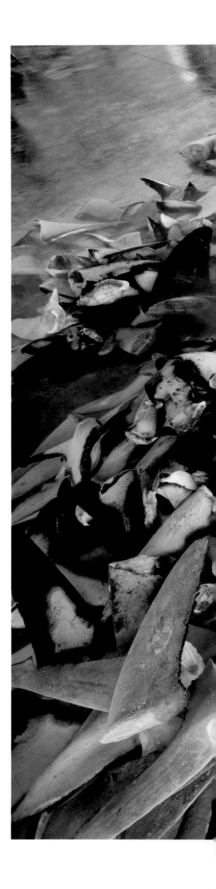

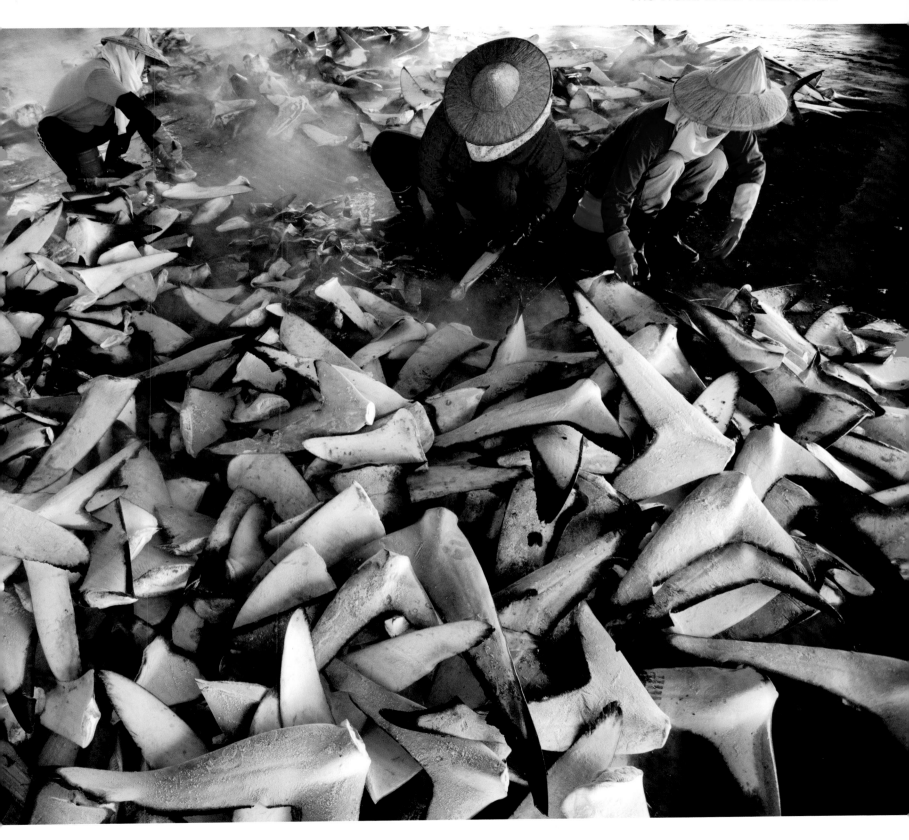

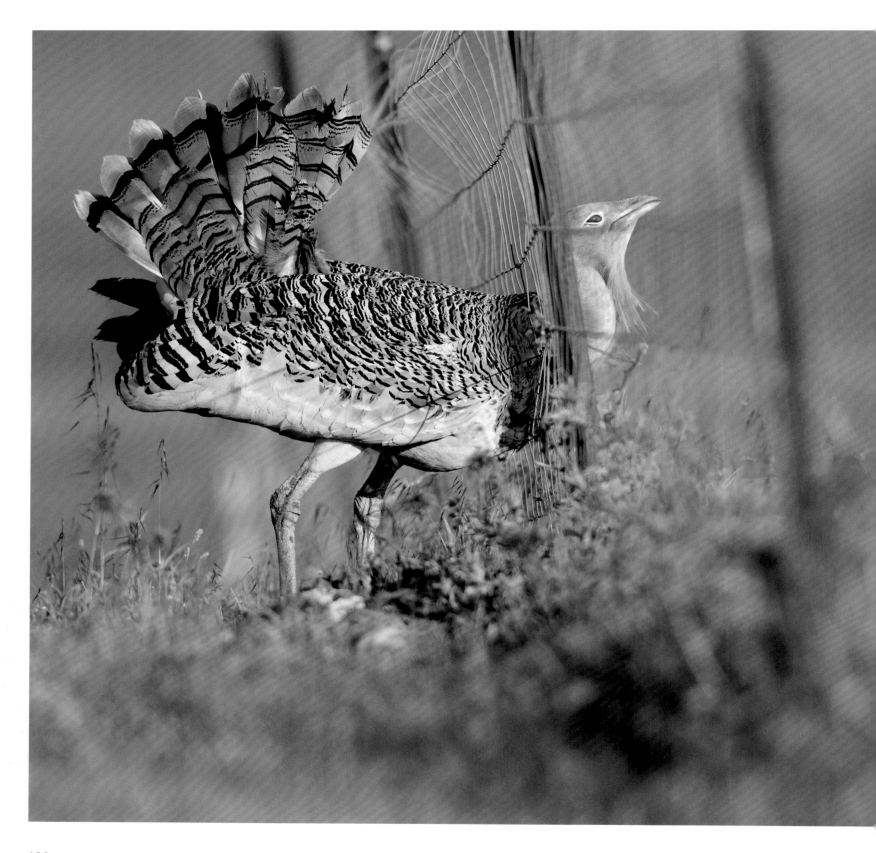

Display of vulnerability

COMMENDED

Staffan Widstrand

SWEDEN

When a great bustard is in mid-display, his concentration is on one thing – females, and attracting them by puffing out his chest, throwing up his whiskers and fanning out his huge tail and wing feathers. A wire fence just doesn't get noticed. Traditional lekking (display) grounds are on open grassland, which allows females to spot displays from a distance, and also approaching predators to be seen. But where exactly the males will display is unpredictable. In fact, Staffan waited for a week, from dawn to dusk, in an old stone hunting hide beside a lek area in Extremadura, Spain, before a displaying bustard came close enough to photograph. But then he watched in horror as the male, in the middle of displaying, walked straight into a sheep fence. Luckily, after a while it struggled free without damage. But other birds aren't so lucky, and many also die from flying into fences. The great bustard's grassland habitat in southern and eastern Europe and across as far as China is increasingly becoming fragmented, crisscrossed with wire fencing, power lines and ditches, and converted to intensive agriculture, especially in eastern Europe. The great bustard is classified as vulnerable, but while it is declining in many countries, it is protected in Spain and throughout the European Union.

Nikon D3 + 600mm f4 lens + 1.4x teleconverter; 1/2000 sec at f9; ISO 640; beanbag; hide.

The tourist tiger trail

COMMENDED

Melisa Lee

MALAYSIA

Tiger Temple is the colloquial name for Wat Pa Luang Ta Bua Yannasampanno, a Buddhist monastery at Kanchanaburi in Thailand. Its relationship with tigers started in 1999, when the Abbot took in a number of injured and orphaned cubs. The monastery then started to breed its tigers. Now it receives hundreds of paying visitors a day wanting to stroke and be photographed with them. Over the years, there has been both positive press for Tiger Temple, including tourism awards and a film, and negative reports that animals are mistreated behind the scenes. In 2008, a report by Care for the Wild International, based on an undercover investigation, claimed major welfare problems, unlicensed breeding of the tigers and trading with a tiger farm in Laos. And in an open letter to the Thai authorities, the International Tiger Coalition criticised the temple's claim that it is involved in tiger conservation. Melisa's picture shows a male tiger leading tourists back from the tiger-petting arena to the monastery, followed by his two-month-old cubs (an unusual sight, since cubs would normally stay with their mother until at least a year old).

Canon EOS-1Ds Mark II + 24-105mm f4 lens; 1/250 sec at f9; ISO 640.

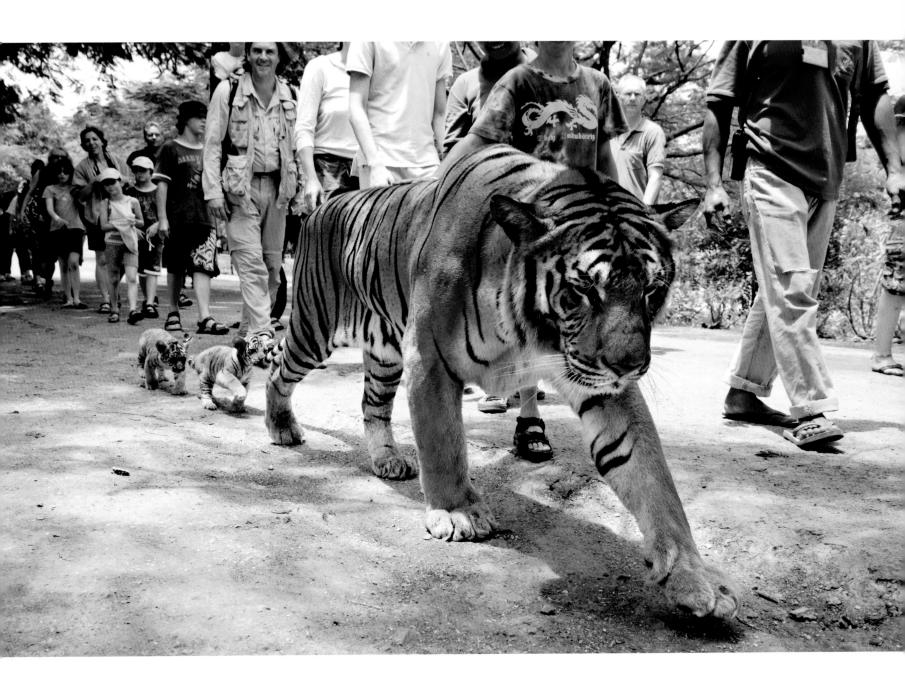

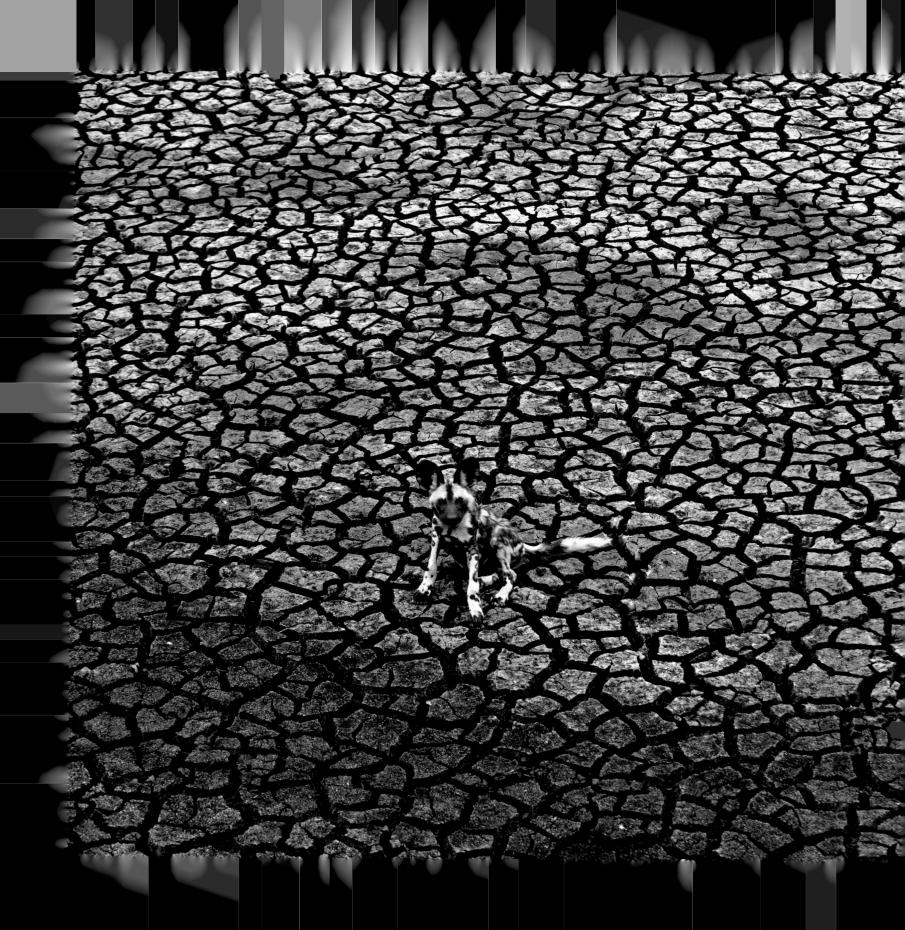

The Gerald Durrell Award for Endangered Species

The purpose of the award, named after the legendary conservationist Gerald Durrell, is to highlight, through photographic excellence, the plight of wildlife under threat. Species featured are officially listed on the IUCN Red List as critically endangered, endangered, vulnerable or near threatened.

Dog days

WINNER

Kim Wolhuter

SOUTH AFRICA

Kim has been filming African wild dogs at Zimbabwe's Malilangwe Wildlife Reserve for more than four years. He knows one pack intimately. 'I have travelled with them, on foot, in the pack itself, running with them as they hunt. It's a privilege, and it's given me a true insight into their life.' Kim has also witnessed first hand the many threats that have made African wild dogs endangered, including increased conflict with humans and domestic animals (poachers' snares, habitat loss, traffic and disease). 'At times, it's heart-wrenching,' he says. 'My mission is to dispel the myth that they're a threat and help raise awareness of their plight.' African wild dogs require huge territories, and so protecting them can protect entire ecosystems. When this picture was taken, the pack had travelled four kilometres to the Sosigi Pan, only to find it totally dried up. 'The mosaic of mud seemed to epitomise the increasingly fragmented world this puppy is growing up in.'

Canon EOS-1Ds Mark II + 70-200mm f2.8 lens at 75mm; 1/160 sec at f4; ISO 200.

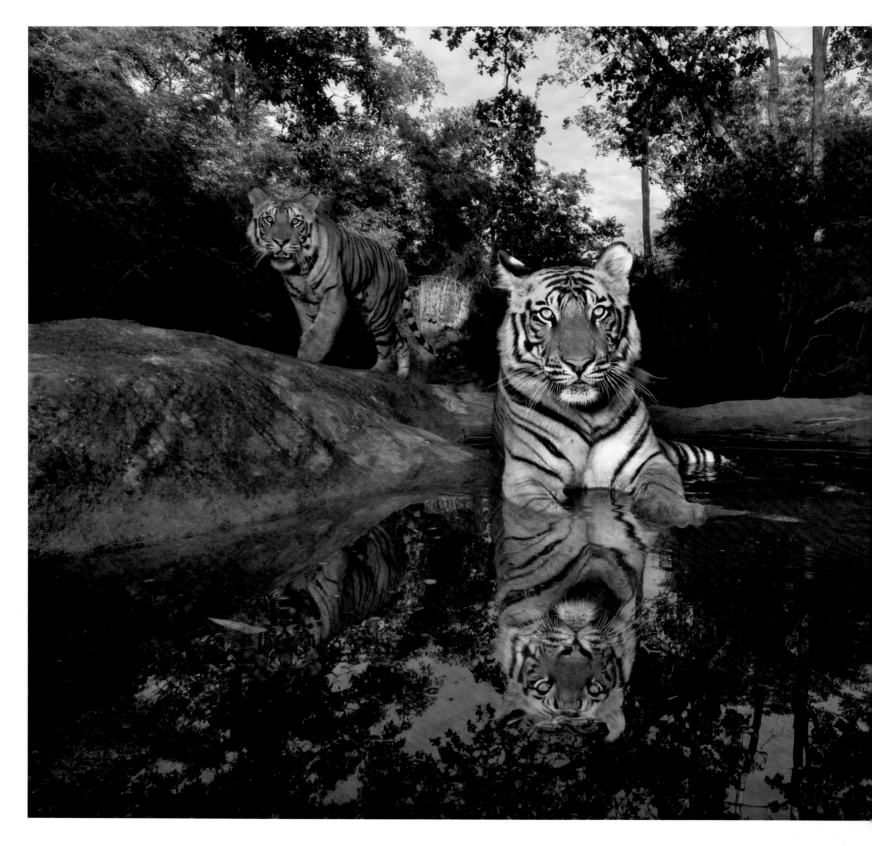

Last wild picture

RUNNER-UP

Steve Winter

USA

These 14-month-old Bengal tiger cubs, cooling off in the Patpara Nala watering hole in Bandhavgarh National Park, Madhya Pradesh, India, turned man-eaters before they were two years old. Between them, they killed three people. But the authorities didn't kill the tigers. Instead, they captured them and moved them to a facility for 'problem' tigers in Bhopal, from which they will never be released. But elsewhere in India and everywhere in their range, tigers are being killed in huge numbers. Fewer than 3,200 tigers remain in the wild, down from 100,000 a century ago. Three of the nine subspecies (the Bali, Caspian and Javan tigers) are now officially extinct, and the South China tiger almost certainly is. The deaths are due to the devastating impact of the demand for tiger parts for traditional Chinese medicine and sky-rocketing human populations, which have eliminated 93 per cent of the tiger's historic range during the twentieth century. Settlements, roads, industry and agriculture all encroach on tiger territory, sparking growing human-wildlife conflict. The remaining wild tigers cling on in isolated pockets, their numbers declining rapidly.

Canon EOS Rebel T1i + 10-22mm f3.5-4.5 lens; 1/200 sec at f16; ISO 400; three Nikon flashes; Trailmaster infrared remote trigger.

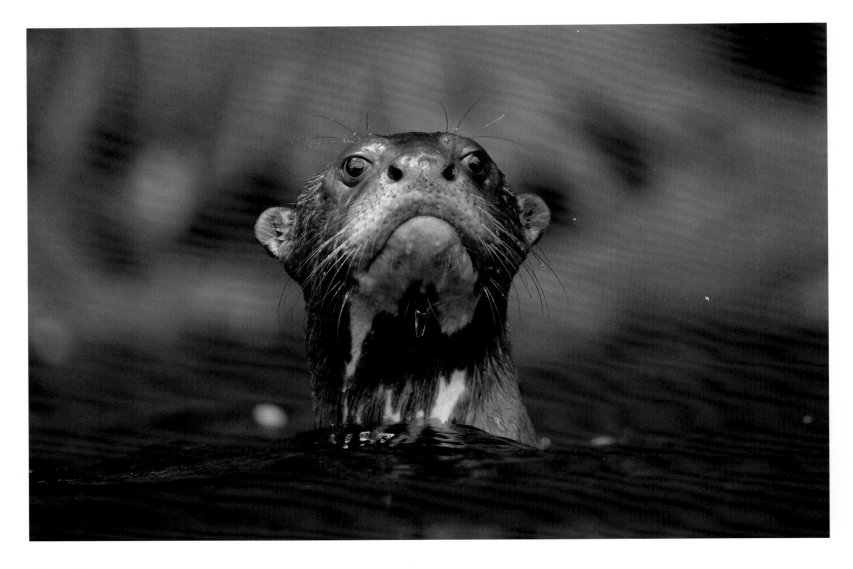

Treading water

COMMENDED

Charlie Hamilton James

UK

While making a film about giant otters in Cocha Salvador, Manu National Park, Peru, Charlie got to know this youngster well. 'He was full of personality,' says Charlie. 'These animals have a lot of attitude.' The portrait of the four-month-old cub was taken lying down in his boat, and the cub was as curious about Charlie as Charlie was about him, craning up its neck while treading water. Giant otters are very social and live in extended family groups, with up to eight or so members, giving safety in numbers where local predators, such as caiman, are concerned. They are officially listed as endangered. In the past, the main threat was hunting, but now their habitat is being destroyed and degraded by logging, mining, pollution, overfishing and even dams, and their numbers are rapidly dropping.

Canon EOS-1D Mark IV + 800mm lens; 1/1600 sec at f5.6; ISO 1000.

Fly-by drinking

SPECIALLY COMMENDED

Ofer Levy

ISRAEL/AUSTRALIA

The grey-headed flying fox is the largest bat in Australia – and one of the most vulnerable. Once abundant, there are now only around 300,000 left. The main threats include loss of habitat, extreme-temperature events and human persecution (roosting in numbers, eating cultivated fruit and an undeserved reputation for bearing disease brings it into conflict with people). The bat is now protected throughout its range, but its future remains uncertain.
Ofer spent several days in Parramatta Park in New South Wales photographing the bat's extraordinary drinking behaviour. 'At dusk, it swoops low over the water, skimming the surface with its belly and chest,' he says. 'Then, as it flies off, it licks the drops off its wet fur.' To photograph this in daylight, Ofer had to be in the right position on a very hot day, with the sun and the wind in the right direction, and hope a bat would be thirsty enough to risk drinking. 'This required standing in chest-deep water with the camera and lens on a tripod for three hours a day for about a week in temperatures of more than 40 degrees.'

Canon EOS-1D Mark IV + 600mm f4 lens; 1/1250 sec at f4; ISO 1250; Miller tripod + Arrow 25 fluid head.

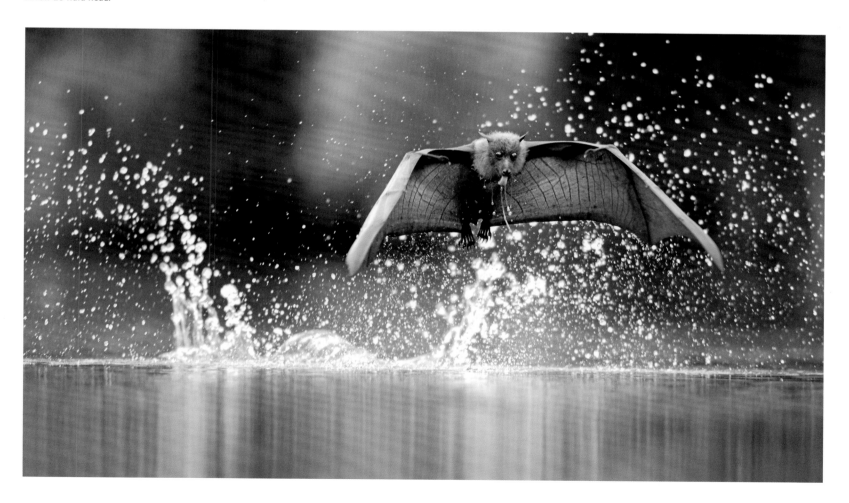

Leaping lemur

COMMENDED

Heinrich van den Berg

SOUTH AFRICA

Verreaux's sifakas are found only in southern and southwestern Madagascar. They are not as endangered as many of the island's lemurs, but their numbers are falling, mainly because of deforestation. They are most often photographed crossing open areas of ground, jumping upright, as if on springs. But when Heinrich found a group feeding in trees in the Nahampoana Reserve, what impressed him was the extraordinary way they use the technique to leap from one tree to another. 'They spring off their back legs, then twist in the air to land perfectly on the next trunk,' says Heinrich. The photographic conditions were ideal – the sifakas in shadow and a bright background behind – enabling him to use a slow shutter speed for the background effect of movement and a flash to freeze the leap.

Canon EOS 5D Mark II + 16-35mm lens; 1/12 sec at f9; ISO 100; two Quantum flashes.

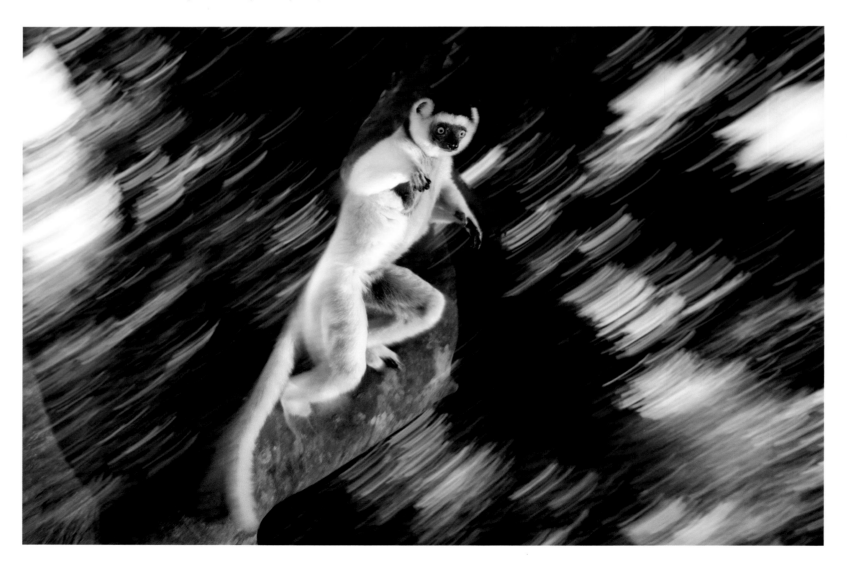

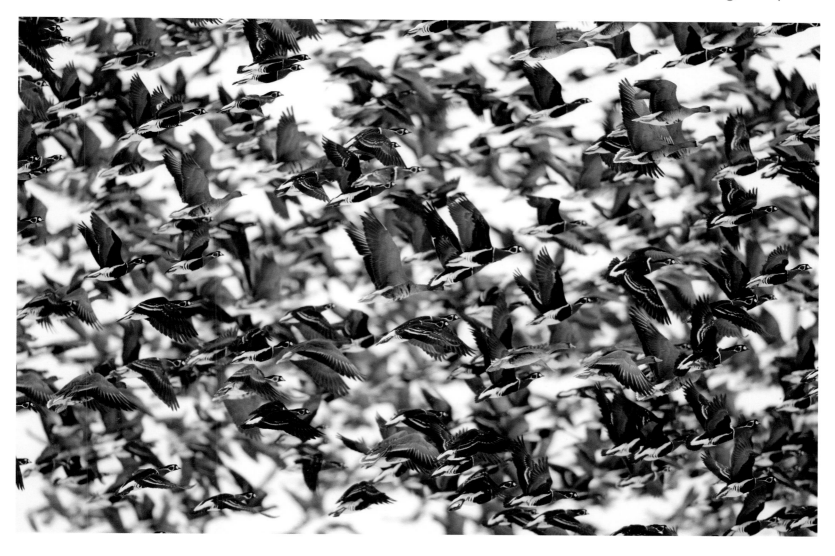

The great escape

COMMENDED

Yves Adams

BELGIUM

In February of 2012, on the Bulgarian coast of the Black Sea, birdwatchers
and hunters waited for migrating wildfowl to arrive at their traditional feeding
grounds. But none came. The hunting season ended, and the hunters went home.
So when winter finally moved the migrants south, only bird-lovers were there to
greet the huge numbers of red-breasted geese that arrived. 'There were so many, it
could easily have been the complete world population of this endangered species,'
says Yves. With the hunters gone, only white-tailed eagles disturbed them. 'On this
occasion, the direction of both the eagle attack and the wind meant that they all
flew in one plane,' says Yves. More than 80 per cent of red-breasted geese winter at
just five sites on the Black Sea coast, threatened by land-use changes and hunting.

Nikon D3X + 600mm lens; 1/800 sec at f4; ISO 200.

The Wildlife Photojournalist Award

One of the most difficult challenges is to tell a story with just six images. The six are judged on their story-telling power as a whole as well as on their individual quality.

Steve Winter

USA

THE TIGER'S TALE

'My aim with this story', says Steve, a photojournalist shooting for *National Geographic*, 'was to try to document the beauty of tigers, the serious threats they face and the heroic efforts to protect them.' Despite millions of dollars spent on tiger conservation over four decades, tiger numbers continue to plummet. Fewer than 3,200 remain in the wild, the majority in India.

Last look

This is a very special tiger. He is one of fewer than 400-500 wild, critically endangered Sumatran tigers. It was a huge challenge for Steve to photograph one, as those that have escaped poaching and forest clearance are mostly confined to patches of forests or the mountains and are extremely shy. A former tiger hunter, now employed as a park ranger, advised Steve where to set up his camera trap. But the challenge remained to position the remote-control camera and the lights in exactly the right position so the tiger would be lit centre-stage in front of a backdrop of forest habitat. The seemingly unstoppable growth of oil-palm plantations in Sumatra and continuing poaching for body parts for use in traditional Chinese medicine indicate that this subspecies of tiger is destined to become extinct in the wild, as have its Javan and Balinese relatives.

Canon EOS XTi + 16mm-35mm f2.8 lens; 1/160 sec at f11; ISO 200; waterproof camera box + Plexiglas tubes for three Nikon flashes; Trailmaster infrared remote trigger.

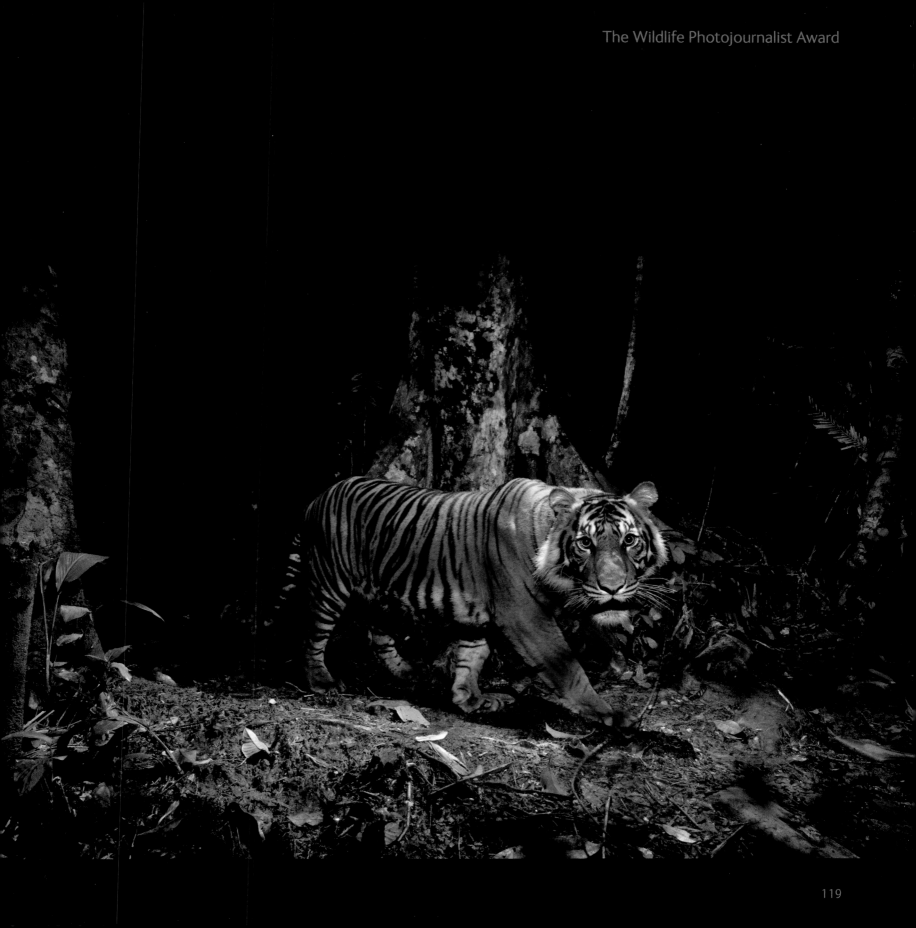

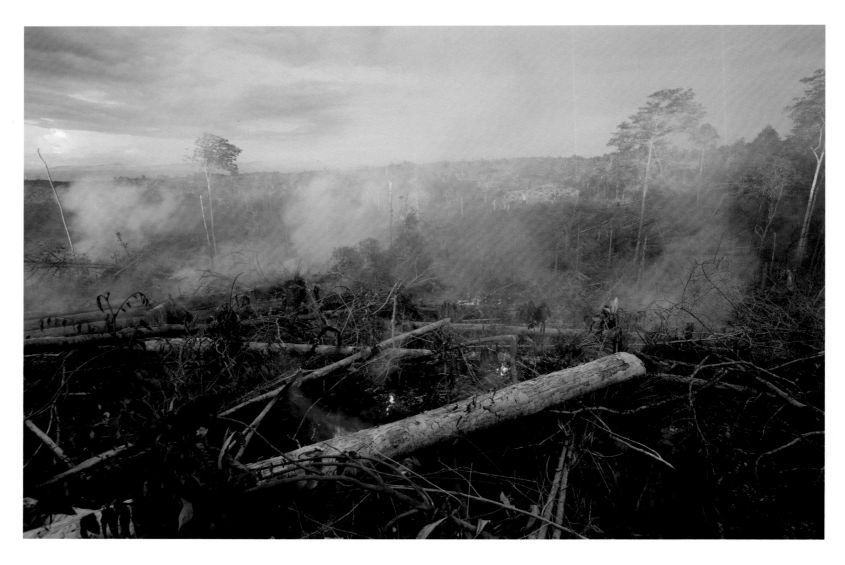

A burning issue

This is one of the main reasons for the likely extinction of the Sumatran tiger: legal and illegal forest clearance (here in Aceh Province, northern Sumatra) to make way for oil-palm plantations. Palm oil is a ubiquitous ingredient in about one in ten of the products we buy, including biscuits, cereals, chocolate, toothpaste and cosmetics. It is also used as a biofuel. Industrial-scale plantations now cover much of the island, and forest clearance is continuing, even in protected areas.

Canon EOS 5D Mark II + 16-35mm f.2.8 lens; 1/125 sec at f8; ISO 400.

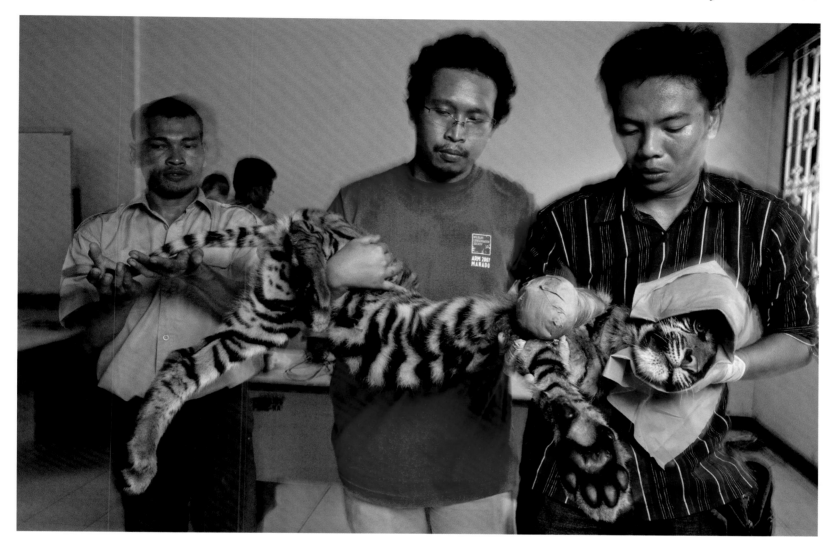

Little victim

A snare cost this six-month-old Sumatran tiger cub not only its right front leg but also its freedom. Caught in a snare for three days, it had to have its limb amputated. Now it lives in a cage in a Javan zoo. Snares commonly catch cubs in Sumatra. They are often set by Javan oil-palm-plantation workers living on forest plots. The workers' wages are low, and they won't see a return on any oil palms they plant on their land for at least five years and so are forced to catch forest animals to feed their families. Tigers are also being snared deliberately.

Canon EOS 5D Mark II + 16-35mm f2.8 lens; 1/125 sec at f8; ISO 400.

Dangerous crossover

This young Bengal tiger triggered Steve's camera trap as it crossed through a hole in the fence at Bandhavgarh National Park in Madhya Pradesh, India. It was almost certainly setting off to hunt local livestock. Some parts of the park have insufficient prey for the big cats, and so park officials have deliberately made holes in the fence so that the tigers can venture out to find food elsewhere. Here in Bandhavgarh, villagers get compensated for any livestock losses. But the result of tigers moving out can be disastrous. Last year, three tigers, including this tiger and his sister, killed three people from one village (see page 112). Conflict will increase as the tigers' habitat shrinks and the human population increases.

Canon EOS Rebel T2i + 10-22mm f3.5-4.5 lens; 1/200 sec at f13; ISO 400; three Nikon flashes; Trailmaster infrared remote trigger.

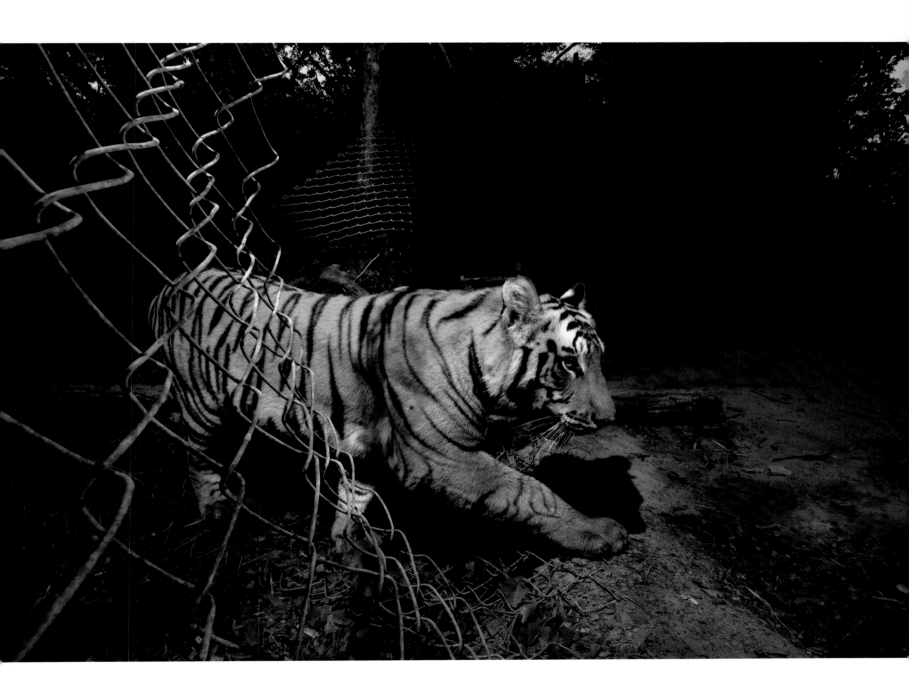

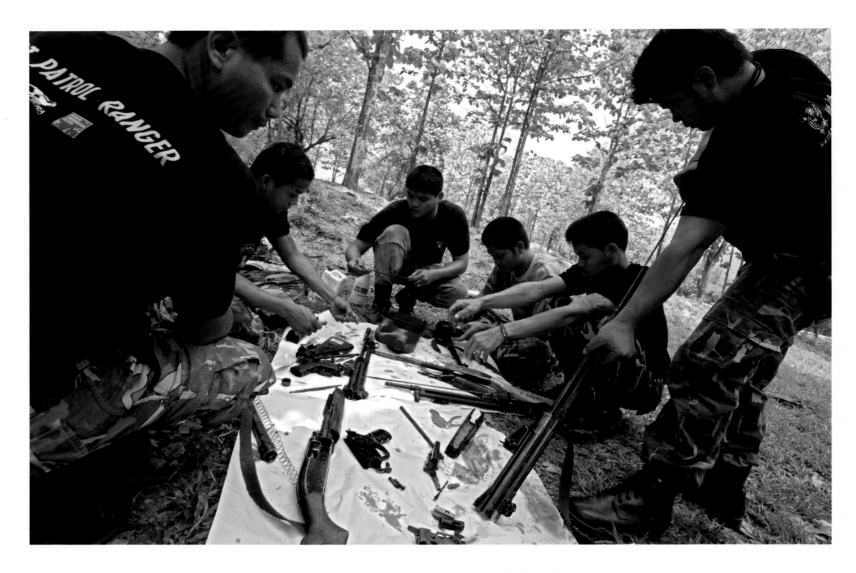

Tiger defenders

In the early 1990s, the demand for tiger parts to satisfy the traditional Chinese-medicine market grew exponentially, fuelling an illicit, multimillion-dollar trade run by arms and drug dealers. The situation has grown so dire that Thailand and some other nations are now using armed commandos to protect tiger reserves. Here, at Huai Kha Khaeng Wildlife Sanctuary, Thailand, which still contains Indochinese tigers, rangers are cleaning their weapons before going on patrol. This Smart Patrol Ranger group is part of a new protection force trained by the military and police, which has had some success in stemming the trade in endangered animals into Burma and China.

Canon EOS 5D Mark II + 16-35mm f2.8 lens; 1/125 sec at f11; ISO 400.

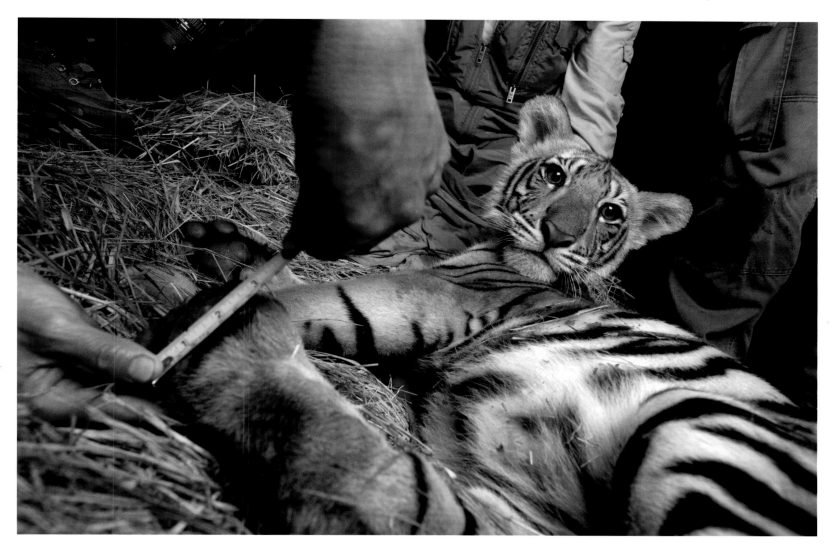

Little cub of hope

An Indochinese tiger cub, captured with its mother, is here being weighed and measured and its DNA sampled by Thai tiger-team staff at Huai Kha Khaeng Wildlife Sanctuary, Thailand. It was released back into the sanctuary with its mother, who was given a satellite collar so their movements could be tracked. The endangered·Indochinese tiger needs all the help it can get. Its population is declining and fragmented and is now substantially below 2,500 throughout its range, with no population larger than 250 (there are fewer than 185 tigers in Thailand). It will soon be classified as critically endangered, along with the Sumatran tiger and the South China tiger (now almost certainly extinct).

Canon EOS 5D Mark II + 16-35mm f2 lens at 24mm; 1/8 sec at f9; ISO 400; Lumidyne flash.

DEADLY MEDICINE

RUNNER-UP

Brent Stirton

SOUTH AFRICA

This is a tragic story about a growing fashion for consuming rhino horn that now threatens the extinction of rhinos. Their horns, mere keratin, the substance of fingernails, is now more valuable than gold on the Asian black market.

The real cost

This female southern white rhino is inseparable from her new male companion (right). It's a miracle she is alive. Four months earlier, in Tugela Private Game Reserve, KwaZulu-Natal, South Africa, she was brutally attacked by poachers. The men surveyed the area by helicopter, mapped out the movements of the rhino and the guards, darted her and then, using a chainsaw, cut off her horn, including a large section of bone. They left her to die, but she was found wandering the following day in unimaginable pain. Her four-week-old calf, which had become separated, died of dehydration and starvation.

Canon-1D Mark IV + 70-200mm f2.8 lens; 1/250 sec at f5; ISO 250.

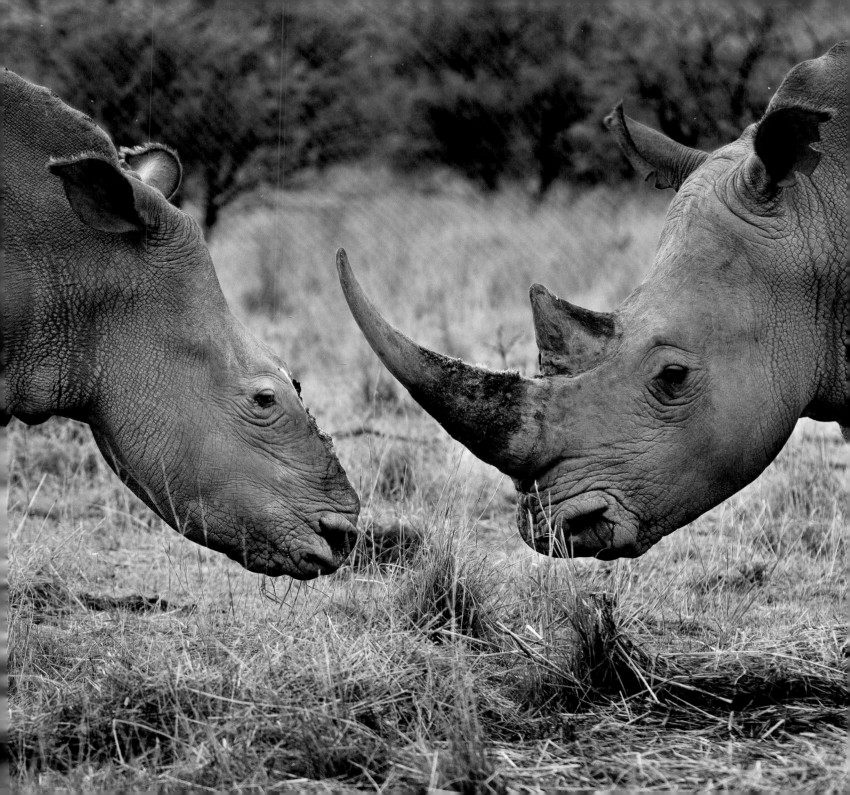

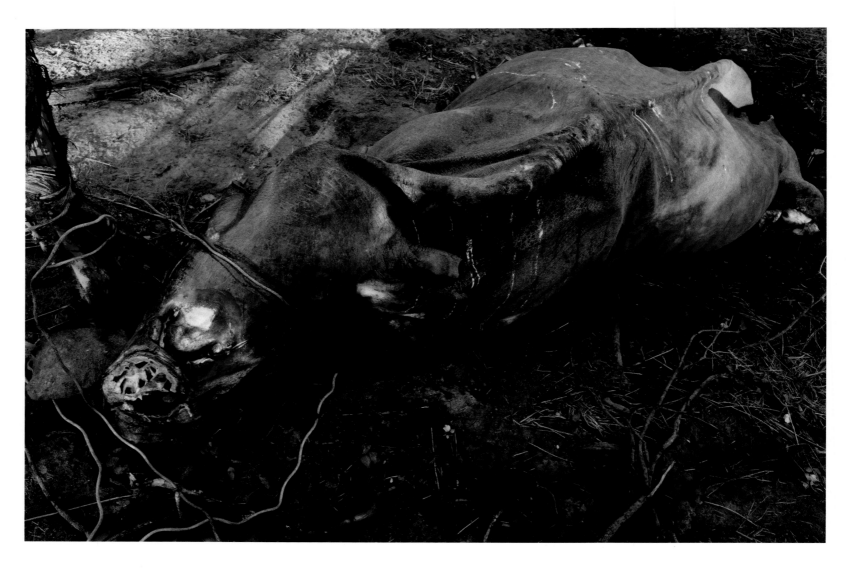

Waste product

This southern white rhino had been snared and killed for its horn on Selati Game Reserve, Hoedspruit, South Africa. It was one of two animals slaughtered in two days. Most reserves now employ armed guards, but it's impossible to protect free-ranging animals in such large areas, and rhino poaching is at an all-time high in Africa. The killing has also become opportunistic, with many poachers who previously would only snare smaller animals taking advantage of the high price paid for horns. The snaring of rhino was unheard of until two years ago. Poaching has also moved into much larger circles, with sinister links to organised crime.

Canon 5D Mark II + 16-35mm lens; 1/10 sec at f11; ISO 100.

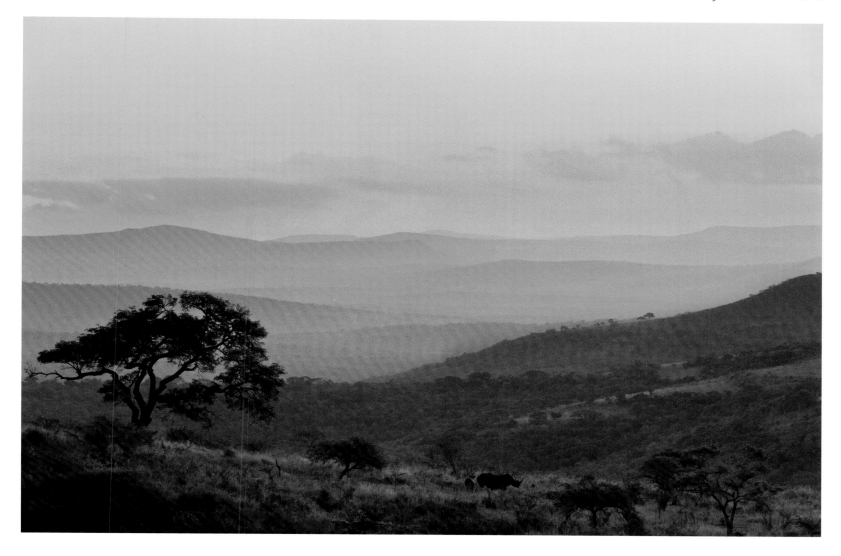

Sunset over the land of rhinos

This is how rhinos should be seen, in their natural terrain, unfenced and with room to roam. The actual location is Imfolozi and Hluhluwe Game Reserve in KwaZulu-Natal, South Africa. This is not only one of South Africa's oldest and largest wildlife reserves but also the world's largest repository for rhinoceroses, home to about 2,000, mainly southern white, though with some black. It's also a major poaching site. In 2011 in South Africa, more than 450 rhinos were killed for their horn, often by well-organised and well-armed gangs, using helicopters and with a supply route to northern ports for export to the Far East.

Canon 5D Mark II + 70-200mm f2.8 lens; 1/60 sec at f10; ISO 250.

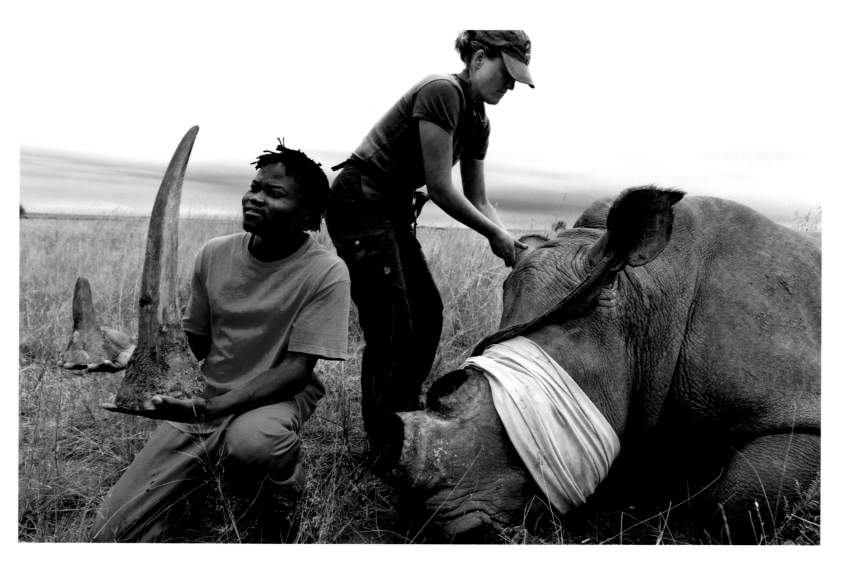

Weighing up the value

In South Africa, many game farms are dehorning their rhinos as a precautionary anti-poaching measure, though poachers may still kill a rhino for the stump, and the horns will grow back after about five years. Here, on a game farm outside Klerksdorp, the vet's assistant holds up the horns of a southern white rhino for an identity picture. The horns will be microchipped and securely stored as investment should trade in rhino horns be legalised. Conservation groups are largely against legalisation as a way of satisfying the Asian-market demand for horn, fearing a lack of ethical policing of any trade.

Canon 5D Mark II + 24mm f1.4 lens; 1/250 sec at f6.3; ISO 100.

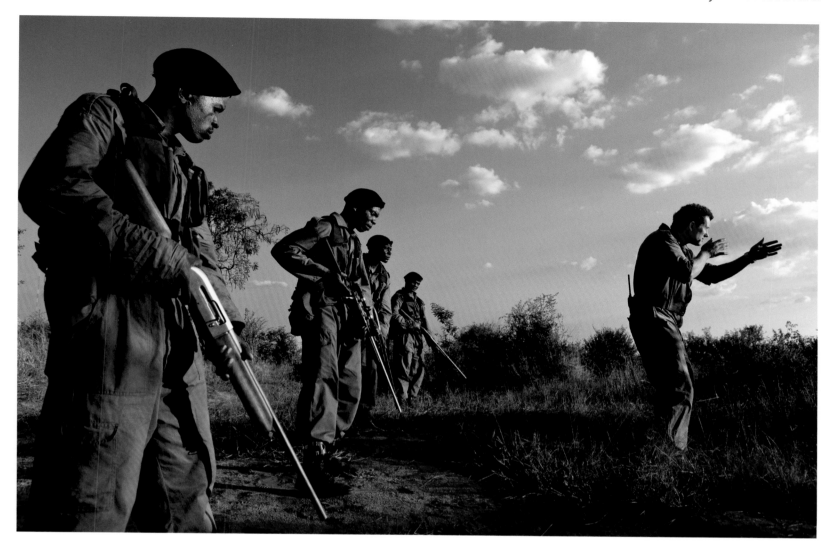

Learning to fight back

The illegal trade in wildlife is now the third largest criminal industry in the world, and men such as these Zimbabwe rangers are in the front line of the fight against it. But unlike the organised gangs of poachers after rhino horn and ivory, rangers seldom have access to automatic weapons or proper training. Damien Mander, a former special-operations soldier in the Australian military, has set up the International Anti-poaching Foundation in response to the rhino slaughter. Here, at Victoria Falls, he leads a free workshop teaching rangers everything from weapon-use and tracking to ambush and arrest techniques.

Canon 5D Mark II + 24-70mm f2.8 lens; 1/250 sec at f5.6; ISO 100.

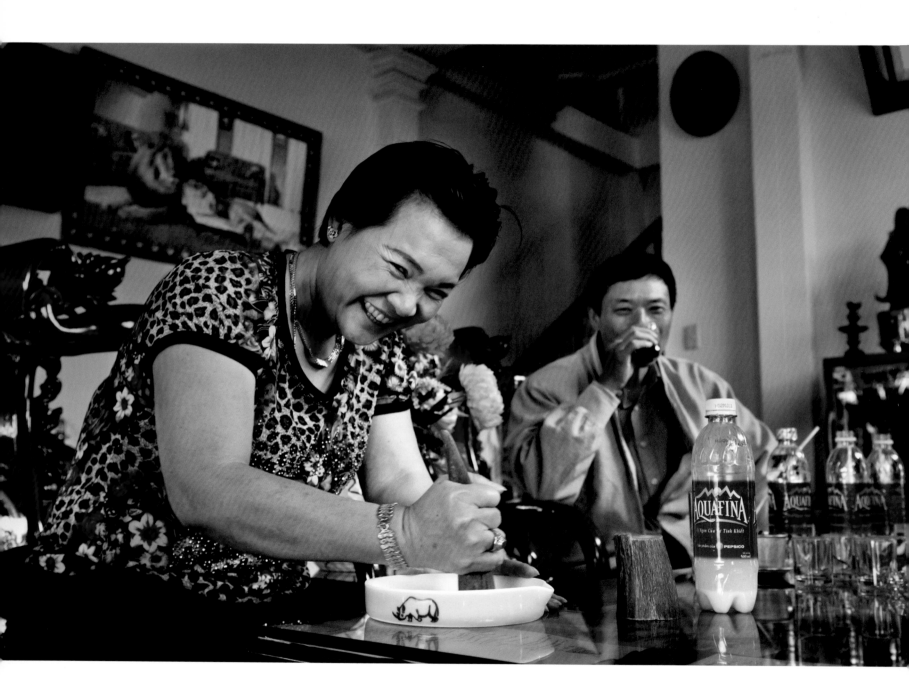

The consumer

The demand for rhino horn is being driven by the growing Asian middle class. Many believe the centuries-old myth that it cures a multitude of ailments, even though it is merely keratin — the constituent of hair, fingernails and toenails. This wealthy Vietnamese woman is a typical consumer. She has bought the horn from the dealer sitting next to her and is grinding it for personal consumption in full public view in a roadside café. The woman claimed it cured her kidney stones and said that she took it daily for her general health. Despite rhino horn being an illegal substance in Vietnam, both the woman and her dealer had no fear of the police and happily ground the horn in full view of the street. The dealer told Brent that he paid $1500 a month to the 'right' people so that he could continue selling it with impunity.

Fuji FinePix X100 + 35mm f2 lens; 1/180 sec at f4; ISO 1000.

The Eric Hosking
Portfolio Award

This award seeks to inspire and encourage young and emerging talent.
It was created in memory of the pioneering natural history photographer
Eric Hosking and is given to a photographer between the ages of 18 and 26
for a portfolio of six images.

Vladimir Medvedev

RUSSIA

**Vladimir started taking photographs when he was 16, and at 18, he won
the very first Russian wildlife photography contest, the Golden Turtle.
He became fascinated with Mongolia and went there every year for four years
during his university holidays. The result was a book, *Amazing Mongolia*,
published in 2010, which won first place in the biggest book competition in
Russia and a special award from UNESCO. Last year, he travelled to Canada
to photograph the Rocky Mountains, and he is now planning to
photograph some of the unique landscapes in his Russian homeland.**

The snow herd

At 1,800 metres in the mountains of Canada's Banff National Park, bighorn sheep
are forced to scrape down into the snow with their hooves to reach the grass below.
Vladimir watched the hardy herd from the shelter of a clump of trees. At first, he took
a series of portraits. But then he realised that the context was missing. By using
a wide-angle lens he could show the whole herd in its environment. Vladimir worked
out which way the herd was heading and then 'walked up the slope and sat right in
their path. They saw me, but they weren't bothered,' he says. 'They simply walked
around me and continued on their way uphill.'

Canon EOS 5D Mark II + 16-35mm f2.8 lens; 1/250 sec at f9; ISO 200.

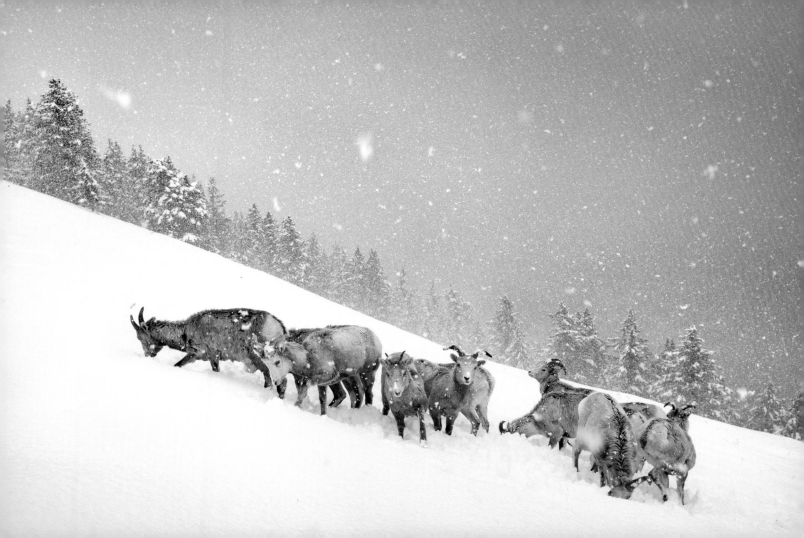

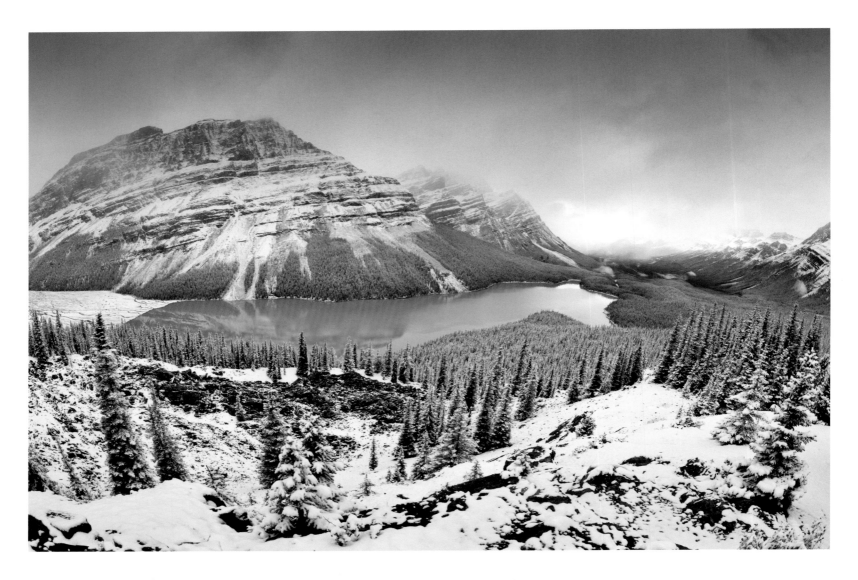

Snowstorm light

Peyto Lake in Banff National Park, Canada, is renowned for its beautiful colour.
The milky turquoise-blue tint is caused by light bouncing off silt suspended in
the water – glacial milk – the result of the grinding action of the glaciers that
feed it. 'On clear days, the light in the morning and in the evening is too weak
to capture its beauty,' says Vladimir. 'During the day, the light is too harsh.'
The solution, he decided, was to wait for a snowfall to soften the light. But that
proved logistically challenging. 'In spring, the lake vanishes beneath the ice,' he
says. 'In autumn, it snowed only twice.' But on one of those occasions, Vladimir
was able to get there in time to catch the brief lull just after one snowstorm
and before the next. The light was perfect, he says, 'with the sun setting over
the horizon and on the opposite side, a new storm front approaching'.

Canon EOS 5D Mark II + 15mm fisheye lens; 1/60 sec at f7.1; ISO 400.

Raven icon

Vladimir was preoccupied with a task when the raven landed on the totem pole, and he didn't think there was any urgency, photographically speaking. He could, of course, see the potential of the scene, in Canada's Jasper National Park. He knew that the raven had great cultural significance. 'According to the myths of the indigenous North Americans, the raven is the god that founded the world,' he says. There was evidence that the totem was regularly used as a perch, and Vladimir assumed that it was one of the raven's favourite spots. He took one shot. The raven flew away and never came back while he was there.

Canon EOS 5D Mark II + 500mm f4 lens; 1/250 sec at f4; ISO 200.

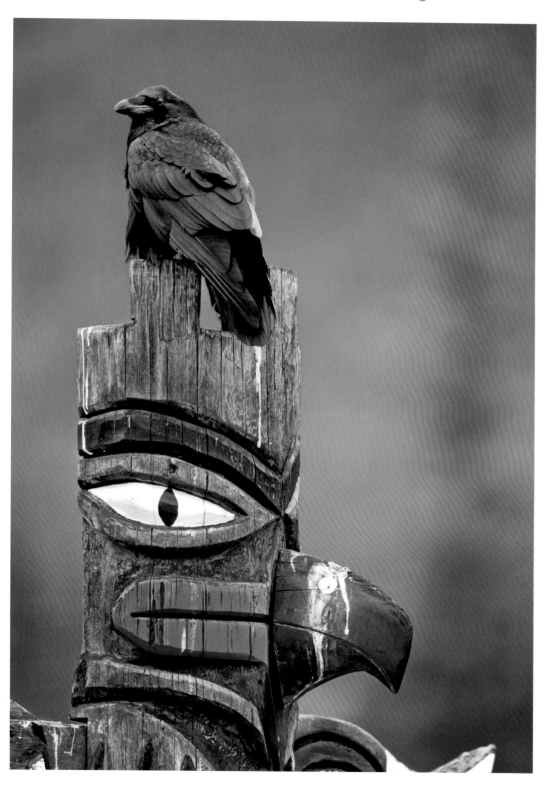

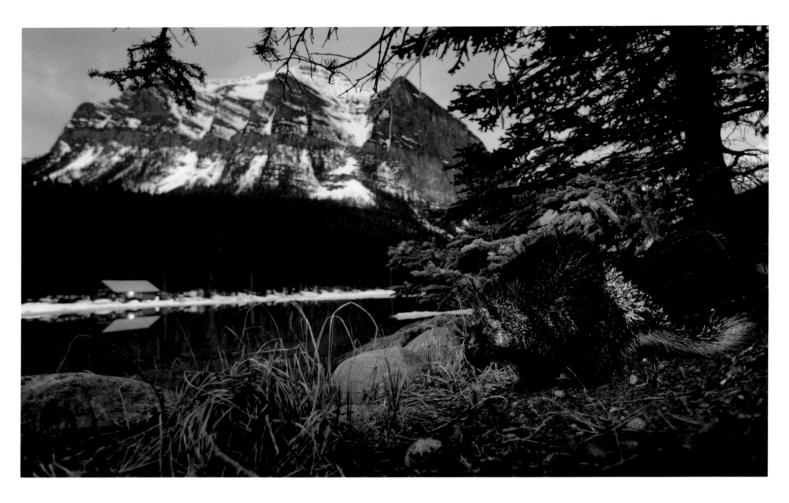

Porcupine watching

Vladimir knew something was watching him. Dawn was still hours away, but he could make out the outline of what looked like a small spiky bush. 'Then, as I approached, I realised that the bush was in fact a beast.' Vladimir, who was looking for nocturnal animals in Banff National Park, Canada, lay down on the ground and waited for the porcupine to feel at ease again. 'I had to use a slow shutter speed and maximum aperture opening, along with a narrow flash beam,' he says. 'I was lucky that light from the boathouse added warmth to the scene on that cold morning and illustrated just how dark it was.' After a few minutes, the porcupine stood up on its back legs, took one last look at Vladimir and ambled off towards the wood, melting into the darkness.

Canon EOS 5D Mark II + 16-35mm f2.8 lens; 1/40 sec at f2.8; ISO 800.

Life in the border zone

The stillness of the red deer stag in the twilight made it almost invisible to motorists speeding down the highway through Jasper National Park, Canada. But its silhouette at the side of the road caught Vladimir's eye. By the time he had pulled over, this image was already in his mind. 'I wanted to show how the natural world often exists so close to us, yet is so often unseen,' he says. Working swiftly, Vladimir positioned his tripod and set the shutter speed low, so that headlights would leave the longest light trail possible, and waited for a truck to thunder by, hoping the deer wouldn't move. 'The stag may have been inconspicuous, but I wasn't. As long as I stayed there, it was no longer invisible. So I left straight away, so as not to betray its presence.'

Canon EOS 5D Mark II + 70-200mm f4 lens; 5 sec at f10; ISO 100.

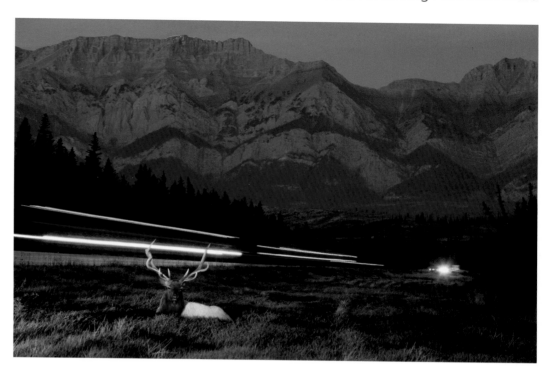

Moonset at sunrise

As the full moon sunk below the horizon on one side of Lake Louise in Banff National Park, Canada, the morning sun edged its way up at the other. The phenomenon occurs just once a month, and Vladimir was determined to photograph both celestial bodies simultaneously. 'I chose a fisheye lens because its wide angle meant that I could include much of the sky as well as the dramatic landscape.' He was lucky with the weather. Shortly after taking the shot, the clouds thickened and hid the sun for the remainder of its dawning.

Canon EOS 5D Mark II + Sigma 15mm f2.8 fisheye lens; 60 sec at f2.8; ISO 800.

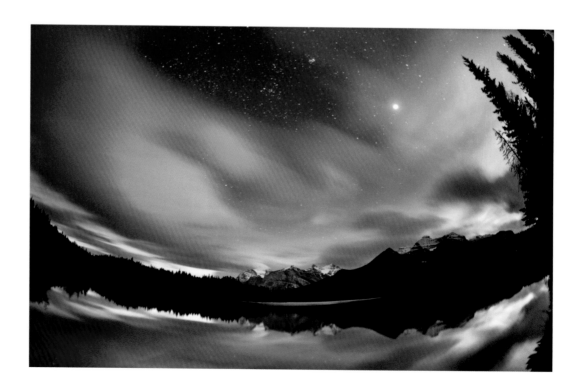

The Veolia Environnement Young Wildlife Photographer of the Year Award

The title Veolia Environnement Young Wildlife Photographer of the Year 2012 goes to Owen Hearn – the young photographer whose picture has been judged to be the most memorable of all the pictures by photographers aged 17 or under.

Owen Hearn

UK

Owen's interest in photography began in 2009, when he was bought a point-and-shoot camera for Christmas. The next year he saved up and bought himself a bridge camera, and then moved on to a DSLR. He sold all his belongings to buy lenses, taught himself photography using internet tutorials and practised on his grandparents' nearby wildlife-rich dairy farm. Now aged 13, he says that 'it's not unusual to see me leave the house before 5am to try and find a hare in the sunrise, or for my mum to search for me at 9.30pm, when I am lying quietly in a hedge, hoping to see an owl or the resident Chinese water deer in the setting sun.' Owen would like a career in photography ('if I'm lucky') but would be happy becoming a farmer.

Flight paths

Harvest time at Owen's grandparents' farm draws in the birds of prey to feed on the fleeing small mammals, and it also attracts Owen, with his camera at the ready. 'Seeing this red kite with an aeroplane in the distance was a moment I couldn't miss,' says Owen. The shot is symbolic for him for two reasons. It was taken at the centre of the Bedfordshire site chosen for London's third airport back in the late 1960s. 'Opposition to the planned airport stopped it going ahead, which is why I can photograph the wildlife on the farm today.' At the same time, British red kites also faced extinction following centuries of persecution. But following reintroductions, numbers have increased dramatically, spreading east from the Chilterns.

Nikon D90 + 300mm f4 lens + 1.4x teleconverter; 1/1000 sec at f5.6; ISO 500; Manfrotto monopod.

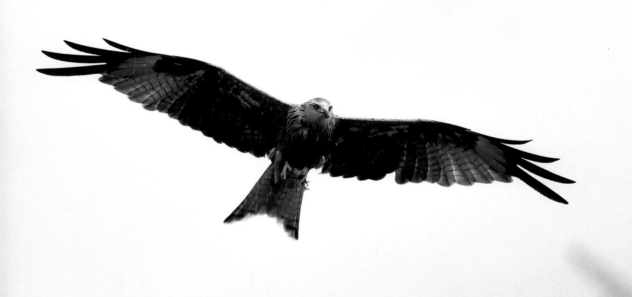

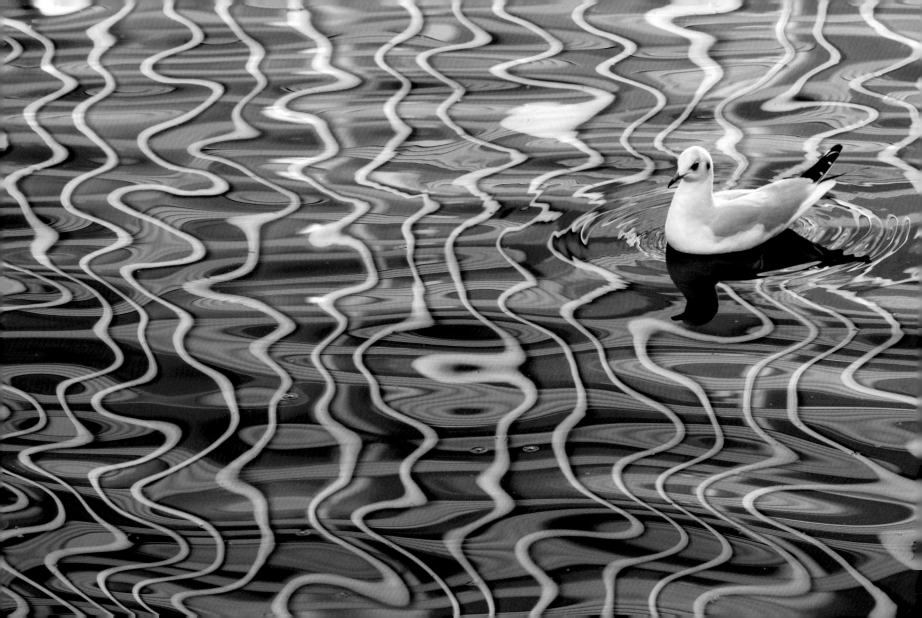

City gull

WINNER

Eve Tucker

UK

Some of the tallest buildings in London surround the docklands at the heart of the business and financial district of Canary Wharf. As Eve walked along the wharf, a bird caught her eye. It was a black-headed gull, of which there are many in the city. But this one was resting on a very remarkable area of water. Eve realised that she was looking at reflections of the straight lines of the nearby office block, distorted into moving swirls. 'The effect was so unusual – it gave a beautiful setting for an urban wildlife image.' Like all true photographers, Eve had noticed what others most often fail to see, even when it's right in front of them.

Canon EOS 450D + 100mm f2.8 lens; 1/250 sec at f4.5; ISO 200.

Pasque perfection

RUNNER-UP

Daniel Eggert

GERMANY

Ever since he'd first fallen in love with pasque flowers, among the first flowers of spring, Daniel had wanted to photograph them covered in hoar frost. Now it was pasque-flower time once again. He had already identified a spot of chalky grassland near his home where the plants grew, on the rim of the Nördlinger Ries crater (a meteor crater) in Bavaria, Germany. So as soon as a cold, frosty, sunny dawn was forecast, Daniel headed up the hill. 'I found the ideal flowers to photograph, but I didn't have much time,' he says, 'because I knew that as soon as the sun rose, the frost would quickly melt.' He took this image just as the rising sun began to bathe the hill in a wonderful orange light. 'I love the colours,' he says, 'and the contrast between the warm background and the cold ice.'

Canon EOS 350D + Sigma 105mm lens; 1/125 sec at f5; ISO 200; beanbag.

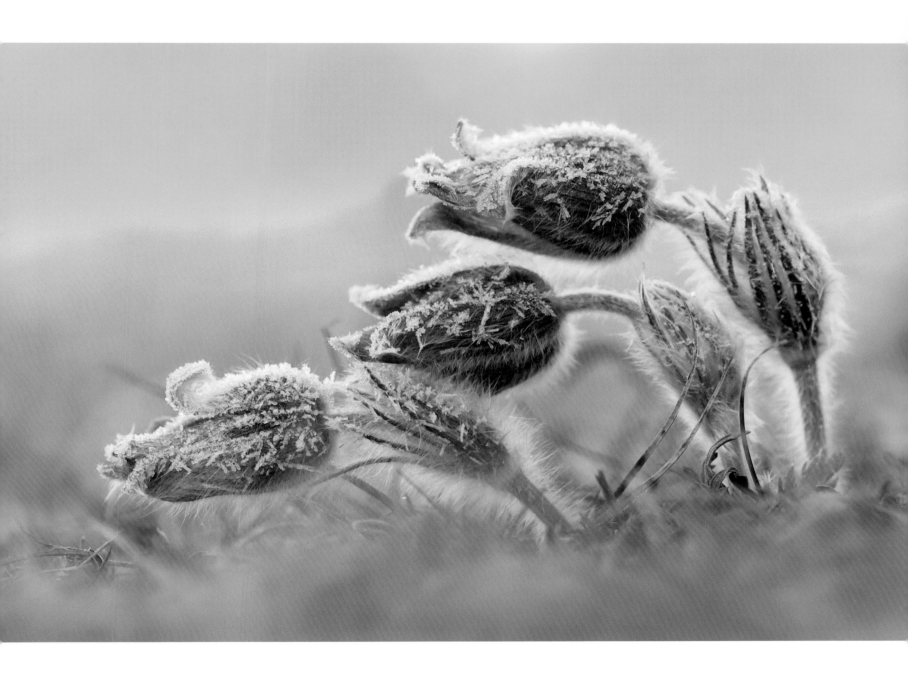

The unexpected hunter

SPECIALLY COMMENDED

Brieuc Graillot Denaix

FRANCE

Brieuc was hiking with his family in Forillon National Park in Gaspé, Canada, hoping to photograph a wild black bear, when this one fell, literally, into his path. 'A terrified young moose suddenly leapt out of the bushes onto the track,' he says, 'followed by a black bear, which jumped onto its back attempting to break its neck.' Brieuc by then was just 30 metres away and was quick enough to get a picture. A few seconds later, a car drew up, and the bear retreated, leaving the moose on the track with fatal neck injuries. (Black bears, being omnivorous, eat other mammals. Later, rangers moved the moose so that the bear could find it.) 'The drama lasted about a minute. But what a memory!' says Brieuc.

Canon EOS-1D Mark IV + 70-200mm lens + 1.4x extender; 1/1250 sec at f5; ISO 400.

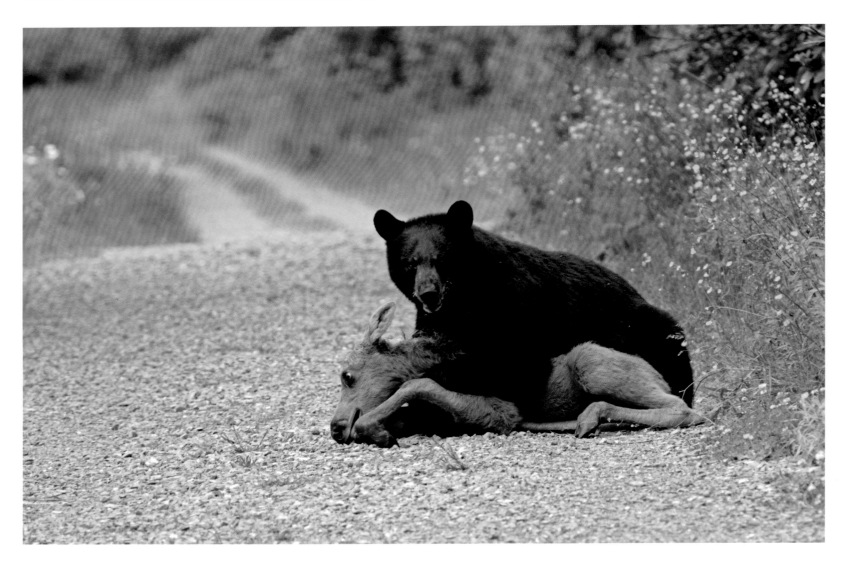

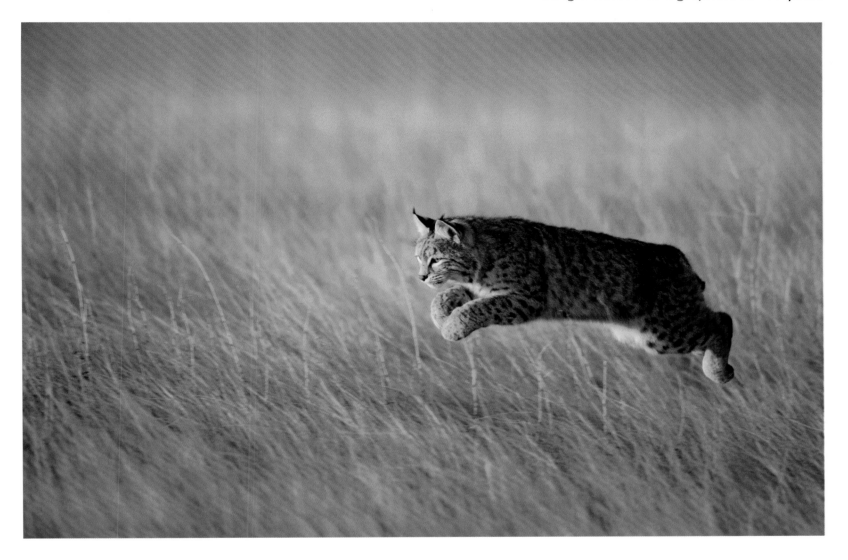

Crouch, pause, action

COMMENDED

Joe Sulik

USA

Joe arrived in the bobcat's territory before sunrise to start looking for her. Finally he spotted her outline. 'She was crouched in the long grass, all hunched up, watching for prey,' says Joe. But she had no intention of rushing. The sun peeked above the horizon, then rose steadily up above Badlands National Park in South Dakota, USA. The bobcat continued to scan. Joe continued to watch, hidden in the long grass. A full hour later, the action began. 'I saw her shift her weight to her hind legs,' Joe remembers. 'I knew I had just a fraction of a second to get ready for the shot.' Sure enough, the bobcat suddenly pounced. Unlike the build-up, breakfast itself took just a few moments. After devouring the vole, she disappeared into the long grass, her patience – and Joe's – rewarded.

Nikon D3 + 600mm f4 lens + 1.4x teleconverter; 1/400 sec at f5.6; ISO 800.

Bittern in winter

COMMENDED

Oscar Dewhurst

UK

One of Oscar's favourite photographic subjects is the bittern. And one of
his favourite places to photograph it is at the London Wetland Centre, where
several of these secretive herons usually overwinter in the reedbeds. They tend
to stay tucked among the reeds, searching for fish at the water's edge and are
notoriously well camouflaged and shy. But when the water freezes, they are
sometimes forced out onto the ice to look for food. 'During the very cold winter
of 2010,' says Oscar, 'there were seven bitterns at the site.' He explains how he
was in the public hide, photographing a bittern close by, when a blizzard started.
He was just about to pack up and leave when he saw 'another bittern suddenly
set off across the ice.' The image ended up being his favourite shot of the day.

Nikon D300S + 200-400mm f4 lens at 380mm; 1/500 sec at f4; ISO 640.

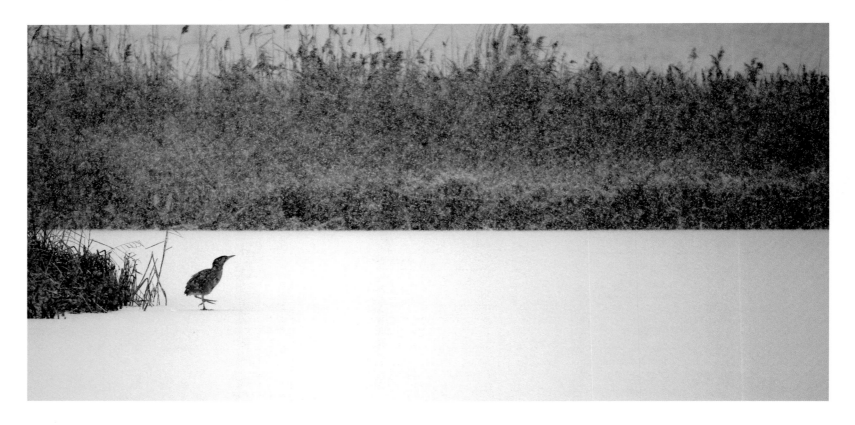

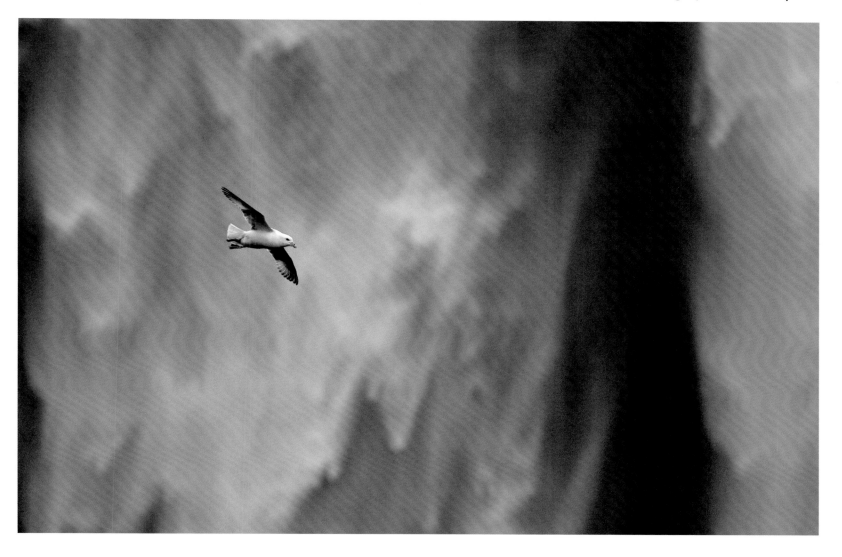

Elemental fulmar

COMMENDED

Sam Cairns

UK

The Skógafoss is one of the biggest inland waterfalls in Iceland, with a 60-metre drop down a cliff. 'My motor drive was doing overtime,' says Sam, 'as I tried to find an alternative way to photograph the impressive scene.' Then a lone northern fulmar came sweeping down in front of the crashing water and spray. 'As it ducked and dived,' he says, 'it seemed tiny against the dark background of the massive falls and was exactly what I needed to convey the atmosphere of this elemental place.'

Canon EOS-1D Mark II + 300mm f2.8 lens; 1/4000 sec at f2.8; ISO 400; Gitzo tripod.

Flight paths

Owen Hearn

UK (see page 140)

Snow hide

Owen Hearn

UK

It was a night of snow that gave Owen the advantage. 'After spending countless hours lying in hedges and long grass trying to photograph hares,' says Owen, 'I couldn't believe my luck when I came across this hare just metres away, crouched down in the snow.' Owen also crouched down in the snow and slowly moved forward until he was close enough to fire off four frames. 'I am sure it thought it was camouflaged,' he says. Owen's hare-stalking ground is his grandparents' Bedfordshire farm. 'I like the challenge of trying to get close to hares, as they are so alert and so fast. They have taught me a lot about fieldcraft.'

Nikon D300 + 300mm f2.8 lens + 1.7x teleconverter; 1/1000 sec at f4.5; ISO 1000; Induro tripod + Manfrotto ballhead.

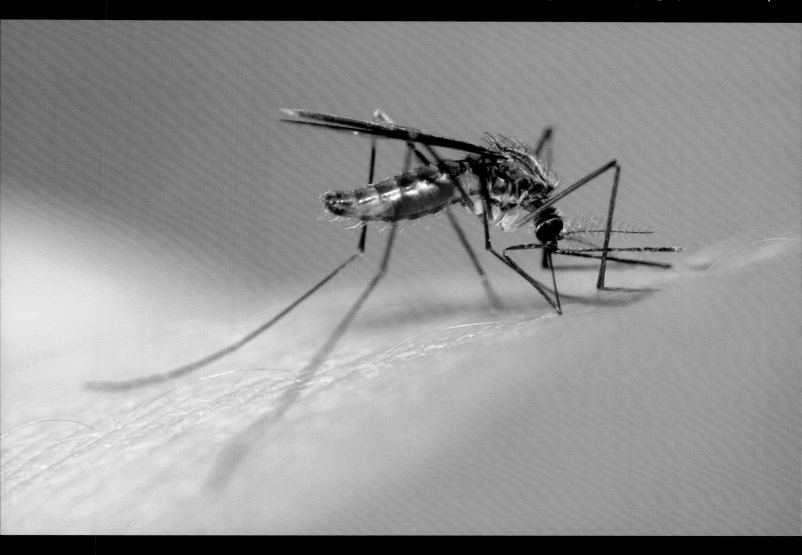

Blood donation

SPECIALLY COMMENDED

Joshua Burch

UK

The dragonflies weren't cooperating. Joshua had borrowed his dad's macro lens
and sat down by the pond in his garden in Surrey to photograph them, but they
just weren't staying still for long enough. Then a very willing subject appeared.
This one offered to sit very still indeed – but for a price. 'I took about 10 pictures
of the mosquito, starting with the 'empty' stage and ending when it had a full
tank,' says Joshua, who had to take the shot one-handed. 'It's a female – they

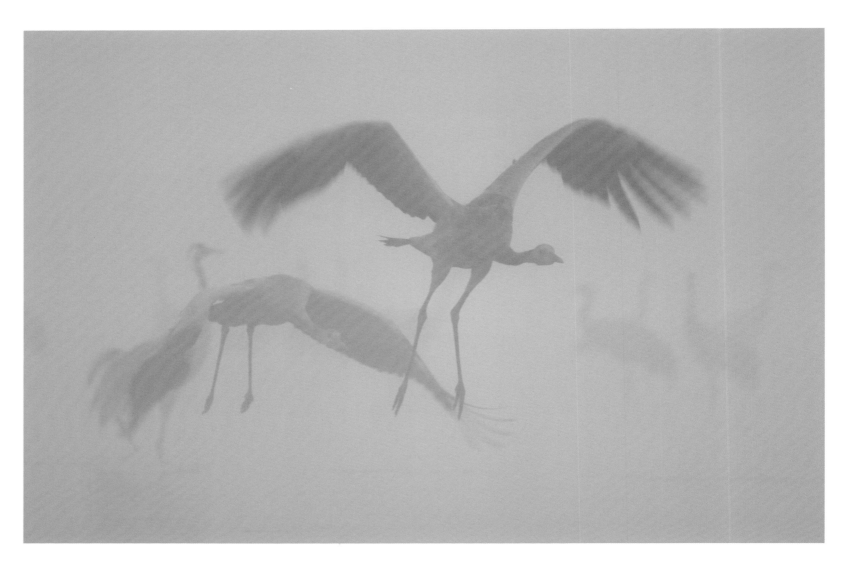

Dawn flight

WINNER

Bartek Kosiński

POLAND

Bartek spent five days with his father at Milicz Fishponds Nature Reserve, western Poland, photographing the common cranes. These impressive birds – adults have a wingspan of more than two metres – spend a few days on the shore of the shallow lake on their way south to Africa for the winter. Bartek spent every morning and evening taking photographs from the lakeshore hide. On the last dawn, a mist descended and gave the scene a wonderfully mysterious atmosphere. 'After sunrise,' says Bartek, 'we could hardly see the birds. I was using manual focus. So I was very lucky to get them as sharp as this.'

Nikon D300 + Sigma 400mm f5.6 lens; 1/250 sec at f5.6; ISO 800; Manfrotto 190PRO tripod + 701HDV head; hide.

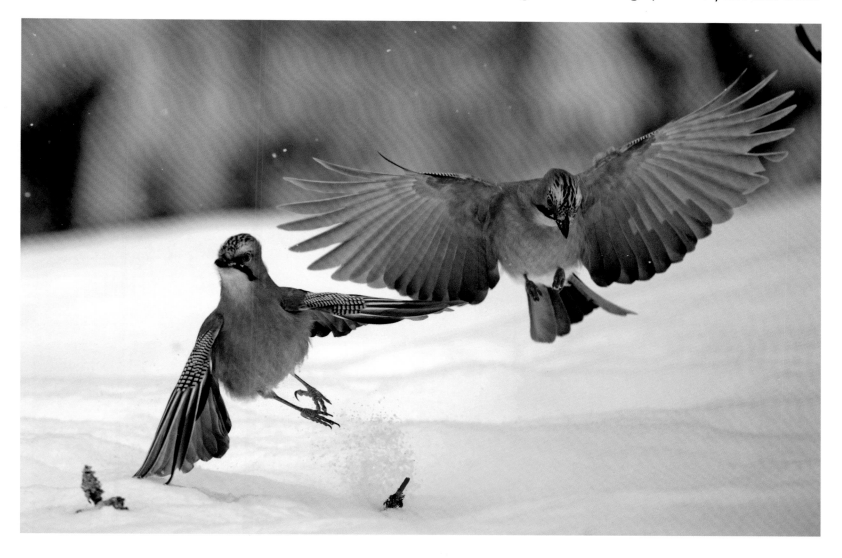

Squabbling jays

RUNNER-UP

Liina Heikkinen

FINLAND

It was winter in Kouvola, Finland, and Liina set off with her father to their hide to take pictures of birds. 'It was still completely dark,' she says, but soon the early morning light revealed a group of around six jays close by. 'There was a lot of squabbling.' This was her favourite shot because of the angle of the birds and the way their feathers are spread apart. The low light also helped bring out their beautiful colours.

Nikon D700 + 200-400mm f4 lens; 1/4000 sec at f4; ISO 1000; Manfrotto tripod; hide.

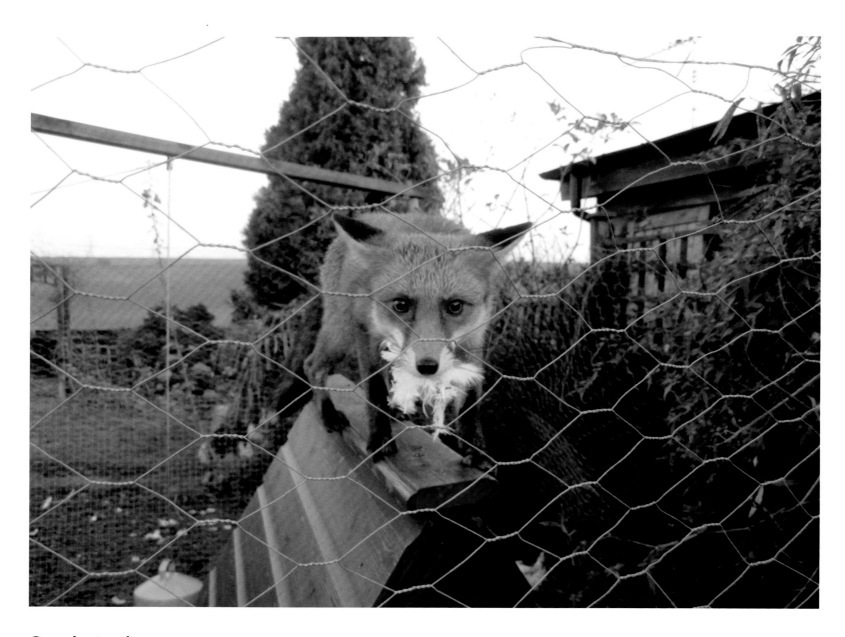

Caught in the act

COMMENDED

Hannah Bedford

UK

'There was a commotion in the garden,' says Hannah, 'and this was what was causing it.' The fox had killed all four hens in the chicken run and was in the process of eating one of them. Hannah dashed in to get her camera, and caught the fox still on top of the hen house, mouth full of feathers, frozen in fear at seeing the family of humans. 'I loved seeing a fox so close up,' adds Hannah, 'but we don't keep chickens any more.'

Canon PowerShot A1100 IS + 35-140mm lens; 1/20 sec at f2.7; ISO 500.

Dipper dipping

COMMENDED

Malte Parmo

DENMARK

One of Malte's favourite places to photograph birds is a stream near his home close to Copenhagen. In winter, there are always four or five dippers there, fishing for insect larvae and other small creatures. 'If you are calm with slow movements,' he says, 'the birds come very close.' Last Christmas, he decided to photograph the dippers in the stream, shooting with a slow shutter speed to show the flowing water. But it would only work if the bird kept still long enough. 'This dipper was very close. It dived several times in the same place. I took a lot of pictures, most of them blurry. But some came out as I wanted. With this one, I think I managed to get the feeling of running water and an almost vibrating active dipper, its head under the water looking for food.'

Canon EOS 50D + 70-200mm f4 lens + 1.4x extender; 1/15 sec at f8; ISO 160; Manfrotto tripod.

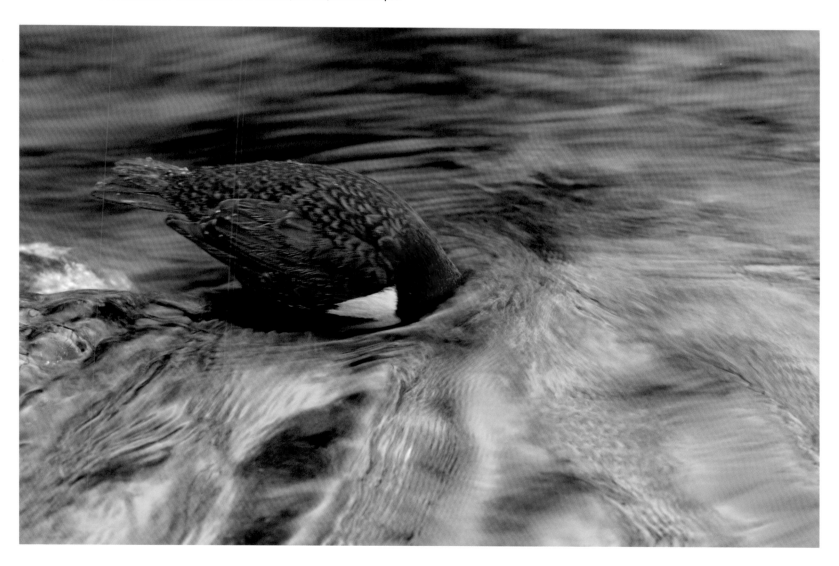

Index of Photographers

117
Yves Adams
BELGIUM
natuurfotografie@yvesadams.be
www.yvesadams.be
Agent
www.vildaphoto.net

85
Cezariusz Andrejczuk
POLAND
ksian@pro.onet.pl
www.cezariusz.com

49
Miquel Angel Artús Illana
SPAIN
artus@tossagestio.com

88
Ralph Arwood
USA
photo@ralpharwood.com
www.ralpharwood.com

94
Alexander Badyaev
RUSSIA/USA
author@tenbestphotos.com
www.tenbestphotos.com

26
Sandra Bartocha
GERMANY
info@bartocha-photography.com
www.bartocha-photography.com
Agent
www.naturepl.com

154
Hannah Bedford
UK
suebedford@ntlworld.com

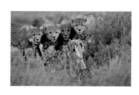

50, 56
Grégoire Bouguereau
FRANCE
contact@viemages.com
www.viemages.com

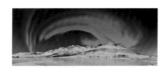

42
Thilo Bubek
GERMANY
thilo@bubek.com
www.bubek-fotodesign.com

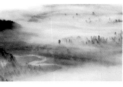

151
Joshua Burch
UK
Joshua@sburch.f2s.com
http://jbwildimages.yolasite.com/

149
Sam Cairns
UK
samcairnsphotography@gmail.com
www.samcairns.com

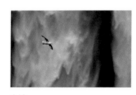

58
Luciano Candisani
BRAZIL
luciano@candisani.com.br
www.lucianocandisani.com

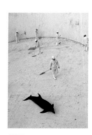

21
Jordi Chias
SPAIN
jordi@uwaterphoto.com
www.uwaterphoto.com

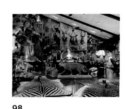

44
Magnus Carlsson
SWEDEN
info@taigavision.com
www.taigavision.com

98
David Chancellor
UK
david@davidchancellor.com
www.davidchancellor.com
Agent
INSTITUTE for Artist Management
http://www.instituteartist.com

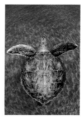

100
Huang-Ju Chen
TAIWAN
huangju.chen@gmail.com
www.wretch.cc/blog/e85841451

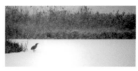

148
Oscar Dewhurst
UK
oscar.dewhurst@gmail.com
www.oscardewhurstphotography.co.uk

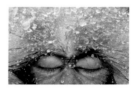

75, 102
Jasper Doest
THE NETHERLANDS
info@jasperdoest.com
www.jasperdoest.com

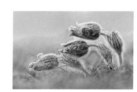

144
Daniel Eggert
GERMANY
eggert.daniel@arcor.de
www.natur-motive.de

90
Kai Fagerström
FINLAND
kai.fagerstrom@evl.fi
www.kafa.fi

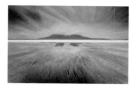

47
Fortunato Gatto
ITALY
fortunato.gatto@gmail.com
www.fortunatophotography.com

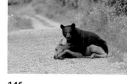

146
Brieuc Graillot Denaix
FRANCE
brieuc.graillot.denaix@wanadoo.fr

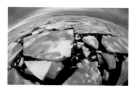

80
Thomas Hanahoe
UK
t.hanahoe@ntlworld.com
www.hanahoephotography.com

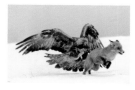

96
Anna Henly
UK
anna.photography@btinternet.com
www.annahenly.com

67
Stefan Huwiler
SWITZERLAND
naturfoto@stefanhuwiler.ch
www.stefanhuwiler.ch

19
Claudio Gazzaroli
SWITZERLAND
info@gazzaroli.ch
www.claudiogazzaroli.com

20
David Hall
USA
david@seaphotos.com
www.seaphotos.com

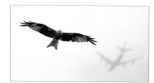

140, 150
Owen Hearn
UK
sales@tringmarketauctions.co.uk
www.ohearnphotography.500px.com

92
Pål Hermansen
NORWAY
palhermansen@hotmail.com
www.palhermansen.com

101
Jabruson
UK
jabruson@gmail.com
www.jabruson.photoshelter.com

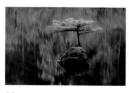

89
Adam Gibbs
CANADA/UK
adam@adamgibbs.com
www.adamgibbs.com

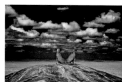

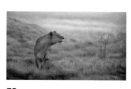

104
Paul Hilton
UK/AUSTRALIA
mail@paulhiltonphotography.com
www.paulhiltonphotography.com

152
Bartek Kosiński
POLAND
bartek@kosinscy.pl
www.bartek.kosinscy.pl
Agent
marek@kosinscy.pl

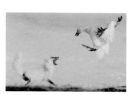

65
Sergey Gorshkov
RUSSIA
gsvl@mail.ru
www.gorshkov-photo.com
Agent
www.mindenpictures.com
www.naturepl.com

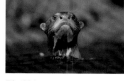

79, 114
Charlie Hamilton James
UK
charlie@halcyon-media.co.uk
www.charliehamiltonjames.com

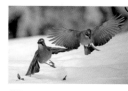

153
Liina Heikkinen
FINLAND
liina.heikkinen@hotmail.com
Agent
jari.heikkinen@ppq.inet.fi

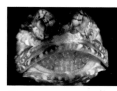

72
Frits Hoogendijk
SOUTH AFRICA
frits@tandmuis.co.za
www.natureimages.co.za

60
Steven Kovacs
CANADA
ngfl2@hotmail.com
www.underwaterbliss.com

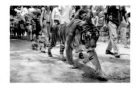

108
Melisa Lee
MALAYSIA
melisalee@mac.com
www.melisalee.com

38
Jeanine Lovett
USA
jeaninelovett@gmail.com
www.jeaninelovett.com

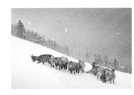

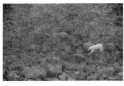

37
Alessandra Meniconzi
SWITZERLAND
alex.photo@mac.com
www.alessandrameniconzi.com

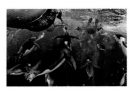

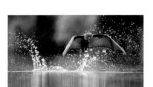

115
Ofer Levy
ISRAEL/AUSTRALIA
olevy@optusnet.com.au
www.oferlevyphotography.com

68
Larry Lynch
USA
lynchphotos@aol.com
www.lynchphotos.com

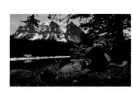

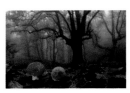

86
Andrés Miguel
SPAIN
andres@dendrocopos.com

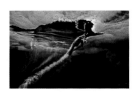

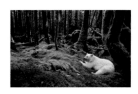

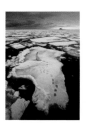

30
Ole Jørgen Liodden
NORWAY
post@naturfokus.no
www.naturfokus.no
Agent
www.naturepl.com

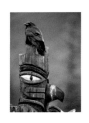

25
David Maitland
UK
dpmaitland@gmail.com
www.davidmaitland.com
Agent
www.gettyimages.co.uk
www.naturepl.com

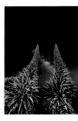

84
Francisco Mingorance
SPAIN
jfmingorance@terra.es
www.franciscomingorance@terra.es

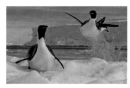

14, 16, 34, 62
Paul Nicklen
CANADA
paulnicklen@me.com
www.paulnicklen.com
Agent
National Geographic Image Collection:
Stacy Gold, sgold@ngs.org

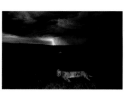

32
Hannes Lochner
SOUTH AFRICA
hannes@lochnerphoto.com
www.hanneslochner.com

70
John E Marriott
CANADA
johnemarriott@gmail.com
www.wildernessprints.com

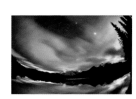

134-9
Vladimir Medvedev
RUSSIA
photo@vladimirmedvedev.com
www.vladimirmedvedev.com

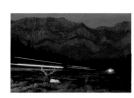

22
Klaus Nigge
GERMANY
klaus.nigge@t-online.de
www.nigge.com
Agent
www.ngsimages.com

155
Malte Parmo
DENMARK
maltephoto@parmo.org
www.parmo.org

18
Thomas P Peschak
GERMANY/SOUTH AFRICA
thomas@thomaspeschak.com
www.thomaspeschak.com

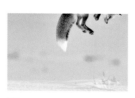

57
Richard Peters
UK
richard@richardpeters.co.uk
www.richardpeters.co.uk

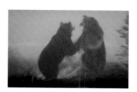

52
Kimmo P Pöri
FINLAND
erajokke@suomi24.fi

54
Jenny E Ross
USA
jenny@jennyross.com
www.jennyross.com
Agent
www.corbisimages.com
www.naturepl.com

40
Joel Sartore
USA
sartore@inebraska.com
www.joelsartore.com
Agent
National Geographic Stock
www.nationalgeographicstock.com
Alice Keating akeating@ngs.org

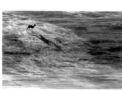

78
Remo Savisaar
ESTONIA
remo@moment.ee
www.moment.ee

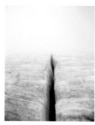

24
Rudi Sebastian
GERMANY
info@rudisebastian.de
www.rudisebastian.de

64
Cristóbal Serrano
SPAIN
cristobal@cristobalserrano.com
www.cristobalserrano.com

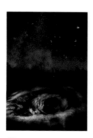

48
Robert Sinclair
USA
rob@sinclairimages.com
www.sinclairimages.com

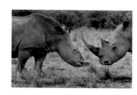

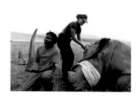

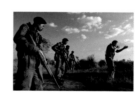

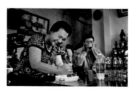

126-133
Brent Stirton
SOUTH AFRICA
brent.stirton@gettyimages.com
www.brentstirton.com

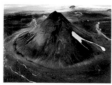

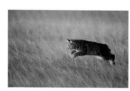

46
Hans Strand
SWEDEN
strandphoto@telia.com
www.hansstrand.com

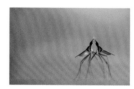

147
Joe Sulik
USA
joseph.sulik@me.com
joesulik.com

61
Klaus Tamm
GERMANY
btamm1@aol.com
www.tamm-photography.com

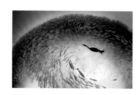

74
Jami Tarris
USA
jami@jamitarris.com
www.jamitarris.com

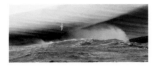

36
Mark Tatchell
UK
mark.tatchell@gmail.com
www.marktatchell.com

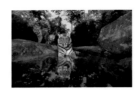

116
Heinrich van den Berg
SOUTH AFRICA
heinrich@hphpublishing.co.za
www.heinrichvandenberg.com

110
Kim Wolhuter
SOUTH AFRICA
wildhoot@mweb.co.za
www.kimwolhuter.com

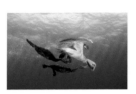

66
Jean Tresfon
SOUTH AFRICA
jtresfon@iafrica.com
www.underwaterimages.co.za

28
Hugo Wassermann
ITALY
hugo.wassermann@gmail.com
www.hugo-wassermann.it

76
Robert Zoehrer
AUSTRIA
zoehrer.robert@aon.at
www.naturfoto-zoehrer.at

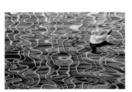

142
Eve Tucker
UK
ejtholmwood@googlemail.com

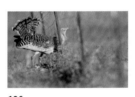

106
Staffan Widstrand
SWEDEN
photo@staffanwidstrand.se
www.staffanwidstrand.se
Agent
www.naturepl.com

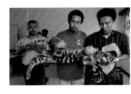

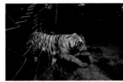

82
Glenn Upton-Fletcher
UK
glenn@gufphotography.com
www.gufphotography.com

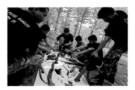

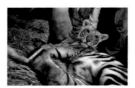

112, 118-125
Steve Winter
USA
stevewinterphoto@mac.com
www.stevewinterphoto.com
Agent
National Geographic Stock
www.nationalgeographicstock.com